MASACCIO'S
TRINITY

Masaccio's "Trinity" examines one of the defining paintings of the Italian Renaissance. Renowned for the grandeur of its characterizations, both sacred and mortal, for the perspectival illusion of its monumental architectural setting, and for its compelling depictions of a human skeleton, the fresco was famous from the time it was painted in the 1420s, and remembered despite its having been hidden from view for nearly two centuries. This volume considers the *Trinity* in its historical and spiritual contexts, its relation to the symbolism of the Trinity, and its liturgical function in the great Dominican church of Santa Maria Novella. Also emphasized are the extraordinary features of the painting, especially its system of spatial illusionism, its problematic state of conservation, and the conception of time and space that the artist masterfully visualized.

Rona Goffen is Distinguished Professor of Art History at Rutgers University, New Brunswick. She is the author of eight books, including *Giovanni Bellini* and *Titian's Women,* and editor of *Titian's "Venus of Urbino"* in the Masterpieces of Western Painting series.

—— MASTERPIECES OF WESTERN PAINTINGS ——

This series serves as a forum for the reassessment of important paintings in the Western tradition that span a period from the Renaissance to the twentieth century. Each volume focuses on a single work and includes an introduction outlining its general history, as well as a selection of essays that examine the work from a variety of methodological perspectives. Demonstrating how and why these paintings have such enduring value, the volumes also offer new insights into their meaning for contemporaries and their subsequent reception.

VOLUMES IN THE SERIES

Masaccio's "Trinity," edited by Rona Goffen, Rutgers University

Raphael's "School of Athens," edited by Marcia Hall, Temple University

Titian's "Venus of Urbino," edited by Rona Goffen, Rutgers University

Caravaggio's "Saint Paul," edited by Gail Feigenbaum

Rembrandt's "Bathsheba with David's Letter," edited by Ann Jensen Adams, University of California, Santa Barbara

David's "Death of Marat," edited by Will Vaughn and Helen Weston, University College, University of London

Manet's "Le Déjeuner sur l'Herbe," edited by Paul Tucker, University of Massachussets, Boston

Picasso's "Les Demoiselles d'Avignon," edited by Christopher Green, Courtauld Institute of Art, University of London

MASACCIO'S
TRINITY

Edited by
Rona Goffen

CAMBRIDGE
UNIVERSITY PRESS

PUBLISHED BY THE PRESS SYNDICATE OF THE UNIVERSITY OF CAMBRIDGE
The Pitt Building, Trumpington Street, Cambridge, CB2 1RP, United Kingdom

CAMBRIDGE UNIVERSITY PRESS
The Edinburgh Building, Cambridge CB2 2RU, United Kingdom
40 West 20th Street, New York, NY 10011-4211, USA
10 Stamford Road, Oakleigh, Melbourne 3166, Australia

First published 1998

Printed in the United States of America

Typeset in Bembo

Library of Congress Cataloging-in-Publication Data

Masaccio's Trinity / edited by Rona Goffen.
 p. cm.
 Includes bibliographical references and index.
 ISBN 0-521-46150-2 (alk. paper)
 1. Masaccio, 1401-1428? Trinity. 2. Masaccio, 1401-1428? -
Criticism and interpretation. I. Goffen, Rona, 1944- .
ND623.M43A74 1998
759.5 - dc21 97-27041
 CIP

*A catalog record for this book is available from
the British Library.*

ISBN 0-521-46150-2 hardback
ISBN 0-521-46709-8 paperback

CONTENTS

ILLUSTRATIONS

CONTRIBUTORS

JANE ANDREWS AIKEN is associate professor of art history at Virginia Polytechnic and State University in Blacksburg. She has published essays in such scholarly journals as *Artibus et Historiae* and *Viator*, and contributed to the volume *Piero della Francesca, "De Prospectiva Pingendi": A Facsimile of Parma, Biblioteca Palatinam MS 1576*.

YVES BONNEFOY, poet, critic, and professor at the Collège de France, has been the recipient of the Prix des Critiques, among other awards. Many of his works are available in English, including *The Lure and the Truth of Painting: Selected Essays on Art*. His semiological essay on "Time and the Timeless in Quattrocento Painting" was previously published in *Calligram: Essays in New Art History from France*, edited by Norman Bryson (Cambridge, England, and New York, Cambridge University Press, 1988).

GENE BRUCKER, professor emeritus of history, University of California, Berkeley, is one of the preeminent historians of Renaissance Italy. He is the author of numerous books and articles, including *Giovanni and Lusanna: Love and Marriage in Renaissance Florence*, a study of love, marriage, and money in fifteenth-century Italy. A chapter from his seminal study, *The Civic World of Early Renaissance Florence*, is excerpted in this book.

ORNELLA CASAZZA, of the Soprintendenza ai Beni Culturali in Florence, directed the recent restorations of the frescoes by Masaccio, Masolino, and Filippino Lippi in the Brancacci Chapel in the Flo-

rentine church of Santa Maria del Carmine. Dr. Casazza has published extensively on Masaccio and on problems of the conservation and techniques of Renaissance paintings. Among her publications that have been translated into English is a volume co-authored with Ugo Baldini, *The Brancacci Chapel Frescoes*.

RONA GOFFEN, distinguished professor of art history at Rutgers, The State University of New Jersey, has published widely on Italian Renaissance art. Among her recent books are *Titian's Women* and another volume in the Cambridge University Press series Masterpieces of Western Painting, *Titian's "Venus of Urbino"* (1997).

KATHARINE PARK is the Zemurray Stone Radcliffe professor of history of science and women's studies at Harvard University. Her most recent book, co-authored with Lorraine Daston, is *Wonders and the Order of Nature, 1150–1750*. They are also coeditors of the *Cambridge History of Early Modern Science* for Cambridge University Press.

RONA GOFFEN

INTRODUCTION
MASACCIO'S *TRINITY* AND
THE EARLY RENAISSANCE

To Meg and Fred Licht

Who can understand the omnipotent Trinity?

Saint Augustine[1]

If a fifteenth-century Italian Humanist were asked to define the Renaissance – a period that named itself – he (or occasionally she) might speak of the revival of classical antiquity, literally its rebirth, *rinascità,* or Renaissance, or more precisely the revival of classical Latin. This was not in any sense an un-Christian or anti-Christian enterprise.[2] On the contrary, a fundamental concern of the Humanists was to master Latin grammar, syntax, and vocabulary so that they might be certain of the Latin writings of the Church Fathers and especially of the Latin edition of the Bible, the Vulgate, traditionally though wrongly attributed to Saint Jerome. Indeed, Lorenzo Valla's historical detective work in analyzing the text of the "Donation of Constantine" may be taken as a paradigm of fifteenth-century Humanist scholarship. Employing methods of textual analysis informed by knowledge of the usage of classical Latin, Valla demonstrated that the "Donation," a document in which the fourth-century Emperor Constantine purportedly ceded certain political rights and properties to the Church, was in fact a forgery written some four hundred years after the emperor's death.[3]

Until late in the fifteenth century, interest in the subjects of classical literature and art was secondary, even peripheral, to the funda-

I

mental concern with the Latin (and Greek) words of God and his saints. Most Italian artists continued to represent the traditional themes of Christian art — and patrons continued to commission representations of these same subjects, including Masaccio's *Trinity*, completed c. 1426 in Santa Maria Novella, the primary church of the Order of Preachers (the Dominicans) in Florence (Figs. 1, 3, 5–7, 10–11, 14). Many more Madonnas were painted or carved in the fifteenth century than mythologies, more images of Christ and the saints than of pagan gods and heroes. Even portraiture (itself a "classical" genre) remained bound to its customary roles in Christian art. Until the mid-fifteenth century, most portraits were not made as independent works of art but as commemorations of donors or as effigies of the deceased on their tombs. The likenesses that flank Masaccio's *Trinity* fit this description: They are donor portraits and perhaps also posthumous portraits associated with the subjects' tomb.

What, then, did "Renaissance" mean for the early Quattrocento, the period that fifteenth-century people themselves recognized as representing a new era? The answer is that Renaissance art is not necessarily concerned with new (pagan) subjects but that it represents "old," that is, traditional Christian subjects in a new way, with new verisimilitude. Renaissance art looks, or is intended to look, real — it simulates or resembles truth — even though it is not and cannot be a photographic reproduction of reality. Nor is it always accurately described as naturalistic. Naturalism or realism is not necessarily suited to the supernatural themes of Christian art or the commemorative intentions of Renaissance portraiture. A verisimilar image, on the contrary, appears real or at least plausible even though what is represented may be unreal or improbable and, more often than not, idealized. Albertian perspective, for example, is not reality but an abstraction — but its purpose is to simulate three-dimensional space, which is one (fundamental) element of reality. Renaissance verisimilitude is both psychological and physical. It concerns both the representation of emotions in a manner intended to engage the beholder's empathy and the representation of visible reality in terms of space and light.

Masaccio's *Madonna and Child,* the central panel of his altarpiece for the church of Santa Maria del Carmine in Pisa, illustrates both of these verisimilitudes, the psychological and the physical (Fig. 2).[4] The traditional and inherently contrived representation of an enthroned woman with an infant in her lap becomes convincing

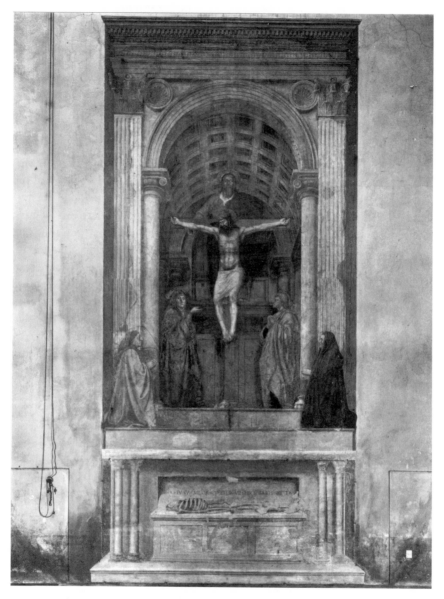

Figure 1. Masaccio. *Trinity*. Fresco. Florence, Santa Maria Novella. C. 1426–27. (Photo: Scala/Art Resource, New York)

when the infant puts his fingers in his mouth like any human child. The action persuades us that the child is real – and really a *human* baby, not a symbol of divinity. Only later, after we have taken his babylike behavior at face value, do we see that he puts his fingers in his mouth to suck the juice of the grapes his mother offers him. The grapes represent or adumbrate Christ's sacrifice, repeated in the Eucharistic offering of the Mass, and drinking their juice signifies his acceptance of his foreordained immolation – and his mother's endorsement of that death.

Masaccio's *Madonna and Child* also demonstrates physical conviction – not to say, the physicality – of early Renaissance art. Even gold ground can seem spatial when populated by such massive figures. Rather than the two-dimensional, abstract network of gold striations to signify the folds of garments, figures are now modeled in gradations of light and shade. These newly volumetric beings inhabit a three-dimensional world that can contain them or that at least does not deny them space in which to exist. In gold-ground panel painting, as in gold-ground mosaics, a figure modeled with gold striations seems to merge with its background: The gold ground in itself is not flat (rather it is aspatial or spaceless, literally without spatial limitations); but in combination with gold-striation modeling, it acts to bring figures to the surface, binding them there with its threads of gold. The eye reads these figures more as silhouettes than as three-dimensional forms requiring or even implying a three-dimensional spatial realm.

A gold ground (or the unmodulated flat blue of some fresco painting) thus acquires spatiality by virtue of its volumetric figures: The human form creates its own space. Alternately, the artist – painter or relief sculptor – can provide more precisely described spatial realms, defined by architecture and/or by landscape. If the space is represented as a landscape, the artist may imply depth by two means: diminution of scale and a softening of colors and contours to suggest distance. Eventually, fifteenth-century painters made all colors blue at the horizon, thus evoking the actual effects of atmosphere in the out-of-doors and the viewer's ocular experience of landscape vistas. This blurring effect is called aerial or atmospheric perspective, and fifteenth-century artists could have seen numerous examples of it in surviving ancient Roman wall paintings. Similar effects can be achieved in relief sculpture by softening of outlines, and indeed the first example of aerial perspective

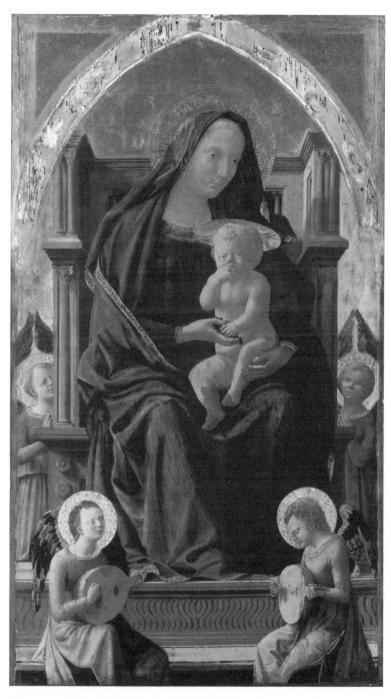

Figure 2. Masaccio. *Madonna and Child Enthroned* (Pisa *Madonna*). Central panel of altarpiece for Santa Maria del Carmine, Pisa. 1426. London, National Gallery. (Photo: Reproduced by courtesy of the Trustees, National Gallery, London)

in Renaissance art seems to be in relief, namely Donatello's *Saint George and the Dragon,* which decorated the base of the niche of his statue of the saint at the Florentine church of Orsanmichele (cf. Fig. 29).[5] The arcade in the right background of the relief where the princess prays for deliverance illustrates an early example of perspective applied to such geometrical forms – but by no means the first example of such perspective in Italian art.

Already in the fourteenth century, the Sienese Duccio, the Florentine Giotto, and their younger contemporaries – most notably the brothers Ambrogio and Pietro Lorenzetti – had experimented with this kind of receding form to suggest spatial recession. Lines incised on the surface of such panels as Ambrogio's *Annunciation* of 1344 (Siena, Pinacoteca Nazionale) allow us to reconstruct the pragmatic procedure he followed in establishing the angles of diagonal lines of the tiled pavement to create the impression of three dimensions on his two-dimensional surface. Some seventy years later, c. 1410–15, the Florentine sculptor-architect Filippo Brunelleschi experimented with mirrors to help define the receding diagonals of a view of the piazza in front of the cathedral in his native city.[6] And approximately twenty years after Brunelleschi's experiment in perspective, in 1435, the Humanist sculptor-architect-author Leon Battista Alberti wrote his Latin treatise *On Painting* (an Italian edition followed in 1436, dedicated to Brunelleschi) with a detailed explanation of a procedure whereby an artist could create consistent three-dimensional settings, usually with one vanishing point or centric point, that is, one point on the horizon where all receding diagonals converge.[7] Now that the diagonals are no longer isolated elements but part of a controlling scheme of the entire composition, they are called orthogonals. Alberti's system, known as one-point or mathematical perspective, was not quite the same method employed by Masaccio for his *Trinity,* though many authors have made that assumption. The Brunelleschian system, related to use of the astrolabe, may be seen as a precursor of Alberti's system but is not identical to it.[8] The goal was the same, however: to create an illusion of three dimensionality that would convince beholders of the reality of the image, or at least allow them to associate the fictive world of the image with experience of this world. Convincing the senses, the artist may hope also to convince the spirit, encouraging belief in

the actual presence before us of the beings represented, making them seem accessible to us.

Masaccio's perspective in the *Trinity* achieves this accessibility by creating the illusion of a vaulted space opening from the west aisle wall of Santa Maria Novella, that is, opening from the actual space where the beholder stands. Masaccio confirms the relation between our space and the fictive realm and the reality of the beings within that realm by two means, psychological and visual. Mary's insistent gaze – Masaccio's psychological means – convinces the beholder of her awareness and hence her presence (Fig. 3). The shadows cast by the sacred beings – Masaccio's visual means of persuasion – convince the beholder of their imminence, their actual presence within this illusionistic realm that opens from our own world.

The device of the cast shadow was not yet to be taken for granted in Italian art in the 1420s despite the examples provided by ancient Roman wall painting. The earliest cast shadows in Italian art, or at least the earliest known to us, are those painted by Pietro Lorenzetti in his fresco of the *Last Supper,* completed before 1319 in the Lower Church of Saint Francis at Assisi, which is also one of the first nocturnes in Italian art.[9] Most of Lorenzetti's successors eschewed this kind of verisimilitude. That is, later masters suppressed or avoided evocations of natural experience of this world in representing the supernatural beings and miraculous events that cannot by definition be explained by laws of nature. Especially after the disasters of the mid-fourteenth century, most notably the Black Death of 1348, artists rejected the stylistic innovations of the earlier fourteenth century and returned to the abstractions of preceding periods.[10]

Many if not most earlier fifteenth-century Italian painters continued to elaborate the more abstract and decorative stylistic elements of the fourteenth-century style that has come to be called International Gothic. Slender, elegant, elongated figures are gowned in extravagantly contoured draperies; fair-skinned, youthful, small-featured blond Madonnas and saints are dressed in the height of contemporary courtly fashion.[11] (Sandro Botticelli, who died in 1510, carried elements of this style into the sixteenth century, and some of its purposefully artificial qualities characterize Tuscan Mannerism of the 1520s and later.) These figures often inhabit worlds characterized by abrupt contrasts of scale, so that a very small landscape in the background, for example, is juxtaposed with

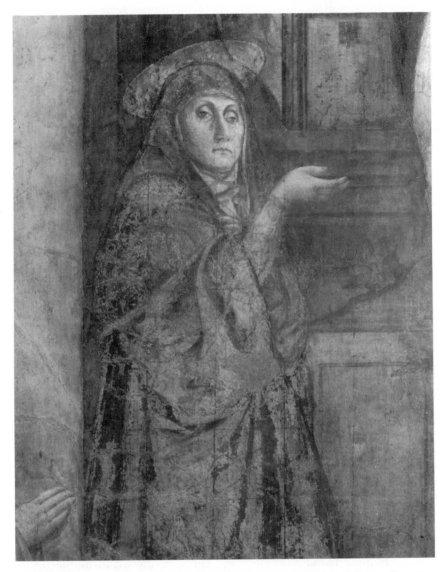

Figure 3. Masaccio. Detail of *Trinity* (Virgin Mary). (Photo: Courtesy Ornella Casazza)

large forms (landscape or architecture) in the foreground, with no middle ground to suggest transition. Despite the patent artifice of the figures – no body can really be so attenuated, no drapery fall into such exuberant calligraphic patterns – their environments may be natural landscapes blooming with plants and flowers represented with almost botanical precision. (Animals too, when they are present, often seem as exact as zoological illustrations of their species.) In any case, like the figures, the settings are exquisite, providing a beautiful world for beautiful beings. Lorenzo Ghiberti was perhaps the most conspicuous master of the International Style in Tuscan sculpture, and Lorenzo Monaco and Gentile da Fabriano in painting.[12] Perhaps it was no coincidence, then, that a new style – which was in part a revival of Giotto's style of the previous century – was put forward as an alternative manner by their greatest rivals. Filippo Brunelleschi, who almost certainly designed the architecture of Masaccio's *Trinity,* had competed directly with Ghiberti in the contest for the commission of the Florence Baptistry doors in 1401. Ghiberti won the commission, though the Florentines preserved Brunelleschi's competition panel as well as Ghiberti's and melted down all the others for their bronze.[13] In the 1420s, Masaccio and Gentile da Fabriano came head to head in an implicit competition or at least a confrontation of their different styles in Santa Maria Novella, with the foreigner painting his *Adoration of the Magi* as the altarpiece of the Strozzi Chapel in the left, or north transept, and the Florentine his *Trinity* in the north aisle (Figs. 1, 4).

These two major commissions came shortly after (and were indirectly related to) a period of particular significance in the history of the church and convent of Santa Maria Novella.[14] Pope Martin V had resided in the convent during his eighteen months in the city (1418–20), using its chapter house as his papal chapel. A son of the noble Colonna family of Rome, Martin had been elevated to the papacy at the Council of Constance in 1417, an election that signified the end of the Schism and the papacy's return to the Eternal City. The pope demonstrated his affection for the Preachers and their Florentine church in various ways, including his attendance at the consecration of Santa Maria Novella on 1 September 1420, with Cardinal Orsini officiating.[15] A few years later, in residence in Rome, Martin (or another member of the Colonna fam-

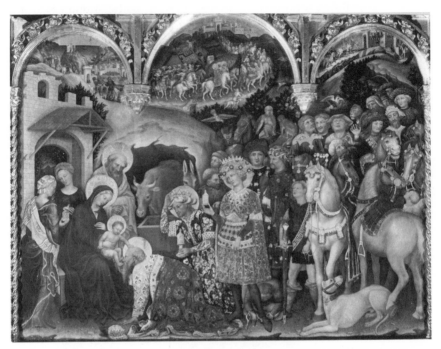

Figure 4. Gentile da Fabriano. *Adoration of the Magi* (Strozzi Altarpiece). Central panel. Florence, Galleria degli Uffizi. 1423. (Photo: Alinari/Art Resource, New York)

ily) turned to Masaccio for a major commission, a double-sided altarpiece for the basilica of Santa Maria Maggiore. It seems unlikely that the pontiff had seen works by Masaccio during his (Martin's) eighteen-month residence in Florence, but perhaps his Florentine friends later brought the young painter to his attention.[16] Meanwhile, back in Florence, the pope's conspicuous signs of favor to Santa Maria Novella seem to have encouraged patronage of the church, including the commissions to Masaccio and Gentile da Fabriano. (If the *Trinity* refers to the Guelphs, the papal party, as has been suggested, this would represent another link to the pontiff.[17]) Although the patrons of Gentile's Strozzi *Adoration* and of Masaccio's *Trinity* shared fealty to the Order of Preachers, however, they clearly differed in matters of taste.

Gentile, like Ghiberti and Lorenzo Monaco, favored the delicate

beauty typical of the International Style, a fragile loveliness that derives from such fourteenth-century predecessors as the Sienese Simone Martini. Masaccio's people were different: more robust, more mature, and perhaps even homely. Purposefully rejecting International prettiness, Masaccio, like Giotto before him, replaced courtly grace with majesty. The figures of International Style art look like dolls compared to these heroic beings. Their largeness of form suggests largeness of spirit and of intellect. Michelangelo appreciated this quality in Donatello's *Saint Mark,* another example of this heroic style: "he [Michelangelo] said he had never seen a figure who had a greater air of an honest man than that one and that if Saint Mark were really like that, he could believe everything the saint had written."[18] Michelangelo's wit does not diminish the sincerity of his encomium, which is equally descriptive of Masaccio's beings, both mortal and divine.

Masaccio has always been admired as one of the defining masters of Italian Renaissance art. Indeed, Leon Battista Alberti explained the new style in terms of Masaccio's accomplishments (and those of Brunelleschi and Donatello), and every generation of art historians and theorists since then has followed suit. The son of a notary, Masaccio was born in San Giovanni Valdarno on 21 December 1401, the feast of Saint Thomas.[19] The usual Italian diminutive for Thomas (Tomaso) is Maso, which is simply an abbreviation, comparable to Tom in English. But "Masaccio" is a nickname with meaning, though precisely what it meant to the artist's friends is uncertain: It may mean "Big Lug Tom," "Klutzy Tom," "Great Guy Tom," or "Rascally Tom" – or all of these. The moniker implies a contrast with that of his frequent collaborator, Tomaso di Cristofano, called "Masolino," implying "Adorable Tommy," "Elegant Tommy," or "Little Tommy." In any case, Masaccio became a member of the Guild of Physicians and Apothecaries (Arte dei Medici e Speziali), in January 1422, and in accordance with the guild's requirements, joined the Company of Saint Luke (Compagnia di San Luca) two years later.[20] He almost certainly painted the unsigned triptych for the church of San Giovenale a Cascia, dated 1422, and shared a commission for gilding candlesticks in 1425.[21] A year later, on 19 February 1426, Masaccio began work on his greatest (partially) surviving altarpiece, a polyptych for Santa Maria del Carmine in Pisa, for which he received final pay-

ment on 26 December (Fig. 2).[22] It may be that the Carmelites of Pisa had learned of Masaccio from their confreres in Florence, because his first known work in fresco – documented but undated – depicted the consecration of the church of the Carmine in that city in 1422.[23] These two commissions suggest a network of patrons, a client base as it were, which probably brought Masaccio his next great commission, shared with Masolino, for the Brancacci Chapel frescoes in Santa Maria del Carmine in Florence. Their work in the chapel is not documented but can be dated with some certainty to 1425–27.[24] The *Trinity* must have been painted during these same years, probably in 1426 or 1427. Masaccio left for Rome in 1428, and died there. He was only twenty-seven and had been a master for only six years – but Masaccio had already changed the history of Western art.

Despite its ruinous condition, Masaccio's *Trinity* has long been considered an epitome of his art and of the early Renaissance heroic style in Florence, distinguished by monumentality and verisimilitude of space, light, and characterization. Recognizing the painting's special status, Giorgio Vasari preserved the fresco even while concealing it in his mid-sixteenth-century redecoration of Santa Maria Novella. Although compelled to cover Masaccio's masterpiece in compliance with the instructions of his Medici patron, Vasari did as little damage as possible to the work, and moreover he carefully described the painting and its precise location in his biography of Masaccio in the *Lives of the Painters*. In 1861, "restorers" partially uncovered the *Trinity*, which was just as Vasari had left it almost three centuries earlier (1570), but they detached the upper part of the fresco, moving it to the entrance wall of the church. Ninety-one years later, in 1952, the Italian art historian Ugo Procacci was able to uncover the skeleton painted below the *Trinity* in situ in the north aisle. Under his direction, the two parts of Masaccio's mural were reunited in their original location, as we see them today.[25]

Records in the convent of the church tell us that a tomb slab in the pavement near the mural was inscribed "Domenico di Lenzo, et Suorum 1426," which is the approximate date of the fresco as well.[26] The date is almost certainly "Florentine style," that is, referring to a year that began on 25 March, the feast of the Annunciation, and the Necrology record of Domenico's death on 19 January 1426 means that according to the modern calendar, he died in

1427.[27] The words *et Suorum,* "and his [family]," indicate that Domenico Lenzi, his wife, and at least some of their kin were interred in the pavement before the fresco; like most medieval and Renaissance tombs, this one accommodated an unspecified number of dead. Presumably it is Lenzi and his wife who are portrayed as the donors of the *Trinity,* and the vigorous intensity of his portrait suggests that it was done or at least begun during his lifetime. His wife's portrait is equally compelling, despite the tendency to generalize likenesses of women as opposed to the customary preference for specificity in depictions of men. The fact that nothing is known of this woman, not even her name, is a concomitant of this Renaissance view of women. The fact that Masaccio gives her individuality despite her anonymity is thus all the more remarkable.

The proximity of the (destroyed) Lenzi tomb and the mural suggest that Domenico (or perhaps a kinsman) commissioned the *Trinity* as the mural of his family funerary chapel. Chapels do not require gates and dividing walls, and evidently there were none here. And though a medieval or Renaissance church may have tombs without altars, there do not seem to have been altars (that is, chapels) without tombs, either in the pavement or on the wall. This feature of church decoration is related to the mechanisms of patronage: A tomb was the donor's quid pro quo in exchange for his building and endowing an altar or chapel and his providing for its maintenance both physical (for example, the necessary candles and incense) and spiritual (the celebration of Mass and of the titular saint's feasts).[28] It seems likely, therefore, that Masaccio's *Trinity* was the altarpiece or mural decoration of a funerary chapel. Indeed, the fresco itself creates an illusionistic chapel where God the Father officiates as priest.

The fresco's funerary function is visualized in a most dramatic way: Beneath the donors, a skeleton is laid to rest on its own illusionistic sarcophagus (Fig. 5). Although its anatomy is not entirely correct, the skeleton is nonetheless "more accurate" than its predecessors in art and in anatomical illustration.[29] Despite this comparative accuracy, however, its gender cannot be determined: It may be either male or female. That, at least, is the bare-bones interpretation of the figure. But Masaccio tells us otherwise. Surely the skeleton represents Adam, because Christ was crucified above the tomb of the first man. In this way, Masaccio reminds us of the historical

Figure 5. Masaccio. Detail of *Trinity* (Skeleton). (Photo: Scala/Art Resource, New York)

Crucifixion while simultaneously recalling imagery unrelated to that or indeed to any other specific historical event. In the medieval confrontations of the quick and the dead, the dead – or Death himself, in the form of a skeleton – speaks to the living, using words much like those inscribed by Masaccio and pronounced by the *Trinity* skeleton: "I was once that which you are; and that which I am, you also shall be."

Masaccio thus evokes the medieval theme of the Three Living and Three Dead, a motif with a rich past that was soon to be abandoned by Renaissance art and literature (Figs. 12, 28). In the *Trinity*, the skeleton's words are addressed as much to the beholder as to the donors kneeling directly above the garrulous corpse. His warning is transmuted into hope, however, as the Virgin Mary returns one's attention to the Savior, through whose sacrifice the faithful may anticipate redemption.

An altar table may have stood in front of Adam's fictive tomb or next to it, perhaps supported on Corinthian colonnettes like those of Masaccio's illusionistic architecture. If the altar was installed in front of the mural, the altar table would have been at the height of the skeleton's niche. The *Trinity* would have become visible in its entirety only when the beholder knelt at the altar – that is, only

kneeling, could one see the skeleton. An altar of the Trinity, though not its precise location, is recorded in a Latin chronicle compiled by Modesto Biliotti in the 1570s and 1580s but likely based on earlier sources and documents. According to Biliotti, an altar of the Trinity was erected by Fra Lorenzo Cardoni during his priorate, that is, between December 1422 and November 1425.[30] To be sure, as a mendicant friar, Cardoni himself cannot have endowed the altar: Those costs would have been paid by lay donors or perhaps by an accumulation of smaller contributions to the church. In any case, the presence of the Lenzi tomb in the pavement near the altar – and of Masaccio's *Trinity* on the wall somewhere behind it – in no way contradicts Cardoni's involvement. Especially in mendicant churches, one may find more than one donor involved in the endowment of an altar or chapel.[31] The chronology also suggests such cooperation between the Lenzi and Cardoni (or perhaps among the Lenzi, Cardoni, and another donor, if the portraits in Masaccio's *Trinity* do not represent Domenico Lenzi and his wife). That Domenico Lenzi was somehow involved, however, seems indisputable, given the evidence of the lost tomb inscription and its proximity to the *Trinity*. Moreover, Cardoni's successor as prior was another Lenzi, Benedetto, whose father was also named Domenico, though given the dates, this Domenico and the man named in the tomb inscription seem to have been two different people.[32]

In addition to serving as the altar of the Lenzi funerary chapel of the Trinity, this altar may well have been the focal point of the celebration of the feast of Corpus Domini, a communal feast in Florence beginning in 1425. The celebrations included a procession to Santa Maria Novella, where Mass was celebrated, possibly at this altar of the Trinity, where God the Father presents the body of Christ for our veneration. The Florentines had decided to celebrate Corpus Domini during the term of office of another member of the Lenzi family, Lorenzo di Piero, as *gonfaloniere di giustizia*.[33] This coincidence of dates may suggest that the Lenzi were particularly devoted to the feast. But does it also mean that the donors are Lorenzo and his wife, and not Domenico and his? The *Trinity* cannot commemorate Lorenzo's tomb: He was buried in the Florentine church of Ognissanti in 1442.[34] In itself, this fact would not preclude Lorenzo's patronage of the fresco near the site of a kinsman's grave: Identification of Masaccio's patron hinges on the donor's cos-

tume. If this red garment represents the robes of a *gonfaloniere di gius-tizia,* as scholars have often assumed, then the portrait cannot represent Domenico, who never held that office, but may well represent Lorenzo, who did. But surely one can question that assumption about the garment, given written descriptions and other, indisputable illustrations of a *gonfaloniere's* robes.[35] Once we discount the donor's red gown as a red herring, we may conclude that Domenico Lenzi and his wife, who were interred nearby, have the best claim to being the subjects of Masaccio's portraits in the *Trinity.*

Questions of identity aside, all donors are alike, or essentially alike: They kneel and they pray, and, for the most part, they appear in profile. The viewer-worshiper understands that they are his or her surrogates and examples of piety. There is no mystery about them, except for the mundane mystery of their identity. But the Trinity is of course the great, ineffable mystery of Christian faith, and there is or was no one way to represent it.

Influenced by Abraham's vision in Genesis 18:1–3, some artists (or the theologians who instructed them) pictured the Trinity in the guise of three standing men, as in the sixth-century nave mosaic in Santa Maria Maggiore in Rome. Later masters might represent the Trinity as three seated or enthroned persons. Still others combined the imagery of the Virgin Mary as Throne of Wisdom (*Sedes sapientiae*) with the description of the Ancient of Days in Daniel 7:9–22: The Father replaces Mary, the Son is in his lap, and the Dove in the lap of Christ. Masaccio represents the Trinity in the form known as the "Throne of Grace" or "Throne of Mercy," that is, with the figure of Christ crucified supported by God the Father, an image inspired by the texts of Isaiah 16:5 and of the Letter to Hebrews 4:16.[36] Between them is the Dove of the Holy Spirit, descending from Father to Son. The surface is particularly damaged here, and so the Dove appears to be only a white silhouette. If we look closely, however, and restore the image in the mind's eye, we see that Masaccio painted the Spirit not as a two-dimensional abstraction but as a powerfully volumetric form in space, a bird (probably based on observation of real birds in flight) whose wings propel his downward motion and whose neck turns to suggest his responsiveness to the Son (Fig. 6).

Like other artists before him, Masaccio flanked the Trinity with figures of the Virgin Mary and Saint John the Evangelist. Mary and

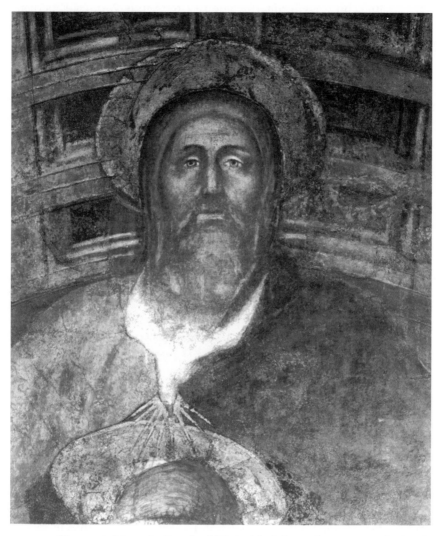

Figure 6. Masaccio. Detail of *Trinity* (God the Father, Dove, and Christ's halo). (Photo: Alinari/Art Resource, New York)

John thus recall their roles at the Crucifixion itself, including the *Crucifixion* by Masaccio for his Pisa altarpiece. In the *Trinity*, while John gazes mournfully at the Savior, the Madonna turns her gaze toward us, compelling our attention and our veneration (Figs. 1, 3, 7,

19). This forceful interpretation of the Virgin Mother is perhaps Masaccio's most startling innovation in the *Trinity*, aside from the extraordinary illusionism of the architectural setting. We do not really know this vehement woman; she seems to have no precedent in art and few if any successors. The only literary precedent for her commanding presence is the account of the wedding of Cana, the single scriptural event to describe any assertive action by Mary: "Do whatever he [Christ] tells you" (John 2:5), she orders, that is, bring the jars of water that Christ may make it wine. Masaccio's Mary thus evokes herself at Cana – and related to this role of enjoining obedience to Christ is her identification with the Church, Ecclesia, an equivalence reified in Masaccio's majestic architecture.

Masaccio's apparent reference to the gospel of John may well be intentional. First of all, John himself is present here. His text describes Mary's demeanor perfectly, and the biblical event he describes is related typologically to Masaccio's subject. That is, the transformation of water into wine at Cana anticipates the wine of the Eucharist. But, as the Evangelist and Masaccio himself remind us, we shall be saved only if we heed Mary's injunction. To be sure, in the context of Santa Maria Novella, Mary preaches to the converted; indeed, she preaches to the preachers of a Dominican church dedicated in her honor and to their congregation. In effect, Masaccio presented his audience with the Madonna as a confrere of the order of Preachers, who offers her sermon near the pulpit from which the Dominicans themselves addressed their flock.

Mary's sermon is an exhortation to acknowledge and to accept Christ's purchase of redemption for the faithful. Her commanding role here is central to the psychology and theology of the image. In order to honor Mary and suit her for this role, Masaccio has sacrificed her loveliness, or at least the refined femininity usually associated with her by medieval and Renaissance people in sacred writings as in art. (In this kind of physiognomy, though not in her demeanor, Masaccio was anticipated by Giotto.) To be sure, Mary is no longer lovely in part because she is no longer the young mother but the survivor of her Son. When Masaccio abandoned feminine beauty as one of Mary's primary characteristics, however, replacing it with an austere demeanor and plain features, he meant to achieve two interrelated ends: to defeminize her and to suggest her *virtù* – that is, her masculine rather than her feminine characteristics. To be sure, the masculinized female – that is, spiritually masculine – had

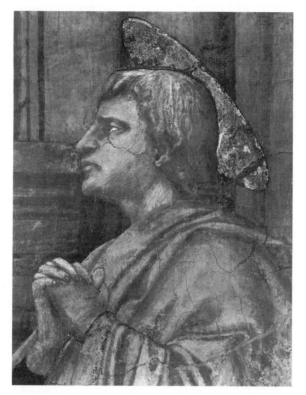

Figure 7. Masaccio. Detail of *Trinity* (Saint John the Evangelist). (Photo: Alinari/Art Resource, New York)

been considered a Christian ideal from the beginning, but her spiritual masculinity was rarely made visible in art.[37]

Although Masaccio's characterization of Mary is new, his primary subject, the Trinity as the Throne of Grace, is old. The theme had a venerable medieval history, though it had become somewhat outmoded in the fifteenth century. The same contrast between traditional iconography and revolutionary interpretation is seen throughout Masaccio's *Trinity*. As we have seen, Mary, John, Christ crucified, and God the Father are characterized as distinctive, knowable individuals of heroic stature whose heroism is at once physical, intellectual, and spiritual. Their physical grandeur, established in part by their monumental scale and by the sculptural clarity of their contours, expresses the force of their individual

personalities: Figural monumentality is thus made a concomitant of spiritual and intellectual heroism.

Masaccio grouped his new race of Christian heroes with a geometric clarity that expresses the hierarchy of their relationships to each other, to the donors who kneel before them, and to the beholder who is invited to emulate this devotion. Closest to us is the skeleton, whose feet overlap the side of the illusionistic niche that encloses him and whose sarcophagus projects forward into the nave of the church, that is, into the earthly sphere. Masaccio painted the illusionistic base of the sarcophagus to make this penetration of our world unmistakable. The donors kneel immediately behind the skeleton and above him; we read the step where they pray as projecting from the actual nave wall, and the pilasters and engaged columns as flush with the wall. Mary and John are just behind the donors and contained within the illusionistic arch. Farthest back, God the Father stands with the crucified Christ somewhere between him and the other two sacred figures. Their precise location cannot be determined, and this spatial imprecision seems purposeful, a way of suggesting the ineffability of the most sacred figures, even though no differentiation of scale distinguishes the holy beings from the mortal donors.[38] Depth and height – but not scale – express the hierarchy of being here, and "here" seems to be a chapel opening from the nave of Santa Maria Novella. This fictive space is a more sacrosanct realm than an architect could construct of stones and mortar – because this chapel is inhabited only by the sacred beings and accessible to humankind not in any physical sense but only through pious devotion.

For the first time in Western art, fictive architecture becomes a protagonist, playing a role nearly as important as that of the figures themselves and fully consonant with theirs. Masaccio's fictive architecture has always been recognized not only as one of the earliest but also one of the most accomplished demonstrations of illusionistic perspective, an invention of his friend Brunelleschi. The architecture itself is close to Brunelleschi in its plan and the use of color for the decorative elements (plum and white), endorsing the conclusion that he was directly involved with its design. This spatial construct is not merely illusion: It is expressive of spiritual meaning.

Masaccio represented a barrel–vaulted chapel within a triumphal arch opening from the nave of the church; ribbed pilasters with

Corinthian capitals support a classicizing cornice and entablature. Smooth, engaged columns with pseudo–Ionic capitals support the arch opening, and this arrangement is repeated at the back wall of the illusionistic chapel. A shelf or ledge projects from this rear wall to support God the Father, and the cross rises before this. The coffers of the vault and the paneling of the rear wall are fashionable decorative details that also serve to create depth and (apparently) to provide modules whereby to measure this space.[39] Pastophories, smaller chambers flanking the central area, open to left and right. Their purpose in actual churches and chapels was to house the Host before celebration of the Mass, a function appropriate to Masaccio's subject as well. The entablatures and rear engaged columns and capitals of his pastophory doorways are visible behind Mary and John, between the rear wall and the large engaged columns of the foreground. Indeed, the placement of these two figures, with their draperies slightly overlapped by the foreground columns, suggests that they have emerged from these flanking chambers.

The monumental forms of the sacred beings require a grand three-dimensional environment to contain them, which Masaccio's architecture provides. He exploits the illusionistic conviction of his architecture as a means of affirming the actuality of these holy personages, and reasserts the reality of their presence by means of the shadows they cast within the tabernacle, the shadow of Christ's halo, for example, against the rear wall (Fig. 14). Masaccio employs his powerful naturalism of space, light, and psychology to express the reality of the supernatural – and that is the primary concern of Italian Renaissance art. But it is rarely quite that simple, and certainly not in the *Trinity*.

Space is related to the perception of time. The illusion of architectural perspective, combined with the perfection or revival of aerial perspective, allowed Renaissance artists a greater precision in this regard than had been possible for (or perhaps desired by) their predecessors. Devotional images remove the sacred subject or the sacred beings from specific narrative events. A Madonna and Child is a devotional image in this sense, whereas a Nativity or a Presentation of the Christ Child in the Temple is a narrative. To be sure, such narratives are also suitable for prayerful contemplation, but by taking the protagonists out of their historical setting, the devotional image invites the worshiper to contemplate the sacred personages

and not their specific situation, the spiritual meaning of their experience and not the historical event.[40]

As a devotional image, Masaccio's *Trinity* is timeless, or at least that part of the fresco representing the Throne of Grace may be described as timeless. But even the Throne of Grace, which incorporates the crucified Christ in representing the second person of the Trinity, has narrative implications. And once the Throne of Grace is flanked by Mary and John, the chief mourners at the historic event of the Crucifixion, those narrative implications become explicit. The distinction is blurred between the devotional image, removed from time, and the narrative, perforce bound to space and time. Although the Trinity, the Madonna, and the Evangelist may be described as contemporaries – or even, in the case of the Trinity and the Madonna, as existing out of time or before time – the donors belong of course to a different moment, and so too does the skeleton. As we have seen, Masaccio locates these different times in different spaces of his illusionistic architecture: His space contains time and defines time.[41] Moreover, Masaccio's composition combines hierarchies of time and space. The knowable present or immediate past, closest to the beholder, is represented by the donors (one or both of whom would have been known to some of the fresco's first audience) and by the skeleton at the bottom of the fresco. While he himself is inert and timeless, his utterance – what I am, you shall be – encompasses the greatest narrative of all, the passage from life to death. The skeleton thus joins time and the timeless, temporality and atemporality. His warning is transmuted into hope, however, as the Virgin Mary returns one's attention to the Savior, through whose sacrifice the faithful may anticipate redemption. Flanking the Crucified Christ as in traditional scenes of the Crucifixion, Mary and John recall the historical past (which is also knowable). And the unknowable mystery of the Trinity, out of measurable time, is located at the back of Masaccio's chapel or tabernacle, and removed from time in the abstract, non-narrative formulation of the Throne of Grace.

Removed from time, the Trinity is also removed from space, and despite Masaccio's dazzling perspectival illusion (or rather because of it) one cannot say with certainty where God the Father actually stands with his crucified Son. In other words, there is no precise answer to the question, "Where exactly is the Trinity in Masaccio's

Trinity?" It is possible to reconstruct (more or less) the ground plan of Masaccio's fictive space, as has in fact been done, but impossible to tell where in this construct to place God's platform, how far behind Mary and John it is, and how far it projects from the rear wall. Surely this spatial imprecision is no accident, due to the newness of Brunelleschian perspective. Masaccio was clearly a master of perspective, here and in every other work involving architectural space. Nor can the difficulty in reading the *Trinity*'s space be blamed on poor condition: This central area is in fact the best preserved part of the fresco. Certainly this spatial imprecision is purposeful, and its purpose is to place the Trinity beyond spatial limits and constraints, literally immeasurable, ultimately and profoundly mysterious. Yet this spatial environment does include the Trinity, and both Mary and the Evangelist respond to its presence, albeit in different ways. And the same light that illuminates them falls also on the Trinity, causing Christ's cast shadows, for example. So clearly they share an environment, even though the mechanics of their spatial interrelations remain inexplicable and even though the Madonna's comportment breaks the space-time continuum to involve the beholder.

Masaccio's interpretation of the *Trinity* is thus unlike other Florentine representations of the Throne of Grace popular in the later fourteenth and early fifteenth centuries and undoubtedly known to him in one or more of its variations. In this type, the Trinity as Throne of Grace is flanked by an anachronistic grouping of saints. To be sure, altarpieces commonly ignore historicity to combine saints who lived in different eras, and in itself, this kind of anachronism may be considered another characteristic of devotional images. Nardo di Cione removes the crucified Christ from space and time in a triptych dated 1365, representing the Trinity with the crucified Christ flanked by Saint Andrew, his contemporary, and by Saint Romuald, the founder of the Camaldolensian order who died in 1027 (Fig. 8).[42] The composition was much copied and varied by late followers of the Cione, that is, Nardo, Jacopo, and Andrea di Cione (called Orcagna).[43] In all of these works, the ahistorical and timeless interpretation of the Throne of Grace is underscored by the lack of any precise space or setting – in this regard too, quite unlike Masaccio's *Trinity*.

Louis Marin has analyzed "relations between a theory of per-

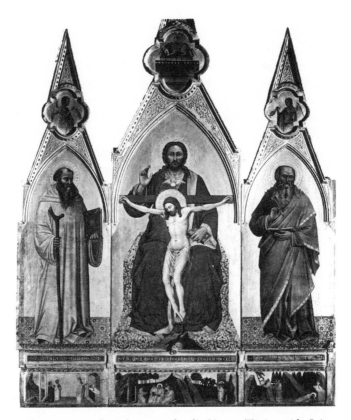

Figure 8. Attributed to Nardo di Cione. *Trinity with Saints Romuald and Andrew.* Triptych. 1365. Florence, Accademia (Photo: Alinari/Art Resource, New York)

spective and a theory of narrative," that is, the interrelated problematics of space, time, and narrative, in Piero della Francesca's frescoes of the True Cross in Arezzo. Piero's paintings are of course a cycle of narrative episodes, and not a single composition, like Masaccio's *Trinity;* and the cycle is derived from a discursive text, Voragine's *Golden Legend,* whereas the *Trinity* has no text per se, though certain elements can be explained by reference to various texts (including the biblical passages and versions of the Three Living and Three Dead). Even so, Marin's observations about Piero are relevant to Masaccio as well. "Perspective theory," Marin reminds us, "constructs a geometric structure for the representation of three-dimensional space in

two-dimensional space ... [and] narrative theory ... on the basis of certain principles, constructs a syntactic, semantic, and pragmatic structure, a representation of history, or rather a *story,* an iconic representation of *a* narrative."[44] The *Trinity* is indeed such an iconic representation of a narrative in three-dimensional space and in time, but not delimited by either space or time.

Masaccio's concern with time and space is a leitmotif of one of his frescoes painted in 1427–28 for the Brancacci Chapel, that is, at the same time or perhaps slightly later than the *Trinity.* In *Saint Peter Healing with the Fall of His Shadow,* Masaccio exploits the plunging perspective of the city street as a counterbalance to Peter's walking toward us to express the drama of this miracle in which nothing, seemingly, happens – or rather, in which what happens is expressed not by any obvious human action but by light, space, and time (Fig. 9). The Brancacci Chapel frescoes have been recently cleaned, and in any case are much better preserved than the *Trinity,* and in part for these reasons, one can more easily appreciate Masaccio's conception of space and time in the *Saint Peter Healing,* which are moreover imbricated with the subject represented: The saint moves, his shadow moves, the crippled and maimed are restored – or will be, as he continues his movement past them.[45] One man has already been healed and begins to rise up; the next anticipates his healing with his hopeful glance at the saint. The cripple knows what will happen in the next moment, even though Peter himself seems oblivious to the healing miracles, immediate past and immediate future, of which he himself is the source.

The *Saint Peter* fresco is Masaccio's most precise treatment of the space-time nexus. In the *Trinity,* however, Masaccio has purposefully confused the relation of these two elements. We have seen that the space is hierarchic, that it implies or contains different times, and that its legibility or measurability is deceptive. In the *Trinity,* a concept – the Triune nature of the Godhead – becomes *historia* (to use the Albertian term), invoking both the historical event of the Crucifixion and its underlying significance, which is beyond history, namely, Christ's redemptive sacrifice, which is commemorated and reenacted in every celebration of the Mass.[46] This dogma, fundamental to Church teaching, implies a kind of temporal *sfumatura,* or blurring, as it were: Christ offered himself once, but the offering takes place again and again, every time the

bread and wine are transubstantiated into body and blood in the offering of the Eucharist.

The spatial unity of the *Trinity*'s architectural setting implies temporal unity, but the beholder realizes that this simultaneity is illusory, despite the conviction of Masaccio's perspective. Masaccio's composition can be seen both to specify time and to deny it or to blur its boundaries, and in this way, while representing the *Trinity* as the object of immediate veneration in the here and now of Santa Maria Novella, the artist also achieves a kind of timelessness. History is rendered ahistorical, or eternal; not the events represented – the Crucifixion, the prayer of the donors – but rather the enduring validity of Christ's sacrifice is privileged, the prayer for salvation reiterated.

THE ESSAYS

Gene Brucker's essay, excerpted from his classic study, *The Civic World of Renaissance Florence,* describes the political forces that changed the Florentine state in the earlier fifteenth century from a government of corporate republicanism to an elitist regime. These are the secular forces that defined the world of Masaccio and his first viewers, including of course his patrons.

Rona Goffen's study of the *Trinity,* a revised version of an article published in 1980, focuses on the spiritual forces that shaped Masaccio's fresco. She interprets Masaccio's style, iconography, and his characterization of the holy beings with reference to sacred texts, Dominican spirituality, and the way the fresco fulfills its dual function as a devotional image and commemorative monument.

Ornella Casazza discusses the recent conservation of the Brancacci Chapel frescoes, Masaccio's technique, and the condition of the *Trinity* in relation to its nightmarish mistreatment in the past. Making use of eyewitness accounts of the painting from the Renaissance and nineteenth century, as well as informed present-day evaluations of its condition, Casazza helps the reader restore the *Trinity* in the mind's eye.

Jane Andrews Aiken analyzes Masaccio's and Brunelleschi's spatial illusionism in the *Trinity* architecture, revealing the use of the projections made with an astrolabe, a procedure widely used in the Middle Ages and Renaissance. Explaining the pragmatics of this

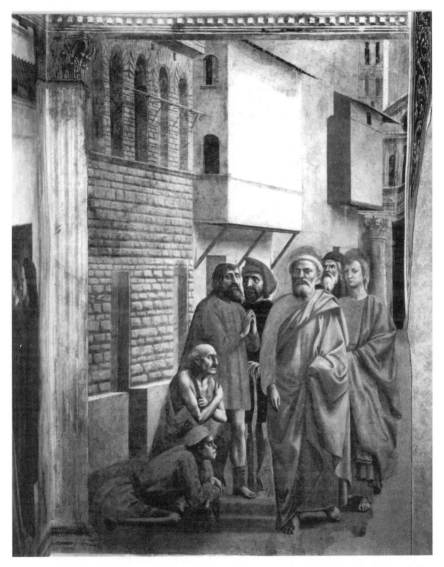

Figure 9. Masaccio. *Saint Peter Healing by the Fall of His Shadow* (after restoration). Fresco. Florence, Santa Maria del Carmine, Brancacci Chapel. C. 1426–27. (Photo: Scala/Art Resource, New York)

perspective system, Aiken distinguishes it from Leon Battista Alberti's mathematical perspective.

Yves Bonnefoy considers not the "how" but the "why" of perspective, elucidating the ways in which Renaissance artists conceived space and contained time in representing sacred themes. Bonnefoy sees the illusion of space as requisite for the representation of time in fifteenth-century art, but he also sees Renaissance perspective bound to its historical moment, when human beings could believe themselves to be at the center of the universe.

Katharine Park discusses the skeleton at the base of the *Trinity*, relating the skeleton to the Renaissance study of anatomy, the practice of dissection, the traditions of representation of the human body, and the role of memory in the conception of such images.

NOTES

Full citations are found in the Selected Bibliography for sources cited more than once or those considered of particular importance in relation to Masaccio. One abbreviation is used throughout: Vasari-Milanesi for Giorgio Vasari, *Le opere di Giorgio Vasari: Le Vite de' più eccellenti pittori, scultori ed architettori.* 9 vols. Ed. Gaetano Milanesi. Florence 1906. Rpt. 1973.

1. Saint Augustine, *Confessions, Books I–XIII,* trans. F. J. Sheed, intro. Peter Brown (Indianapolis and Cambridge, 1993), p. 264. On the saint's theology of the Trinity, see also O'Carroll, pp. 42–45.

2. The modern use of the words *Humanist* and *Humanism* is misleading in this regard and is unrelated to the Renaissance meaning. Most Humanists, including Platonists, were Christians, and many clerics were Humanists; see, inter alia, Paul Oskar Kristeller, "The Role of Religion in Renaissance Humanism and Platonism," in *The Pursuit of Holiness in Late Medieval and Renaissance Religion,* ed. Charles Trinkaus with Heiko A. Oberman (Leiden, 1974), pp. 366–70.

3. See Valla, pp. 1–8 (the editor's introduction), pp. 63–73 (Valla's *Treatise*); as Coleman notes, p. 3, Valla's study of the "Donation" had been anticipated by Nicholas Cusanus. On Valla, N.B. also Camporeale, 1972.

4. And the *Crucifixion* that once crowned the Pisa altarpiece. For color illustrations, see the recent monographs by Joannides and by Spike.

5. Now in Florence, Museo Nazionale del Bargello, and executed 1417–18. See John Pope-Hennessy, *Donatello Sculptor* (New York, London, Paris, 1993), pp. 116–18. This kind of relief is called *schiacciato* or *stiacciato,* meaning flattened.

6. See Battisti, pp. 102–13.

7. For the Latin and an English translation, see Alberti, ed. Grayson. For a translation of the Italian, see Alberti, ed. Spencer.

8. See Aiken, this volume, ch. 4.

9. See Carra Ferguson O'Meara, "In the Hearth of the Virginal Womb: The Iconography of the Holocaust in Late Medieval Art," *Art Bulletin* 63 (1981): 75–88.

10. Despite its disputable dating and attribution of some works and other problems of methodology, Meiss, 1951, remains a classic study of the period.

11. The finest exposition of the International Style is still Krautheimer and Krautheimer-Hess, especially pp. 76–85, 88–89.

12. For Ghiberti and the International Style, see Krautheimer and Krautheimer–Hess and Kanter et al. Although Lorenzo, a Camaldolensian monk (*monaco* in Italian), was born in Siena, he spent most of his creative years in Florence. For Lorenzo, see Eisenberg. Fabriano is in Umbria, but Gentile's greatest commissions were his frescoes for the Palazzo Ducale in Venice (which do not survive) and the Strozzi altarpiece (Fig. 4); see Christiansen, 1982.

13. Krautheimer and Krautheimer-Hess, vol. 1, pp. 31–50.

14. Incorrect modern usage of the word *convent* has created confusion even among scholars. Dominicans, like Franciscans, are not monks but friars, and their houses are properly called friaries or convents, not monasteries. (Similarly, some orders of nuns are properly said to live in a monastery of nuns.) Monks live in isolated communities and have little or no contact with laypeople; friars live in towns or cities where they preach and teach the faithful. For distinctions between friars and monks, see Goffen, 1988. The old church of Santa Maria Novella was consecrated in 1094 and given to the Dominicans in 1221. They began to rebuild their church by mid-century. See Lunardi, 1990, p. 254.

15. For Martin's sojourn in Florence beginning 26 February 1418, see Brucker, 1977, pp. 421–5, and Lunardi, 1983. Martin V died in 1431.

16. The commission for the Colonna altarpiece is undocumented and may have been awarded to Masaccio and Masolino jointly. In any case, Masolino painted all but one panel, representing *Saints Jerome and John the Baptist* (London, National Gallery), which is by Masaccio. It seems complete but for the absence of a clasp at the neck of the Baptist's mantle. I owe this observation to the late Professor Howard McP. Davis. For the altarpiece, see Joannides, pp. 414–22. He dates Masaccio's panel c. 1424.

17. See Hertlein. The fictive architecture of the *Trinity* recalls the niche designed for the Parte Guelfa statue of *Saint Louis of Toulouse* at Orsanmichele. For the resemblance, see Lieberman, p. 129, and Lunardi, 1990, p. 258; for the Guelphs and their statue, see Zervas, 1987. The statue, by

Donatello, is now in the church of Santa Croce; the niche has been removed to the Bargello.

18. Vasari-Milanesi 7: 278. Michelangelo also greatly admired Masaccio, and among his earliest works are drawings after the older master; see Michael Hirst, *Michelangelo and His Drawings* (New Haven and London, 1988), pp. 59–60.

19. His parents were Iacopa di Martinozzo di Dino and Ser Giovanni di Mone (Simone) Cassai. *Ser* is the honorific title for a notary, and the name "Cassai" identifies Masccio's paternal grandfather Simone as a furniture maker, *cassonaio* (a maker of *cassoni*). For documentary evidence, see Beck and Corti, pp. 5–7, doc. 1, and passim. Documents drawn during Masaccio's lifetime do not use this nickname but refer to the artist as "Maso di ser Giovanni," though Beck, 1978, argues convincingly that his friends indeed knew him as "Masaccio." Masaccio's younger brother, Giovanni, also became a painter with a strange nickname, Lo Scheggia, which means "Chip" or "Splinter." On Scheggia, see Christiansen, 1990, p. 15.

20. Beck and Corti, pp. 11–12, 14–15, docs. 7, 11. As a physician and painter, Saint Luke was patron of doctors, apothecaries, and painters – hence the odd assortment represented in the guilds. Masaccio's inscription in the Arte in 1422 marks his setting up shop as an independent master. Before then, he would have worked in another master's shop, first as a *garzone* (boy), then as an apprentice.

21. Ibid., pp. 14–16, docs. 9, 12. The triptych is now in Florence, Uffizi; if autograph, it is Masaccio's earliest surviving work. The candlesticks are lost (or unrecognized).

22. Ibid., pp. 17–23, 31–50, docs. 14–25, and appendix docs. 1–14.

23. Ibid., pp. 12–13, doc. 8, for the lost work, known as the *Sagra*.

24. Ibid., p. 27, pp. 54–60, appendix docs. 20–23, Joannides, pp. 321–22, and Ladis. Assuming that this dating is correct, the painters' work in the Brancacci Chapel would have been interrupted; for example, Masaccio was in Pisa for much of 1426 until January 1427, and Masolino went to Hungary on 1 September 1425, returning to Florence sometime around July 1427.

25. The conservator of the *Trinity* was Leonetto Tintori, who also restored numerous other frescoes, including Giotto's cycles in Santa Croce in Florence (the Bardi and Peruzzi chapels) and in the Scrovegni or Arena Chapel in Padua, and Piero della Francesca's cycle of the True Cross in the church of San Francesco in Arezzo. In recent years, Tintori's work has been criticized, both for aesthetic reasons (e.g., the areas of loss in the Santa Croce frescoes having been left conspicuously blank) and, more seriously, for what may have been unwise decisions concerning the chemicals applied to the frescoes. Other problems beset the *Trinity:* Two

sections of Masaccio's fictive architecture were lost during the reinstalla-
tion (sections of the string course and of the frieze – the latter including
the artist's indications of the axis and compass marks); see Polzer, p. 20,
and Schlegel, p. 19. As Joannides notes, p. 357, "It is disquieting that no
official report" of the fresco's conservation has been made public, though
Tintori did publish an essay on his work in 1990, quoted at length by
Casazza, this volume, pp. 77–84.

26. See Goffen, this volume, p. 45.

27. For the Necrology, see Procacci, p. 233. He describes Domenico's coat of
 arms, ibid., and identifies him as a *linaiuolo* residing in the parish of San
 Biagio (p. 234). According to Procacci, Masaccio's portrait cannot repre-
 sent Domenico because the donor is clothed as a *gonfaloniere di giustizia,*
 a rank Domenico never held. Procacci seems to have been mistaken,
 however, about the costume. See this volume, p. 16.

28. See Goffen, 1986, pp. 23–24 and passim.

29. See Park, ch. 6 this volume. Even so, the skeleton may be taken to be
 male because no specifically female skeleton was represented in art until
 the eighteenth century. See Schiebinger.

30. Bilioctus (that is, Biliotti), ch. 14, p. 168 (corrected to p. 48), in the
 printed ed., which corresponds to ch. 14, fol. 17, in the MS preserved in
 the Archives of Santa Maria Novella. Cardoni, a master of theology at the
 universities of Padua and Florence and a noted preacher, continued to
 serve as prior until June 1426, substituting for his successor. See Orlandi,
 1955, vol. 1, p. 154, and vol. 2, pp. 192–6 (pp. 192–3 for the extension of
 Cardoni's service); Lunardi, 1990, p. 259n2; and Joannides, p. 356. Joan-
 nides also discusses the eighteenth-century chronicle of Vincenzo
 Borghiniani according to which the altar was erected in 1430 – when the
 friars walled up the door in the wall near the *Trinity,* which led to the
 cloister. On the altar of the Trinity, see also Hertlein, pp. 12–16, pp.
 20–45; Lunardi, 1990, p. 251; Orlandi, 1952.

31. See Goffen, 1979, pp. 202 ff., 215 ff., and idem, 1986, pp. 107–10, for Fran-
 ciscan examples of this kind of "multiple" or shared patronage involving
 works by Bellini and Titian.

32. See Joannides, p. 357, and Spike, p. 205. Benedetto di Domenico Lenzi
 was prior from June 1426 to September 1428; but according to Joan-
 nides, he was "probably not Domenico's son."

33. Lorenzo di Piero's term as *gonfaloniere di giustizia,* the highest civil officer,
 was August and September 1425. See Joannides, p. 357.

34. Ibid.

35. See Goffen, 1980, and p. 46 this volume; and Joannides, p. 357.

36. The Letter to Hebrews recalls Isaiah, as noted by Shearman, p. 64. See ch.
 2 this volume.

37. Later masters – most notably Michelangelo in the Doni Tondo – some-

times made the Virgin Mary explicitly masculine in appearance, again with the intention of exalting her. See Costanza Barbieri, "Sebastiano del Piombo in Rome: Venetian *Colorito,* Florentine *Disegno,* and the Viterbo *Pietà,*" Ph.D. dissertation, Rutgers University-New Brunswick, 1998; Yael Even, "The Heroine as Hero in Michelangelo's Art," *Woman's Art Journal* 11 (1990): 29–33, and "Mantegna's Uffizi Judith: The Masculinization of the Female Hero," *Konsthistorisk Tidsskrift* 61 (1992): 8–20; and Rona Goffen, *Titian's Women* (New Haven and London, 1997), ch. 5, and "Agnolo and Maddalena Get Married, or The Virgin's One Bare Arm," unpublished paper on the Doni Tondo read at the College Art Association meetings, New York, 1994.

38. Here too Masaccio was anticipated by Giotto; see the donor portrait of Enrico Scrovegni in the *Last Judgment* of the Scrovegni or Arena Chapel in Padua.

39. See Aiken, pp. 94–5 this volume.

40. This is what happens when the protagonists of a narrative, such as the Nativity, are represented as half-length figures with little or no setting. In this way, the narrative becomes a devotional image. See Ringbom, and Goffen, 1979.

41. The phrase is Yves Bonnefoy's, p. 108 this volume, in reference to another image that contains time.

42. For Nardo, who died in 1365 or 1366, and this triptych in Florence, Galleria dell'Accademia, see Richard Offner, *A Critical and Historical Corpus of Florentine Painting,* sec. 4, vol. 2 (New York, 1960).

43. A similar *Trinity*/Throne of Grace, painted as a pinnacle of the high altarpiece of San Pier Maggiore in Florence, c. 1370–71, is ascribed to Jacopo di Cione and workshop; Martin Davies, *The Early Italian Schools Before 1400,* rev. ed. Dillian Gordon (National Gallery Catalogues, London, 1988), pp. 50–4. For another version, dated c. 1400, see Charles Seymour, Jr., *Early Italian Paintings in the Yale University Art Gallery* (New Haven and London, 1970), p. 48, cat. no. 30. Yet another variant is sometimes attributed to Niccolò di Pietro Gerini (documented 1368–1415) in the Vatican Pinacoteca (Anderson photograph no. 23983).

44. Marin, p. 108. Bonnefoy has also discussed the space-time nexus in relation to Italian Renaissance narratives; see ch. 5 this volume.

45. See also ch. 2 this volume, at nn. 46–7. For color illustrations of the Brancacci Chapel frescoes after the recent cleaning and conservation, see Baldini and Casazza, 1990 (English ed., 1992), and Ladis.

46. For the *historia* or *istoria,* which means history or narrative, see Alberti, ed. Grayson, pp. 79–81, 95–7 (describing the *Calumny of Apelles* as an exemplary *historia*), and pp. 103–5.

1 GENE BRUCKER

THE FLORENTINE ELITE
IN THE EARLY
FIFTEENTH CENTURY

The donors of Masaccio's Trinity, *life size and in the immediate foreground, are portrayed with such energy, specificity, and conviction, that they seem knowable. Despite Masaccio's remarkable commemorations of their identity, however, the present-day beholder knows next to nothing about this man and his wife except their family name, Lenzi – and even that is not absolutely certain.*

Gene Brucker's study of the Florentine elite helps compensate for our historical ignorance about Masaccio's patrons by presenting a portrait of their class, the bankers and merchants who governed Florence in the early fifteenth century. Brucker's essay is unlike the other chapters in this book: His subject is not the Trinity *per se but rather the society and psychology of Masaccio's time and place. Describing that world, Brucker allows us to imagine how Masaccio's first viewers saw the* Trinity.

As Brucker explains, during a thirty-year period beginning in the 1380s, the ruling class of the Florentine republic was transformed (or transformed itself), replacing "corporate order" with a "stable, cohesive elite." In describing the language of Florentine political discussions in the first decades of the fifteenth century, Brucker provides a picture of the mentality of the early Renaissance that is as relevant to understanding Masaccio's Trinity *as the sacred texts that inspired it. The Virgin Mary's exhortatory manner in the* Trinity, *for example, echoes the tone of contemporary civic or political discourse. Reading the fifteenth-century texts that Brucker quotes, we can hear*

Excerpted from Gene Brucker, Chapter 5 of *The Civic World of Early Renaissance Florence* (Princeton, 1977), pp. 283–318; reprinted by permission of Princeton University Press.

the speakers' voices and imagine how they in turn might have heard Mary address them in Masaccio's remarkably expressive image. Similarly, the donors' prayerful presence in the Trinity exemplifies the hopeful confidence of their generation as "the makers of their destiny" whose worthiness in this life will be rewarded by Mary's mediation in the next.

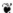

THE SELECTION PRINTED HERE is taken from Chapter 5 of *The Civic World of Early Renaissance Florence,* which describes the composition of the Florentine political elite, the men who controlled the city's government, in the early fifteenth century. The primary source for this selection is the record of the debates (*Consulte e Pratiche*) on important issues confronting this city–state: diplomacy, military affairs, taxation, internal security, the Church. The *pratiche* identify the most prominent leaders of the regime, as measured by their participation in the deliberations. They also reveal the political ideology of this elite and its style of governance as these evolved over time. The most significant changes were the shift from a corporate to an "elitist" polity, the development of a more rational and analytical approach to political issues, and the introduction of historical perspective in these debates.

The image of this elite presented here was constructed by its own members, and it may be too positive, too idealized. Though it does identify some of the negative aspects of this government, e.g., factionalism, self-interest, it ignores its most fundamental flaw: its narrow social base, and its effective exclusion of the vast majority of Florentines from participation in the city's political life.[1] Though remarkably successful in creating a civic myth that stressed its commitment to liberty and republicanism, and thus legitimizing their rule, the members of this elite were primarily concerned with preserving their power and protecting their material interests. Two significant pieces of legislation enacted in the 1420s illustrate their program: the creation of a fund to provide dowries for the daughters of the elite; and the establishment of a new system of fiscal assessments (the *catasto*) designed to make the tax burden more equitable.[2] But while this regime did develop effective strategies for enhancing its authority and repressing dissent, it was not able to control the divisive pressures fueled by the wars against Milan and Lucca in the

late 1420s and early 1430s. These forces destroyed the fragile political consensus and led to the triumph of the Medici faction (1434) and the establishment of a regime dominated by one family that was to govern Florence for sixty years.[3] The conflicts within its ranks notwithstanding, this political elite remained the most potent and influential force in fifteenth-century Florence. Some four hundred lineages comprised this ruling group, the most famous being the Medici, but including too such prominent houses as the Strozzi, Capponi, Rucellai, Guicciardini, Machiavelli, Pitti, Bardi and Peruzzi.[4] These families controlled the commercial, banking and industrial enterprises that produced much of the city's wealth, and they expanded their ownership of rural property in Tuscany.[5] They constituted the upper echelon of Florentine society and perfected strategies to preserve their status, specifically, by forging marriage alliances within their own ranks.[6] These lineages also strengthened their representation in the upper ranks of the Tuscan church (bishoprics, canonries, heads of monasteries and convents), from which they gained both income and prestige.[7] They developed patronage networks in the city and dominion, forging bonds of friendship and mutual support with urban and rural clients. The Medici were particularly skilled in constructing and sustaining these bonds, but they had no monopoly on this activity which literally linked together every inhabitant of Florence and its territory.[8]

Florence's civic monuments, her churches and monasteries, her private palaces were all planned and subsidized by this elite. These men staffed the civic commissions that organized and funded the construction and decoration of the Cathedral, the palace of the Signoria (the Palazzo Vecchio), the Loggia dei Lanzi, and the buildings that housed the commune's judicial and fiscal offices. As prominent members of the major guilds, they were selected as officials (*operai*) responsible for commissioning the Baptistry doors, and the sculptures placed in niches outside of Orsanmichele, and on the facade of the Cathedral.[9] They conceived and implemented the construction of the orphanage of the Innocenti, and the great hall designed by Brunelleschi for the palace of the *Parte Guelfa*.[10] Their role in the creation of these civic monuments was matched by their involvement in projects for the building, restoration and decoration of the city's churches, monasteries, friaries, and nunneries. Among the churches whose building projects were supervised by these

operai were the Vallombrosan monastery of Santa Trinita, the mendicant churches of Santo Spirito (Augustinian) and Santa Maria del Carmine (Carmelite), the Servite church of Santa Maria Annunziata, and the Augustinian house of the Convertite.[11]

In their promotion and execution of these civic and religious enterprises, this elite sought to create testimonials to their city's reputation and fame. These monuments were visual symbols of Florence's wealth, power and prestige, as important for civic pride as the histories written by her scholars and the battles won by her soldiers. Secular and religious interests and values were intermingled in this civic patronage, since a major concern of this elite was to claim divine support for the city and its enterprises.[12] These patricians were also deeply engaged in creating memorials to themselves and their lineages, by constructing palaces and by endowing burial chapels in their neighborhood churches. The 1420s witnessed the beginning of a palace building "boom" that was to continue throughout the fifteenth century.[13] A wealthy banker, Giuliano Gondi, spoke for many of his fellow builders when he stated that his palace was erected "to preserve his memory and for the honour of his sons and the house and family of the Gondi."[14] Similar motives inspired the endowment of family burial chapels, which provided the setting for so much of Florentine religious art.[15] The most famous of these chapels (the Pazzi Chapel at Santa Croce; the Medici in San Lorenzo; the Sassetti in Santa Trinita; the Tornabuoni in Santa Maria Novella) are well documented; their patrons, builders and decorators identified by wills and notarized contracts.[16] But these are only a tiny sample of the hundreds of funerary monuments that fifteenth-century Florentine testators had commissioned in their wills, and whose histories remain to be written.[17]

In *The Civic World of Early Renaissance Florence,* the analysis of the Florentine *reggimento* in the early fifteenth century emphasizes the emergence of a leadership elite that had subtly altered the political system – the ways in which the republic was governed. In 1382 the polity was still predominantly corporate, though the collective ethos and the institutions which embodied that spirit were weaker than they had been a half-century earlier. But policy decisions were still made collegially, and the sporadic attempts of certain groups and individuals to subvert that process were

condemned, and sometimes penalized, by the citizenry. Men chosen to civic office regarded themselves primarily as representatives of corporate entities, and in their political behavior they subsumed their identities into that of the group. In the thirty years since the establishment of the regime, the corporate spirit had been further weakened, though never entirely extinguished. But as each year brought a new crisis – either an internal conspiracy to subvert the regime or a foreign effort to conquer it, or both – the pressures to modify the system intensified. How to strengthen the regime and to maintain control by the "good Guelfs" without destroying traditional liberties and customs became a crucial issue. Magistracies with special authority (*balìe*) were created to deal with major crises, but they aroused the hostility of many citizens who viewed them as threats to constitutional government. Very gradually and unobtrusively, the regime was transformed without any major alteration of the institutional framework, through the establishment of a cadre of prominent citizens who formed a kind of unofficial *balìa* to guide the *reggimento* through these difficult years.

The intensity of this elite's commitment to the regime and the republican values that it symbolized distinguished it from earlier forms of civic leadership, which were usually linked to some party based on blood or ideology. These men, whose power depended in some part upon the numbers of their *amici e seguaci* (friends and followers), did not ignore competing claims to lineage, guild or faction. But these claims usually ranked below the public interest in their system of priorities. The strength of an individual's loyalty to the regime was indeed an important criterion for promotion to the inner circle.

The *pratiche* are the key to this regime's methods and values, and to its resilience in the face of adversity. The debates became the institutionalized channel of communication for the elite, and the only legal means by which those statesmen not in office could offer counsel and guidance to successive priorates, whose members might be inexperienced and inept, or immobilized by personal enmities. The number of *pratiche* convened annually by the executive remained constant through the 1380s and 1390s, but then rose significantly after Giangaleazzo Visconti's death in 1402. Civic representation in the meetings also increased during these years. The significant expansion, in space and in detail, of the record of these deliberations paralleled this trend toward more frequent *pratiche*.

The draft of a speech that Palla Strozzi prepared for delivery in a *practica* on fiscal policy in the early 1420s illustrates the new oratorical style. The minute contains numerous insertions and emendations that Palla had made to clarify his argument. In his opening remarks he took note of the storm of criticism over a new *prestanza* distribution that had passed the bounds of civic propriety and was threatening the public welfare. Palla's speech was a justification of the new assessment, and a critique of the arguments advanced by its opponents. All republics, he said, incur fiscal deficits resulting from ordinary expenses and the costs of defense; these obligations must be met by taxing the citizenry. Finally, in his peroration Palla called his audience's attention to the wise practices of their ancestors, who never revised a tax schedule until it had been in effect for several years:

> Do we think that they were less pious and merciful than ourselves? Do we think that they were less prudent? Do we think that they were less expert, less intelligent, less solicitous of the public welfare than ourselves? Such a position is untenable! Our ancestors were more prudent and more dedicated to the state than our own generation. Their record proves this, for under their guidance, a puny state was transformed into a great power!

More accurately than any other indicator, this change in the form and content of Florentine political debate reflected the regime's transformation from corporate to elitist. By 1410, the *practica* had been gradually transformed into a forum where prominent citizens might speak on behalf of the leadership, or as individuals whose views carried weight by virtue of their particular expertise or status in the regime. Speakers harangued, exhorted, encouraged their audiences; they sought to arouse and incite them to act. They heaped praise and commendation upon those whose opinions they supported, or they complained about politics or viewpoints they deplored. Among their listeners were uncommitted men who had to be persuaded and stimulated by these orations, or hostile minds to be converted. The *practica* became the arena in which the conflicting views of the leaders competed for the approval of the whole *reggimento*. And in those verbal struggles for control of policy, the rhetorical skills of the orator assumed a greater importance than ever before in Florentine history.

The first signs of this new style appear after Coluccio Salutati's

for the republic. The leadership, on the other hand, was aware of the risks but confident of the regime's ability to surmount them. These statesmen used the *practica* as an educational forum.

Underlying debate over a council site were two contrasting images that Florentines had constructed about themselves and their world. The traditional vision, inherited from the past, was dominated by a sense of vulnerability that reached intense proportions in the decades following the Black Death of 1348. One manifestation of this attitude was a reluctance to admit distinguished visitors into the city. Prior to 1343, Florence had welcomed a host of dignitaries. But after the Black Death the city gates were closed to emperors, kings, and many lesser princes. The more sanguine image of Florence that emerges during these debates over a council site was developed by the leadership. These men felt greater confidence in the regime's stability, and in their mastery of events, than did many of their fellow citizens. The conciliarists with their ebullient visions of divine favor and temporal glory scored a qualified victory with the convocation of the council in Pisa on 25 March 1409. But their triumph was marred by the failure of that conclave to end the schism. That some citizens were still troubled by the prospect of Florence's gates being open to all was evident from a discussion (July 1409) over inviting the newly elected pope, Alexander V, to visit the city. Not until 1419, when Florentines received Pope Martin V, the newly elected head of a unified church, did the fears subside and the citizenry feel secure with their distinguished guest, who remained with them for eighteen months.

In these debates on Florence's suitability as a council site, as in the related deliberations on war and peace, on finance and justice, one can discern some distinctive elements in this regime's style. In seeking to persuade each other, as well as the rank and file, the leaders systematically employed the skills of the logician and the rhetorician. Speeches became longer and more analytical; they were studded with allusions to historical precedents and references to classical authors. These innovations were not simply rhetorical gambits, but signs of a basic shift in historical outlook. Florentines were being taught, in these debates, to view their past as a unique experience. Though they still referred to divine grace as essential for Florence's prosperity, they placed increasing emphasis upon themselves as the makers of their destiny. This confident mood was to be

death in 1406; they proliferate after Leonardo Bruni's brief tenure as chancellor in 1411, in the minutes kept by his successor, Ser Paolo Fortini. This notary's records also contain the earliest references to a historical frame of reference in Florentine debates. In a speech delivered in May 1413 a civil lawyer expressed the opinion that "it is essential to look into the past, in order to provide for the present and the future." Thereafter, and with increasing frequency, the phrase "we know from experience" prefaced many orations in the *practiche*. Thus, with remarkable suddenness, history became a staple of Florentine political discussion: a voluminous source of precept and example, a valid guide for statesmen.

The refinement of the methodology for examining problems and issues was quite as significant as the introduction of rhetoric and a sense of history into Florentine political discourse. Here, as in other aspects of the deliberative process, Salutati's death in 1406 marks a turning-point, which might have been less abrupt in reality than it appears in the protocols. But the trend toward more complex and sophisticated analysis is very clear. To persuade a knowledgeable and experienced group of citizens of a policy's merits required more than an elegant oratorical style and a talent for quoting Livy and Cicero. As Gino Capponi insisted, the arguments ought to have substance.

These changes in perception and deliberation influenced this regime's *modus operandi*: the ways in which it confronted and solved problems. A good illustration is the Florentine effort to end the Great Schism. Lauro Martines has described the Florentine role in this crisis, and the pressures that forced the regime to abandon its traditional commitment to the Roman obedience by first declaring neutrality, and then accepting the legitimacy of the council of Pisa and its papal nominee, Alexander V. The government had given its permission for the council to meet in Pisa, and Florence was one of the first European states to recognize the new pope, Alexander V, chosen by that conclave on 26 June 1409. In his analysis of the deliberations on this controversial issue, Martines emphasized the traumatic nature of this decision to break a thirty-year-old commitment to the Roman papacy. Resistance to this breach came primarily from the rank and file of the guild community, and not from the leadership. Artisans and shopkeepers were frightened by this violation of a traditional bond; they feared for their souls and

severely tested in subsequent years, but it did reflect an important element in Florentine civic mentality of the early Quattrocento.

The introduction of a hortatory style of political debate, of historical perspective and classical quotations, inevitably raises questions about the relationship between these developments and the rise of civic humanism, which Hans Baron has charted in his classic work, *The Crisis of the Early Italian Renaissance.* The evidence in these protocols does lend support to Baron's major thesis about the emergence in Florence of a new view of history and politics in the first decade of the Quattrocento. The *practica* was an ideal forum for introducing humanist attitudes to a Florentine audience. The ideas that had been nurtured in private by Salutati and his circle were being spread, through the medium of the *pratiche,* to a large group of citizens, whose minds must have been influenced by their exposure to humanist propaganda.

The regime's willingness to consult the citizenry was perhaps most evident in the decade after 1415, a period marked by the absence of serious crises. In those years a rough consensus may have been achieved on this issue, as formulated by Giovanni Capponi: "The *popolo* ought to concur in all deliberations and in all agreements." Within the palace, free debate was tolerated and even encouraged. But once a decision had been reached, then the quarrels must cease and criticism was no longer to be tolerated. Paolo Biliotti argued strongly for the primacy of public authority. Citizens should express their opinions fearlessly, without any concern for their private interest. They should concentrate so intently upon the public welfare that they would never be tempted to use the civil forum to pursue their private quarrels. And they should treat each other not as vassals but as brothers.

This civic ideal – with its emphasis on fraternity and equality, of willing sacrifice for the *res publica* – was much discussed by Florentine statesmen in these years. A profile of the model citizen can be constructed from the records of the *pratiche.* So dedicated was the paragon to the public interest that he gave no thought to private sentiments, nor was he swayed by the importunities of friends and relatives. "If we are true citizens," Jacopo Vecchietti said, "we will not consider our personal feelings." The effectiveness of these exhortations to promote civic virtues and the dramatization of individual sacrifices (or readiness to sacrifice) for the common

good is not easily measured. Pressures to conform to this ideal were very powerful, though it would be unrealistic to believe that the public interest invariably triumphed over the desires and passions of individuals, even those most strongly committed to the regime.

NOTES

1. See Najemy, 1985 and 1991.
2. See the volumes by Kirshner and Molho and by Herlihy and Klapisch-Zuber.
3. See D. Kent.
4. F. W. Kent, 1977, has studied three of these families. The patrons of the Brancacci Chapel in Santa Maria del Carmine are the subject of Pandimiglio's monograph. Lorenzo Lenzi, who has been identified by some scholars as the patron of Masaccio's *Trinità,* has not found a modern biographer. [Editor's note: Nor has his kinsman, Domenico Lenzi, who was interred in the pavement near the fresco.]
5. See Goldthwaite, 1968; Herlihy and Klapisch-Zuber, pp. 93–109.
6. See Molho.
7. See Bizzocchi.
8. Examples of these networks are in F. W. Kent, 1991, and in Phillips.
9. See Brucker, 1971, pp. 93–4; Chambers, pp. 42–51.
10. See Gavitt; and Zervas, 1987.
11. On the Annunziata, see Zervas, 1988.
12. Weinstein, ch. 1.
13. Goldthwaite, 1980.
14. F. W. Kent, 1987, p. 46.
15. See Coolidge.
16. See Borsook and Offerhaus; Simons.
17. Testaments are an important and largely unexplored source for these funerary monuments, but see Sharon Strocchia. [Editor's note: Goffen, 1986, has also made use of testaments in studying monuments of Renaissance Venice.]

MASACCIO'S *TRINITY* AND
THE LETTER TO HEBREWS

Long regarded as a paradigm of the heroic Renaissance style despite its ruinous condition, Masaccio's fresco of the Trinity in Santa Maria Novella is a summa of the primary concerns of Italian artists: monumentality and verisimilitude of space, light, and characterization.[1] Its noble personages, whose majestic stature expresses their psychological gravity and spiritual grandeur, exist in a harmonious architectural realm rendered in convincing perspective (Figs. 1, 3, 5–7, 10–11, 19). Indeed, it was the setting that Giorgio Vasari particularly admired in the *Trinity* – before hiding the fresco from view in 1570 with his own *Madonna del Rosario* – praising the illusionistic perspective that seems to "puncture" the church wall.[2] Vasari also mentioned the donor portraits and the figures of Mary and Saint John who "contemplate Christ crucified." This terse allusion to the Christ is Vasari's only reference to the persons of the Trinity, but even so, it would have been sufficient for the knowledgeable reader (who could not, after 1570, actually see Masaccio's

This chapter is an emended version of an article first published in *Memorie Domenicane* NS 11 (1980):489–504, reprinted here with their gracious permission. When I began to organize the present volume, my intention had been to reprint the article unchanged, but I found myself unwilling to do so, reading it again after almost twenty years – after the restoration of the Brancacci Chapel cycle and after the publication of a number of excellent studies of Masaccio. These publications have prompted me to change my mind about some details of my own earlier essay but not about fundamental observations of style and iconography.

fresco) to visualize how the Triune God must have appeared, with the Father supporting the crucified Son, and the Holy Spirit somewhere between them.

Such depictions of the Trinity are understood as representing the *thronum gratiae,* the Throne of Grace (or Throne of Mercy), a reference to the Letter to Hebrews (Heb. 4:16), which recalls in turn the text of Isaiah 16:5, "And in mercy shall the throne be established," that is, the throne where the Lord sits in judgment.[3] The Epistle thus explains Vasari's abbreviated description of Masaccio's *Trinity,* and indeed much more about the fresco. Similarities of idea and also of language, written and visual, suggest a close relation between this text and Masaccio's image, a kinship that is to be expected, given the Epistle's importance for the doctrine of the Trinity.[4]

The Letter to Hebrews is characterized throughout by a remarkable combination, even an alternation, between heartening and warning, encouragement and admonition. Essentially the thesis is this: Christ's sacrifice, which is permanent, renders obsolete the rites of the Old Covenant and offers redemption for humankind. Neglect of his great gift will therefore bring a great punishment. This hortative leitmotiv sounds throughout the Epistle, but we may summarize the theme by citing chapter 7:4–8:

> For when men have once been enlightened, when they have had a taste of the heavenly gift and a share in the Holy Spirit, when they have experienced the goodness of God's word and the spiritual energies of the age to come, and after all this have fallen away, it is impossible to bring them again to repentance; for with their own hands they are crucifying the Son of God and making mock of his death. When the earth drinks in the rain that falls upon it from time to time, and yields a useful crop to those for whom it is cultivated, it is receiving its share of blessing from God; but if it bears thorns and thistles, it is worthless and God's curse hangs over it; the end of that is burning.[5]

The Blessed Humbert of Romans, a venerated Dominican preacher whose works remained influential long after his death in 1277, refers to these last two verses (6:7–8) in his *De Eruditione Praedicatorum.*[6] Noting that not all who hear Christ's message put it into practice (Ezek. 33:31), the Dominican preacher cites Hebrews to explain that those who are not responsive to the Lord will know bitterness.[7] Later on, again quoting Hebrews 6:7 (–8), Humbert

writes that God's blessing will indeed come to those who both lis-
ten and act accordingly.[8] Finally, Humbert advises preachers how to
convince their audience to hear and to practice God's command-
ments, "to promise good things to good listeners and to threaten
evil to the evil, as one reads in the Letter to Hebrews."[9]

This seems also to be Masaccio's intention in the *Trinity,* simul-
taneously to encourage and to warn. Indeed, such an interpretation
would explain those features generally recognized among the most
unusual aspects of his composition, the characterization of the
Madonna and the depiction of the skeleton. The son in Masaccio's
Trinity is the crucified Christ, but Mary's role here is not that of the
mother who mourns her child's death (Figs. 3, 19). Rather, she
bears witness to his sacrifice and admonishes the viewer-worshiper
to acknowledge "the heavenly gift" (Heb. 6:5). Compelling our
attention with her unwavering glance and directing us with her
gesture, this extraordinary figure insists that viewer-worshipers keep
their "eyes fixed on Jesus" (Heb. 12:1–2). Masaccio's Madonna is
the *Hodegetria* who, pointing at Christ, literally indicates the way to
the faithful.[10] Mary seems to declare, in the words ascribed to her
by Saint John, "Do whatever he [Christ] tells you" (John 2:5).[11] As
in the Letter to Hebrews, in the fresco the exhortation is at once
both an admonition and an inspiration. In this way, the Virgin's role
parallels that of the skeleton, as we shall see.

This skeleton represents simultaneously Death himself, a
memento mori, and Adam (Fig. 5).[12] Death is typically personified
as a skeleton, and the *Trinity* may be interpreted in a general way to
represent Christ's triumph over death by his own dying and Resur-
rection. At the same time, the skeleton is a reference to the imagery
of *transi* tombs, concomitant with the fresco's funerary associa-
tions.[13] A lost inscription, known through records of the Convent
of Santa Maria Novella and from other sources, identified a tomb
in the pavement near the mural, presumably the burial site of
Masaccio's patrons: "Domenico di Lenzo, et Suorum 1426."[14] We
can assume, therefore, that the patron is either Domenico Lenzi
himself or one of his kinsmen, "Suorum" (Figs. 10–11). Despite the
evidence of the inscription, there has been some confusion about
the patron's identity arising from the assumption that his red gown
is the costume of a *gonfaloniere di giustizia,* a rank that Domenico
never held (his highest rank was prior). The donor's gown, how-
ever, bears only a superficial resemblance to the two-toned red toga

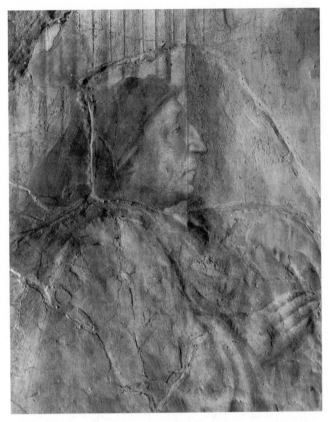

Figure 10. Masaccio. Detail of *Trinity* (Donor). (Photo: Courtesy Ornella Casazza)

worn by a donor in another painting of the Trinity, formerly in the Cathedral of Florence.[15]

Whichever member of the Lenzi family may have commissioned Masaccio's fresco, its proximity to Domenico's tomb and the way in which the donors are portrayed underscore its funerary connotations. In this context, the mural represents "the promise of entering his rest" (Heb. 4:1). That is to say, the faithful may expect the reward of eternal rest, which is heaven itself.[16] Masaccio represented his Lenzi patrons in a scale equal to that of the sacred beings as visual evidence of the fulfillment of that promise after their deaths, a promise, like that of the Epistle, offered to all the faithful.[17] Moreover, their scale is also life size, and this fact allows the beholder to

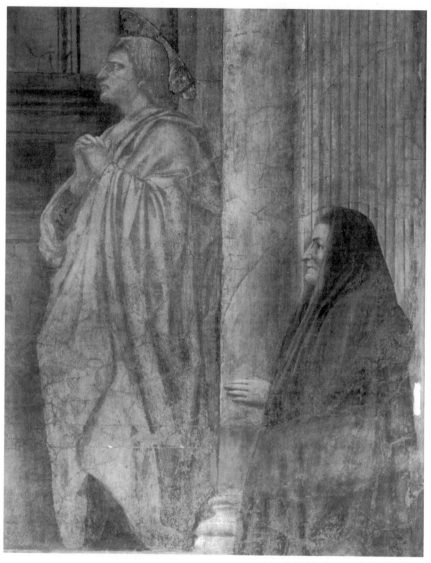

Figure 11. Masaccio. Detail of *Trinity* (Saint John and Donatrix). (Photo: Courtesy Ornella Casazza)

identify with them, hence with their fate – a sense of identification encouraged by their seeming to kneel before the Trinity, not within its arched setting. That is, the donors exist in the same space, the same realm as the beholder – a world shared also by the skeleton.

Masaccio's depiction of the skeleton does not, however, refer only to the funerary context of the fresco. The words of the skeleton inscribed above its recumbent figure recall the Everyman/memento mori in the literature of the Three Living and Three Dead: IO. FU. GA. QUEL. CHE. VOI SETE: E. QUEL. CHI. SON. VOI. ACO. SARETE, "I was once that which you are, and what I am, you also shall be."[18] A similarly unpleasant declaration appeared in Italian writings during the fourteenth century: "The first Dead being spoke: 'We used to be as you are. . . . Now we are vile, as you will eventually come to be.'"[19] Masaccio's wording is somewhat different, but his inscription is clearly related to this literary tradition and to the visual tradition as well, in making Death voice sentiments recalling the inscriptions "read" by the monk and by one of the corpses in the *Triumph of Death* fresco in the Pisa Camposanto (Fig. 12).[20]

The skeleton's declaration warns the observer, or we may almost say, listener, of the transience of all earthly life. In his role as Adam, however, instead of threatening, the skeleton embodies the promise of redemption. And that he is indeed Adam is undeniable. According to tradition, the first man was buried at the site where later Christ was crucified.[21] The death of the Second Adam expiated the sin of the first, and Adam himself was the first man to be redeemed by Christ's blood as it flowed from the stigmata to Adam's head, buried beneath the cross.[22]

Masaccio refers explicitly to the historical Crucifixion and consequently to Golgotha and the redemption of Adam and of all humanity. For example, within the architectural setting, the cross stands on a small mound, an abbreviated representation of the "Place of a Skull." Furthermore, unlike the Virgin, Saint John enacts his role as a witness and mourner of Christ's death. Standing next to the cross, gazing sorrowfully at his Lord, with his hands clasped in a gesture combining prayer and despair, the Evangelist appears in the *Trinity* exactly as he is depicted in innumerable narrative Crucifixions, including one by Masaccio himself (cf. Fig. 2).[23] Thus, in the *Trinity*, while Mary emphasizes the non–narrative, doctrinal aspect of the Crucifixion in the tabernacle-shrine, the Evangelist refers instead to the historical event at Golgotha.[24] And in so doing, he affirms the identity of the skeleton as Adam and underscores the innately hopeful aspect of Christ's death, the guarantee thereby of humanity's redemption (Heb. 2:9).

Figure 12. Buonamico Buffalmacco or Francesco Traini (?). *Triumph of Death (Three Living and Three Dead)*. Detached fresco. Pisa, Camposanto. C. 1330. (Photo: Alinari/Art Resource, New York)

This historical aspect of the composition may substantiate the suggestion that Masaccio's architecture represents a Golgotha Chapel, like its architectural descendant, the Cardini Chapel in the church of San Francesco in Pescia (Fig. 13).[25] As the site of the Crucifixion, which marks the beginning of our judgment, Golgotha was considered the center of the rule of justice.[26] Masaccio's fictive Golgotha Chapel may therefore be related to the frequent use of legal metaphors in the Letter to Hebrews (including 1:8; 7:11–8:13; 9:15–17; and 12:1). Perhaps the apparent donor, Domenico de' Lenzi, who twice served his city as prior, wished to associate himself with these biblical and visual references to justice.

In any case, Adam's skeleton inevitably recalls the historical Crucifixion. We find a similar emphasis on Christ's actual death in the Letter to Hebrews. The author explains that this sacrifice inaugurated the New Convenant, sealed by Christ's blood: "For where

Figure 13. Pescia, San Francesco, Cardini Chapel. 1451. (Photo: Alinari/Art Resource, New York)

there is a testament it is necessary for the death of the testator to be established. A testament is operative only after a death; it cannot possibly have force while the testator is alive" (9:16–17). In other words, heirs – humankind – cannot inherit their estate – salvation – until the testator has died and his testament is probated, that is,

until Christ has been crucified and resurrected.

Both the Virgin and Saint John in the *Trinity* are in effect the legal witnesses of this sacrifice and testament. The Madonna, as we have seen, presents an exhortation to the faithful, but she is also a witness; the Evangelist is primarily a witness, but is also, by his exemplary actions, encouraging the faithful to worship. This juxtaposition and counterbalance of their roles may be reflected in the colors of their garments. Mary's blue mantle covers all but one sleeve of her red dress; John's red cloak conceals all but one blue sleeve and a segment of the skirt of his blue gown. (Perhaps the red of the Madonna's skirt was visible originally? The lower part of her figure has been lost and repainted entirely in blue.) Indeed, Masaccio alternates shades of red and blue throughout the composition in an almost symmetrical distribution of color, a motif typical of Florentine painting in the fourteenth and earlier fifteenth centuries. Here, the donor wears red, his wife blue; Mary is in blue with a red detail, and John in the opposite combination; God the Father has almost equal areas of both hues, and the coffers above his head alternate red and blue. Unfortunately, the subtle variations of Masaccio's chromatic symmetry have been diminished by past mistreatment and concealed by dirt, so that the reds and blues seem identical shades of these colors where in fact they are (or were) quite different.[27]

By bearing witness and by his prayer before the Trinity, Saint John obeys the injunction of the Madonna and of the Epistle, metaphorically illustrating the words of the text: "With all these witnesses to faith around us like a cloud, we must throw off . . . every sin to which we cling and run with resolution the race for which we are entered, our eyes fixed on Jesus, on whom faith depends from start to finish: Jesus who . . . endured the cross . . ." (Heb. 12:1–2).

The Evangelist's example of faith is emulated within the composition itself, by the praying figures of the donors. Kneeling in the foreground, in a space that illusionistically belongs to our realm – that is, the actual space of the church – the donors are also witnesses of Christ's sacrifice and further examples of faith.[28] They pray before the Trinity as though they were communicants at the Mass, just as living worshipers knelt before the actual altar of the Trinity in Santa Maria Novella, dedicated by Fra Lorenzo Cardoni.[29] The precise relation of altar and fresco is unknown, but the Cardini Chapel,

completed in 1451, provides a clue. Attributed to Andrea di Lazzaro Cavalcanti, il Buggiano – Brunelleschi's adopted son and heir – the Cardini Chapel of the Trinity is in effect a three-dimensional "copy" or variant of Masaccio's fictive architecture. The altar of the Cardini Chapel is freestanding, which suggests a similar arrangement for the altar of the Trinity in Santa Maria Novella.[30] The Sacrament represented by Masaccio is not the earthly ritual performed by the priest at the actual altar of the Trinity, however, but rather the heavenly Mass at which the Father himself officiates.

The author of the Letter to Hebrews repeatedly asserts that the high priest and the eternal sacrifice are one individual: "Such a high priest [as Christ] . . . has no need to offer sacrifices daily . . . ; for this he did once and for all when he offered up himself" (Heb. 7:26–28). Saint John explains this extraordinary (self-)immolation and the equivalence of Christ and the sacrifice: "God loved the world so much that he gave his only Son, that everyone who has faith in him may not die but have eternal life" (John 3:16); and, quoting the words of Christ himself, "my Father gives you the true bread from heaven, and gives life to the world. . . . I am the bread of life" (John 6:32, 35).

The conception of God as the celebrant of the heavenly Mass also entered the popular imagination. For example, the influential Dominican preacher Giordano da Pisa (d. 1311) narrated an *esempio* of a pious woman whose devotion to the Sacrament was rewarded by a splendid vision. The woman saw all the saints united with Christ at Mass, with angels in attendance and with Saint Lawrence and Saint Vincent as deacons.[31]

To be sure, the unity of Father and Son is inherent in any representation of the Trinity.[32] Masaccio affirms the identity of the priest who offers the Son as the Eucharist: One person of the Trinity presents the other, and in effect, visually and spiritually, the priest offers himself. For this reason, because he is the celebrant, God the Father is shown standing and not seated as in many representations of the Throne of Grace.

The third person of the Trinity, "the Spirit of truth that issues from the Father" (John 15:26), flies down from the Father to the Son, signifying the Incarnation as revealed by God's acknowledgment of Jesus at the Baptism.[33] Christ's sacrifice is efficacious, valid, and permanent precisely because of the unity of the Trinity and the dwelling

of the Spirit in the Son. In this connection, it is noteworthy that the Florentine celebration of Corpus Domini, commemorated the Thursday after Trinity Sunday, was a communal feast with a procession through the city that culminated at Santa Maria Novella. This celebration of the Eucharist was instituted in 1425 during the term as *gonfaloniere di giustizia* of Lorenzo di Piero Lenzi, possibly a cousin of Masaccio's likely patron.[34] Now, just as the Eucharist of an earthly Mass is contained in the tabernacle of an altar, the Eucharist, that is, the Son, of this heavenly Mass of the Trinity is also presented in a sanctuary. The numerous tabernacles by Italian sculptors which recreate or emulate Masaccio's architecture in miniature are testimony that his fictive structure was indeed understood as an appropriate scheme for an altar tabernacle.[35] In addition, it seems likely that Masaccio's architecture is intended as a mathematical expression of God's perfection and harmony, worthy of the "real tabernacle" of the Lord to which the Epistle refers (Heb. 8:2).[36] In the same way that the heavenly Jerusalem, of which the Lord himself is the architect (*artifex*), will replace the earthly city, God's tabernacle supplants the tent of the Covenant (Heb. 11:10; 8:2).[37]

Within Masaccio's representation of the perfect tabernacle that supersedes the earthly sanctuary (Heb. 8:5), God stands on a box-like structure that has been identified as the ark of the Covenant:[38]

> The first covenant indeed had . . . its sanctuary, but a material sanctuary. . . . Beyond the second curtain was the tent called the Most Holy Place. Here was . . . the ark of the covenant. . . . But now Christ has come, high priest of good things. . . . The tent of his priesthood is a greater and more perfect one . . . ; the blood of his sacrifice is his own blood . . . ; and thus he has entered the sanctuary once and for all and secured an eternal deliverance. . . . And therefore he is the mediator of a new covenant, or testament.[39]

In the Hebrew Bible, the ark of the Covenant is a gilded chest representing the Covenant in two ways: It contains the tablets of the Law, and its cover is the place to which God comes as if to his throne (Lev. 16:2, 13). On the day of Atonement, the cover of the ark was sprinkled with the sacrificial blood of the bull and the goat in the rite that reunited the Israelites with the Lord (Lev. 16:14–15). This sacrifice and the "place of expiation" (Exod. 25:20), the "mercy seat" (Exod. 30:6), have been replaced by the self-sacrifice

of Christ and by the ark of the New Covenant, as the author of Hebrews explains.

But if Christ's sacrifice is permanent, as the Letter to Hebrews declares, is he then sacrificed again in the Sacrament? This is Saint Thomas Aquinas's first point in his discussion of the ritual of the Eucharist in the *Summa Theologiae*.[40] The questions posited and answered by Aquinas are pertinent also to Masaccio's sacramental depiction of the Trinity. To be sure, Aquinas asserts, Christ's sacrifice on the cross is not repeated by a crucifixion during the Mass. Furthermore, the saint continues, in Christ's sacrifice priest and victim are one and the same, as Saint Augustine – and the Letter to Hebrews – had noted. And yet the priest who celebrates the Mass is clearly not Christ.[41]

Aquinas then cites Saint Ambrose's commentary on the Letter to Hebrews to explain the commemorative aspect of the Mass: "Hence Ambrose writes on Hebrews, 'In Christ was offered once a sacrifice potent for eternal salvation. What do we do? Is it not to offer it every day, yet for the recalling of his death?' . . . By this sacrament we are made sharers of the fruit of the Lord's Passion. Hence in a Sunday secret prayer it is said, 'Whenever the commemoration of this sacrifice is celebrated the work of our redemption is carried on.'"[42] The "secret prayer" to which Aquinas refers is that of the Dominican missal for the seventh Sunday after the octave of Trinity.[43]

The locus of Christ's sacrifice is the cross, and this in turn is signified by the altar where the Crucifixion is commemorated. Aquinas explains this equivalence: "As the celebration of this sacrament [the Eucharist] is an image representing Christ's Passion, so does the altar represent the cross on which Christ was sacrificed in his own proper form and figure."[44] By the same reasoning, Aquinas continues, "the priest also bears Christ's image. . . . And so in a measure the priest and the victim are the same."[45]

Aquinas's writings constitute the spiritual and theological environment of Masaccio's *Trinity*. The artist makes these references immediate and compelling by associating the *Trinity* visually with its physical environment, the church itself. Masaccio's fictive architecture, the "more perfect sanctuary" that contains the New Covenant, is illusionistically connected to the actual space of the church as though the one were accessible from the other. Indeed, this is so, the access being both a visual illusion and an illustration

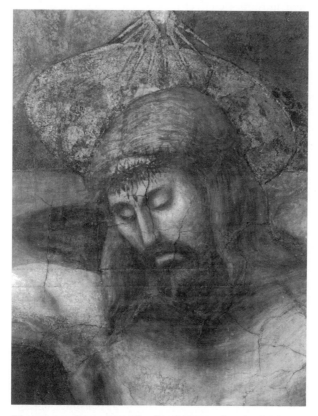

Figure 14. Masaccio. Detail of *Trinity* (head of Christ).
(Photo: Courtesy Ornella Casazza)

of the idea expressed repeatedly in the Letter to Hebrews: "the blood of Jesus makes us free to enter boldly into the sanctuary" (Heb. 9:19–20). (The theme of entry and approach is repeated throughout the Epistle, e.g., 4:16.) In other words, "bold entrance" to the heavenly sanctuary is possible because of Christ's sacrifice, which is commemorated in the Mass.

This spatial illusionism and the possibility of bold entry were greatly enhanced by fictive shadows cast by the figures and by the architecture. The surface of the fresco is badly damaged, and these shadows are in fact easier to see in photographs than in the painting itself (Fig. 14). Their authenticity, however, has been confirmed,[46]

and their illusionistic effect may be reconstructed in the mind's eye
with reference to Masaccio's nearly contemporary work, including
the Pisa *Madonna* and the Brancacci Chapel fresco of *Saint Peter
Healing by the Fall of His Shadow* (Figs. 2, 9).[47] In these paintings as
in the *Trinity*, light, shadow, and mathematical perspective work
together to establish a convincing three-dimensional realm. In the
Brancacci Chapel mural, however, as customarily in Italian fresco
decoration from Giotto's time onward, the real source of light,
entering through the window on the altar wall in this case, has
determined the direction of light and shadow in the paintings.[48]
(The direction of light in the Pisa altarpiece was likely also related
to its original site.) All scenes on the left wall of the chapel are illu-
minated from the right, as though by actual light from the real
window. The directions are logically reversed on the right wall.
Finally, on the altar wall itself, scenes to the left of the window
(including the *Saint Peter Healing by the Fall of His Shadow*) are lit
from the right, and vice versa.

Within the *Trinity*, the shadows of Saint John and of Christ are
cast to the left (their proper right), evidently in response to light
entering the fictive sanctuary from the lateral opening behind the
saint. (Masaccio's space is closed behind God the Father and is open
in front and at the sides, roughly approximating the spatial relations
of an apse in juxtaposition with the aisles of a nave and transepts.)
Because Christ and Saint John have such prominent shadows, we
may postulate that originally shadows were cast also by God the
Father and by the Madonna. Indeed, the dark area to the right of
Mary's head (that is, her left) may be such a shadow. If so, it results
from a second light source entering behind her figure, counterbal-
ancing that behind Saint John. Elsewhere, as in the Brancacci
Chapel, Masaccio was quite clear about the relation of ambient and
pictorial illumination, representing a verisimilar, consistent conflu-
ence of real and painted light. In Santa Maria Novella, however, he
seems purposefully to have confused the issue.

The *Trinity* is not (or was not) illuminated as though from the
portal in the opposite (east) wall, now sealed but in Masaccio's time
the main entrance to the church.[49] Similarly, the pictorial light
within the fictive realm seems unrelated to the window in the wall
above the fresco, although that window may account for the light-
ing of the most external elements of the architecture – that is, those

elements existing illusionistically in our world. The cornice, the rondels immediately below it, and the skeleton's niche all cast shadows downward that might result, as it were, from light entering the window above the fresco.[50] In any case, the shadows of the outer surfaces of the architecture are caused by a different light than that which illuminates the sacred beings: Light and shadow *within* the *Trinity* seem unrelated to the ambient lighting of the church, but rather are governed by a hidden light source (or sources) existing only within the sacred realm of the picture space.

Even if we cannot explain the shadows cast by the sacred beings, these shadows are an assertion of their real presence before us, albeit in a realm different from our own, which we share with the donors. Indeed, the donors are not only our neighbors, inhabiting the same space, but also our spiritual counterparts or exemplars who pray before the sacred beings as we are meant to do. Their equality of scale notwithstanding, Masaccio has differentiated the donors in every way possible from the beings of the Trinity, the Virgin, and Saint John, who are more monumental than the Lenzi couple, more convincing as three-dimensional figures who dominate their illusionistic space physically and psychologically. The mortals are seen in profile, which is essentially a two-dimensional view. Although they kneel, figuratively, in the viewer's space, they seem less present than the sacred characters, two of whom, moreover, address us directly with their eyes. Thus by stature, glance, space, and light, Masaccio makes these holy figures seem to be truly present before us, and not merely visions, as has been suggested.[51] Masaccio's visual insistence on their actuality evokes the *Suscipe Sancta Trinitas,* the words spoken by the priest during the Mass, addressed directly to the Trinity: "Holy Trinity, accept the offering we here make to thee in memory of the passion, resurrection, and ascension of our Lord Jesus Christ; and to the honor of blessed Mary, ever-virgin, . . . and of all the saints."[52]

Thus Masaccio's imagery of the Trinity has a twofold meaning. Just as Christ is both sacrifice and priest, enacting the heavenly Mass in the presence of Mary, John, and the donor-communicants, the Trinity is also the recipient of the Eucharistic sacrament offered by the mortal priest of an earthly Mass in the presence of living communicants.

Masaccio's fictive shadows may bring to mind, once again, the

Letter to Hebrews, albeit seemingly in a contradictory way. With an apparent reference to Plato, the biblical author writes (8:1–5):

> Now this is my main point: just such a high priest we have . . . in the heavens. . . . Now if he had been on earth, he would not even have been a priest, since there are already priests who offer the gifts which the [old] Law prescribes, though they minister in a sanctuary which is only a copy and a shadow [*umbrae*] of the heavenly.

Evidently by the word *umbrae*, the author seems to intend a double meaning, both literally "shadow" and figuratively (and chronologically) "to foreshadow."[53]

Given Masaccio's naturalistic idiom, we are to understand the shadows of the holy beings as testimony of their reality, but perhaps at the same time, their images "only copy" and foreshadow the heavenly. This suggestion is offered as an hypothesis. In any case, like the author of the Letter to Hebrews, Masaccio's main point was at once an admonishment and an encouragement, affirming the permanence of the self-sacrifice of the eternal high priest, offered in the heavenly sanctuary.

NOTES

1. Mesnil discussed the *Trinity* as an embodiment of the early Renaissance style in an essay published in 1928 – before its restoration and its return to its original site. See Offner, 1959, on Masaccio's use of light. Hertlein (pp. 177–95, 205–22) argued for a political interpretation of the *Trinity*. See ibid., pp. 2–8, for bibliography before 1979. For the recovery of the lower part of Masaccio's fresco, including the skeleton, see Procacci, 1956. More recently, on Masaccio, see the monographs by Joannides and by Spike.

2. Vasari-Milanesi 2: 291. For Vasari's appreciation of Masaccio, see Rubin, p. 266. The *Madonna del Rosario* was painted in collaboration with Jacopo Zucchi. Vasari explained the commission in Vasari-Milanesi 7: 709–10. For his redecoration of the church of Santa Maria Novella at the behest of Duke Cosimo de' Medici, see also Hall, especially pp. 62, 114–6, and Satkowski, pp. 92–7. For Masaccio's perspective construction, see Aiken, ch. 4 this volume.

3. The author of the Letter to Hebrews, identified in the Bible as Saint Paul, is in fact unknown. He may have been one of the saint's Jewish colleagues, Apollos of Alexandria. See Davies, p. 11 and passim. For the term "Throne of Grace," and for its relevance to Masaccio's fresco, see Panofsky, pp. 433–4, Braunfels, p. 48, and Simson (who also discusses Luther's

incorrect translation of the biblical Latin as *Gnadenstuhl*). Shearman, p. 64, calls attention to the text of Isaiah.

4. See Davies, p. 23; Michel; and Philip, pp. 61–78 and notes.

5. The English translation quoted here and throughout this essay is *The New English Bible with the Apocrypha* (New York, 1971). See also John 3:35–36 and 15:6.

6. For the Latin text, see Humberti, ed. Bigne, pp. 424–56. For an introduction to the preacher's life and works, see Umberto de Romans, ed. Mosca, pp. 7–34.

7. Humberti, ed. Bigne, Liber I, cap. xxv, p. 445. For an explanation of the text of Heb. 6, see Davies, pp. 59–60.

8. Humberti, ed. Bigne, Liber I, cap. xxix, p. 447.

9. Ibid., cap. xliv, p. 456. See also Liber II, cap. xvii, p. 463.

10. *Hodegetria,* which means Indicator of the Way, describes the mother who holds the infant Christ and calls attention to him, usually with her right hand. I adopt the term for Masacco's Madonna because her action and intention are identical with those of the traditional *Hodegetria.* For the Byzantine Madonna types, see Lasareff; and for the importance of the figure who directs the viewer's attention, see Alberti, ed. Grayson, p. 83. Cf. Polzer, p. 43, who interprets Masaccio's Madonna as symbolizing *Mater Ecclesia.*

11. I thank Professor David C. Steinmetz of the Duke University Divinity School for pointing out to me the importance of the text of John 2:5 in understanding Masaccio's Madonna. This is the only biblical text that attributes an active role to Christ's mother, as discussed also in the Introduction, p. 18 this volume.

12. The skeleton, which measures a lifelike 160 cm, long enjoyed an exaggerated reputation as one of the first accurate representations in art. For a more informed consideration of its anatomical correctness, see the essay by Park, ch. 6 this volume. For its measurements, see Janson, p. 85. For an early reference to the skeleton, see Billi, ed. Frey, p. 16, and ed. Ficarra, pp. 54–5. On Billi himself, see Geisenheimer. For the representation of Death, see Tenenti, pp. 91 ff., and Camporeale, 1977–78. Dempsey, pp. 280–2, interprets the skeleton as a memento mori/Everyman; Simson, pp. 141–2, sees it as Death, but not Adam; Joannides, p. 178, writes that the skeleton is Adam's but also Everyman's.

13. For *transi* tombs, see Cohen, pp. 104–8. Popular north of the Alps, these tombs with their images of decaying corpses or skeletons were rare in Italy. Italians preferred effigies of their deceased intact and (well) dressed for burial, laid out on their biers, sometimes seeming not dead but merely asleep and sometimes seen as though still (or once again?) alive. An exception – a drawing, not a monument – is the tomb conceived by Jacopo Bellini for a scholar who both published and perished. The front

of the sarcophagus has rows of students listening attentively to their pro-
fessor as he lectures; he appears again on the top of the tomb as a rotting
corpse with his head resting on a book – presumably one of his own
publications. See Colin Eisler, *The Genius of Jacopo Bellini: The Complete
Paintings and Drawings* (New York, 1989), fol. 12 of the Paris sketchbook.

14. *Il Sepultario di Santa Maria Novella* (an unpublished MS of 1617, pre-
served in the Convent), fol. 64v. I am most grateful to Father Isnardo
Grossi and to Father Salvatore I. Camporeale for arranging my consulta-
tion of the MS. The entire relevant text reads: "Mon. di Que [quelli] di
Lenzo. Fra l'Altare del Rosario, et la colonna di lungo Il muro verso la
Piazza al principio del terzo arco monumento con chiusino quadro di
marmo, con armé e lettere di quelli di Lenzo. – Domenico di Lenzo, et
Suorum 1426[.] Questa sepultura fu concessa da Signori operai L'Anno
1636. al Sig.re Dott.re Giuseppe Lapi, et a suoi descendenti. Canc.re del
opera d[ella] Sa Ma Novella." Much the same information is found in
Roselli (1657) and in the eighteenth–century *Sepolcriorio della Chiesa di S.
Maria Novella di Firenze,* Florence, Biblioteca Riccardiana, cod. 1935. For
these sources see Hertlein, pp. 106–8, and Simson, p. 123n10.

15. Now in the Cloisters in New York. For information on the costume, see
Meiss, 1954, p. 310. For Domenico's highest rank as prior, see Borsook, p.
75. A government of priors was first established in Florence in 1282, with
one of them serving as *gonfaloniere di giustizia;* see Martines, p. 49. On the
probable identity of the donor, see also Joannides, p. 357, Spike, p. 205,
and the Introduction, p. 15 this volume.

16. For a discussion of *requiem ejus* to signify heaven, see Davies, pp. 43–6.

17. To be sure, equality of scale is typical of Masaccio's compositions, includ-
ing the donors in the Brancacci Chapel *Tribute Money* and the donors in
the *Adoration of the Magi,* the central predella panel of the Pisa altarpiece,
now in Gemäldegalerie, Berlin. Trecento precedents for this naturalism of
scale include Enrico Scrovegni in Giotto's Arena Chapel *Last Judgment*
and the knight presented to the Virgin by Saint John the Baptist in Pietro
Lorenzetti's fresco in the church of San Domenico, Siena (illustrated in
Meiss, 1976, fig. 113).

18. For the form of the inscription, see Covi; Hertlein, pp. 63–6; and Meiss,
1960, rpt. 1976.

19. "Lo primo mortu prese a dire: nui fuimo comme vuy syte. . . . Ora simo
vile, cussi vui tornarite." For this South Italian poem from a MS in the
Biblioteca Vaticana (Ottoboni 1220, fol. 56v), which was inspired by the
French "Conpains, vois-tu ce que je voi," see Guerry, p. 40, and Schlegel,
p. 25.

20. For the fresco in Pisa, in which a monk explains the meaning of the
Three Dead to a larger group of prosperous but revolted living, see
Polzer, 1982, who convincingly dates the frescoes to the early 1330s.

Attributed to Francesco Traini by Meiss, 1951, pp. 74–6 (repeating the attribution first put forward in his dissertation of 1933), the cycle has more recently been given to Buonamico Buffalmacco, c. 1328–30, by Luciano Bellosi, *Buffalmacco e il trionfo della Morte* (Turin, 1974); and to two or more anonymous painters in the 1350s, by Maria Laura Testi Cristiani, "Maestri e maestranze nel 'Trionfo della Morte' di Pisa, 3," *Critica d'arte* ser. 7, vol. 58 (June 1995): 28–41. See also Park, ch. 6, at nn. 39, 45–6 this volume.

21. For Adam's foreshadowing Christ, see Romans 5:12–19. For the story of the True Cross, see Voragine, pp. 303–11. The legend was represented in Florence by Agnolo Gaddi's fresco cycle in the Franciscan church of Santa Croce (1388–93); see Cole, pp. 21–31. For earlier decoration of that church and its rivalry with the Dominicans of Santa Maria Novella, see Goffen, 1988.

22. For Christ and Mary as the Second Adam and Eve, see Esche. For the redemption of Adam by the blood of the Crucified, see Bandmann, p. 171 and n. 89.

23. Masaccio's *Crucifixion,* Naples, Capodimente, was originally the crowning element of his altarpiece for the church of the Carmine in Pisa, dating 1426; for the contract and other records, see Beck with Corti, pp. 17–22. For the altarpiece, see Gardner von Teuffel, Joannides, and Spike. The biblical source for Saint John and the Virgin at the Crucifixion is John 19:25–7.

24. The imagery of the tabernacle-shrine is discussed here at nn. 35–8.

25. For the Cardini Chapel, see Gurrieri and Lieberman, and here on p. 52; for Golgotha Chapels, Bandmann, pp. 170–2, and Schlegel, pp. 19–33. Golgotha Chapels, including the Cardini Chapel, are located on the liturgical north. Santa Maria Novella is not oriented: Its altar is geographical north, which is considered liturgical east. The *Trinity* on the geographical west wall thus becomes liturgical north.

26. Bandmann, p. 171.

27. See Cavalcaselle's description of the colors as they appeared before the transfer of the painting, quoted in Casazza this volume, at n. 28. Masaccio may have intended his limited palette as an evocation of Apelles, praised for his ability to represent three-dimensional forms with only four colors, as in his portrait of Alexander the Great with a thunderbolt. The portrait is described by Pliny the Elder, *Natural History Books XXXIII–XXXV,* translated by H. Rackham (Loeb Classical Library, 394; Pliny, *Natural History,* 9 [Cambridge, Mass., and London, 1952; rpt. 1995]), 35.91, pp. 328–9. The favorite painter of Alexander, Apelles became the archetypal great artist for Renaissance authors, painters, and their patrons. A number of great masters were accordingly described as *alter Apelles,* another Apelles, among them Masaccio's contemporary and compatriot

Fra Angelico (died 1455), in the inscription of his tombstone in the church of S. Maria sopra Minerva in Rome.

28. Shearman, pp. 64–5, adds that the greater percentage of the *Trinity* fictive architecture "is an illusion of forms in front of the wall . . . occupying his [the viewer's] space and belonging . . . to his reality."

29. For the altar of the Trinity and for "shared" patronage of chapels in the fifteenth century, see the Introduction, p. 13 and nn. 30–31. N.B. also the slightly earlier altar of the Trinity in the Cathedral of Florence; see Meiss, 1954, pp. 312, 315–6, and notes.

30. For the Cardini Chapel, see Coolidge, Gurrieri, and Lieberman. Most scholars assume that the chapel was based on earlier designs by Brunelleschi. The tomb in the chapel pavement is inscribed with the verse from Isaiah 6:55: "Quarite Dominum inveniri potest/Invocate eum dum prope est"; see Nucci, p. 23.

31. For the text of *esempio* 51, dated 2 February 1304, see Delcorno, p. 275, and Manni, p. 140, cols. 21–34.

32. For Aquinas on the "Processions of Divine Persons," see the *Summa Theologiae* I, qq. 27–32 and 33–43. Approximately a decade after Masaccio painted his *Trinity,* the *Filioque* became a primary subject of discussion at the Council of Florence in 1439, for which see Camporeale, 1972, especially pp. 253 ff., and Gill, pp. 194–226, 230–66.

33. For the Holy Ghost at the Baptism, see Mark 1:8–11; Matt 3:16 and 28:19; Luke 3:22; and John 1:32. The Baptism is the announcement of the Trinity in the New Testament, the Dove representing Christ's divinity; Parente, col. 529. It has been suggested that the direction of the Dove's flight in art is significant; when the Dove proceeds from the Father to the Son, as in Masaccio's *Trinity,* it may refer to Christ's redemptive role. See Hackel, p. 123, and Philip, p. 64.

34. See Ammirato, p. 336, and Borsook, p. 75 and n. 6. N.B. also that the feast of the Trinity (the first Sunday after Pentecost) was celebrated by the Dominicans from c. the mid-thirteenth century, and extended to the entire church in 1331 by Pope John XXII. See Frutaz, cols. 542–3, and the Introduction, this volume, p. 15.

35. Tabernacles based on Masaccio's conception are very common; see Schlegel, pp. 31–2 and n. 92; and Freiberg's Master's essay, Appendix A, pp. 93 ff., listing seventy-eight examples.

36. For the symbolic implications of perfect forms in architecture, see Wittkower, 1965, pp. 27 ff. and passim. For bibliography on suggested reconstructions and studies of Masaccio's architecture, see Aiken, ch. 4 this volume.

37. For the relation between the Heavenly Jerusalem and sanctuary and the earthly city and tent, see also Davies, p. 108.

38. Shearman, p. 64, citing Ex. 25 ff., 37 ff., and 2 Kings 6:17, and with refer-

ence to the similar structure in Raphael's *Expulsion of Heliodorus,* clearly representing the ark.

39. See also Heb. 7:11–19, 8:7–13.

40. Aquinas, 1975, IIIa, 59, pp. 132–3 (Quaestio 83, articulus 1). On his theology of the Trinity, see Merriell.

41. Ibid., pp. 132–5.

42. Ibid., p. 135.

43. Ibid., p. 134.

44. Ibid., p. 137.

45. Ibid.

46. See Polzer, p. 48. Crowe and Cavalcaselle, 1864, vol. 1, pp. 543–6, note the damages inflicted by "restorers" immediately after the fresco's discovery under Vasari's *Madonna del Rosario* and give some indication of colors as they appeared before this damage. For the areas of loss, for the *giornate,* and other technical information, including comments by the conservator in 1950–51, see Casazza, ch. 3 this volume.

47. Similarly in the *Adoration of the Magi* predella panel now in Berlin, shadows cast by the figures are instrumental in the creation of the pictorial space. For the fifteenth-century artistic interest in light as well as space, see Meiss, 1945, rpt. 1976, pp. 3–13. Meiss notes that the subject of Saint Peter's healing by the fall of his shadow is extremely rare and that its very selection by Masaccio indicates the painter's concern with effects of light and shadow.

48. Giotto's fresco cycles in Padua (Cappella Scrovegni) and in Florence (Santa Croce, the Bardi and Peruzzi chapels) are illuminated so that the direction of the pictorial light coincides with the ambient light. In the Scrovegni Chapel, for example, shadows indicate that all the frescoes are lighted from the west or entrance wall: Murals on the south are illuminated from the left, those on the north from the right. Cennini, who was trained by Giotto's successor, Taddeo Gaddi, recommends this "coincidence" of illumination; see Cennini, 1933, p. 6. See also the Introduction, this volume, pp. 21, 23.

49. Cf. Lunardi, 1990, p. 254. His assertion that lighting in the *Trinity* was determined by the direction of light from the portal opposite the fresco seems arbitrary. One would have to posit extremely bright light entering the church at a very sharp angle from the geographical north to cause such strong shadows in the fresco that fall to the geographical south. Even then, the actual light from the door would not explain the illusionistic shadows cast by Masaccio's architecture.

50. Although the fresco's condition does not allow for certainty, the colonnettes flanking the skeleton's niche appear to be lighted from the right, like Christ and Saint John.

51. Cf. Schlegel, p. 30, who interprets the *Trinity* as a vision; and Simson, p.

150, who suggests that the image is the "expression of personal prayer." For the greater reality of the sacred figures in contrast to the donors, see also Tolnay, p. 37.

52. "Suscipe, sancta Trinitas, hanc oblationem, quam offerimus ob memoriam passionis, resurrectionis et ascensionis Iesu Christi Domini nostri: et in honorem beatae Mariae semper Virginis, et beati Ioannis Baptistae, et . . . omnium Sanctorum." I am grateful to Salvatore I. Camporeale, O.P., who discussed this text with me. Cf. Orlandi, 1952, p. 272. Father Orlandi interpreted this as a reference to the priest's celestial vision, which, I suggest, Masaccio's verisimilar style transforms into actual presence. The *Suscipe S. Trinitas* (like the *Placeat S. Trinitas*) is of French origin and began to appear in the Ordinary of the Mass, in Sacramentaries, and in Missals between the ninth and the eleventh century; see Parente, col. 541, and O'Carroll, pp. 148–9.

53. For the meaning(s) of the word and the possible Platonic reference, see Davies, p. 79, citing also Heb. 10:1.

ORNELLA CASAZZA

MASACCIO'S FRESCO TECHNIQUE AND PROBLEMS OF CONSERVATION

The recent conservation of the Brancacci Chapel frescoes by Masaccio, Masolino, and Filippino Lippi in the Florentine church of Santa Maria del Carmine was necessary to preserve one of the greatest decorative cycles of art from a dangerous condition of decay (Fig. 9). The conservation campaign provided those involved not only a great lesson in methodology but also a secure and objective font of knowledge. This newly acquired technical knowledge, together with documentation of the cycle's history, has made possible our understanding of the techniques employed by the three artists, and especially Masaccio, who of the three worked in the chapel most extensively and for the longest period of time.

With the Brancacci Chapel conservation successfully completed, we may hope for a decision by the appropriate state offices for conservation of Masaccio's *Trinity* (Figs. 1, 3, 5–7, 10–11, 14–17). Such intervention is absolutely necessary and indeed becomes more urgent every day. Admittedly, the visual text is not so clear regarding technique in the *Trinity* as it is in the Brancacci Chapel. Nevertheless, we may logically suppose an affinity in the execution of the two works because they are contemporaneous. This technical affinity must be remembered in any study of the *Trinity* and also as a corrective introduction to its conservation.

At the conclusion of the conservation campaign in the Brancacci Chapel, our team made a full record of our research, includ-

Translated by Rona Goffen.

65

ing the methodologies we had employed and the types and characteristics of technical analyses done before, during, and after the conservation itself. We also took note of new studies of the chapel and research on changes brought about by time; and we considered scholarship concerning the Brancacci family, the iconography of the chapel cycle, and information related to its realization.[1]

The conservation campaign began in February 1984 and was completed in 1990. At that time, the results were published and documented. Scholars considered these results in relation to other recent discoveries and in light of the clarifications gained from daily study in direct contact with the frescoes, observed from the restorers' scaffolding and analyzed using the most modern technology.[2] But most important, our team completely documented the procedure at the conclusion of the cleaning process when, with the recovery of a new painting – intact and free of any overlying modifications whatsoever – we were also presented with the problem of how to deal with losses, great and small, in the pictorial fabric. To be sure, with the intention of returning a text once again "whole" to a state of complete restoration, our conservators did not employ those "glazings" (velature) or "adjustments" that even today are often used to reequilibrate a painting that has perhaps become visually unbalanced precisely because of a phase of cleaning. Using such glazes would be to fall into the very errors of the recent and distant past, against which, indeed, one has been arguing since Filippo Baldinucci's time in defense of the intangibility of the work of art. In Baldinucci's words, "The best pictures are not to be repainted or retouched at all, in any way whatsoever, for this reason: because, whether a little or a lot, whether immediately or with time, it is rather difficult that one not recognize the restoration, however small it may be, and it is also true that the picture that is not unadulterated is always accompanied with great discredit."[3]

In the Brancacci Chapel, it was necessary only to eliminate the negativity of losses from the chromatic context, working with connecting passages of chromatic selection and abstraction. That is, missing passages were "toned in" to blend with surrounding areas. For the most part, the methods and principles followed here were those developed in the Florentine school of restoration from the time of the conservation of Cimabue's Santa Croce Crucifix, which was nearly destroyed in the floods of November 1966.[4]

When Masaccio – like Masolino and later Filippino Lippi –
painted his frescoes on the walls of the fourteenth-century chapel,
he proceeded according to the practice of medieval and Renais-
sance Florentine artists as described in Cennino Cennini's *Crafts-
man's Handbook.* The *giornate* revealed in all the chapel scenes clearly
document the rigorous observation of Cennino's rules in laying the
intonaco: working from the top of the wall downward in accordance
with the lowering of the scaffolding, and always using fresh (wet)
intonaco. This procedure results in larger passages of *intonaco* where
more rapid pictorial execution was involved (e.g., architectural set-
tings, skies, landscapes, and in many draperies) and smaller areas in
those places where the execution had to be slower in order to
achieve more detailed pictorial definition (e.g., heads and hands).[5]

Masaccio's and Masolino's use of *sinopie,* or underdrawings, is
demonstrated in the Brancacci Chapel by two discoveries. One was
the recovery of part of the original *arriccio,* the first, rough layer of
plaster, which remained intact beneath the eighteenth-century fres-
coes at the sides of the eighteenth-century window above the sec-
ond register of the narratives on the altar wall.[6] Other sections
were rediscovered beneath areas plastered in gesso to repair losses of
intonaco due in large part to the damage caused by the fire in the
church of the Carmine in 1771.[7]

Conservation revealed such aspects of the artists' technique as
the use of outlining architectonic divisions made on the wet
intonaco either by means of direct incision or with the aid of snap-
ping lines. In the *Tribute Money,* snapping lines were employed for
the cadenced marking of verticals to indicate the location of the
figures. *Spolvero* (pouncing) was used for the transfer of the design
onto the fresh *intonaco.*[8]

Before conservation, aside from the presence of phenomena of a
chemical reaction of accumulation of lead sulfur (which can be
present on the carbon-stained surfaces in the interior of a chapel in
a church), the superficial layers of the fresco revealed two primary
causes of deterioration. First, natural aging and modifications
caused by the changing ambience had taken a toll. In addition, the
frescoes had been damaged by a mixture containing protein com-
bined with paraffin or wax, which was found in areas that had pre-
viously shown themselves to be in need of consolidation. Such
mixtures were applied in keeping with restoration techniques com-

mon in the nineteenth century, with the twofold intention of protecting the fresco surfaces and freeing them from salts.[9] With age, the layers of the proteinaceous mixture had undergone a chemical alteration of color that strongly obscured the frescoes' legibility. In more than one area, these layers had also resulted in a dangerous action of traction, seriously threatening the integrity of the original underlying color. Removal of the protein-wax layers resolved the problem appropriately, eliminating also another ill-advised application, the so-called *beverone,* in this case, a concoction of water and oatmeal. The *beverone* had probably been applied to the fresco surfaces immediately after the cleaning and renovations executed after the fire in 1771, in keeping with the procedures described in eighteenth-century manuals.[10]

Before the recent conservation of the Brancacci Chapel, certainly no one in our own century had ever clearly seen the landscape of Masaccio's *Baptism of the Neophytes* or that of Masolino's *Preaching of Saint Peter,* a landscape that continues on the other side of the fictive pilaster painted in the corner of Masaccio's *Tribute Money.* Rereading the pictorial texts revealed by conservation has also allowed for the identification and removal of heavy, arbitrary modifications applied in the past. Perhaps the most conspicuous of these alterations were the fig leaves painted in tempera over the original fresco to cover the nudity of Adam and Eve both in the *Temptation* by Masolino and in the *Expulsion* by Masaccio.[11]

Variations to the *Trinity*'s pictorial text do not appear at first to have changed the image so much as in the Brancacci Chapel. Even so, the why and the how of cleaning the *Trinity* will have to be founded on absolutely rigorous rules of method combined with a complete correctness of procedure. Great care must be used to determine the choice of means that permit the gradual removal of substances placed on top of the original pictorial layer. The superimposed layers must be thinned bit by bit until the conservators arrive at the desired effect. Working gradually will provide the time necessary to come to know Masaccio's original text. The procedure should not be carried out, however, in plugs or patches (*a tasselli*) or so as to arrive at the end result in one fell swoop. Rather, the work should proceed in stages, effecting a first removal of the *beverone* on all the surfaces, then a second and a third removal, until the final result is achieved. This slow procedure will allow the conservators

to see the entire text in a provisional manner and time to meditate on it, in order then to complete any "adjustments" or balancing. At the same time, working slowly will enable the conservators to examine details that otherwise might escape attention.

Cleaning the fresco would be the first step in the process of conservation, assuming that no other problems require immediate attention. Certain kinds of problems, if not corrected at the start, can prejudice every subsequent step taken. For example, if the fresco structure requires consolidation, this must take priority over any other procedure; if there are problems of continuing loss of the pictorial surface (which occurs rather often), this too must be immediately corrected. In relation to the painting's chemistry and physics, conservators must eliminate a series of substances sometimes incorrectly called "products of corrosion." These are substances that have accumulated on the fresco over time because of various natural and human causes – the human causes generally due to old restorations. The substances actually constitute a kind of conglomerate patina of varied composition incorporating dust, carbon particles, and so on. When parts of the pictorial text are entirely invisible (or lost, in the case of the *Trinity*), it may well prove necessary to devise a gradual system of recovery, involving dissolution of the *beverone*. The thinning of the dirt must be accomplished in the solid state, however, because if one actually dissolves the *beverone* into liquid, the *intonaco*, which is porous, will absorb it. Once absorbed, the *beverone* causes alterations of color and remains as degrading material within the *intonaco*, beneath the chromatic pigments.[12] In fact, such degrading substances are still present in large measure on the surface of the *Trinity*, notwithstanding their partial elimination during the fresco's restoration in 1950.

Cited in fifteenth-century sources, the *Trinity* was also described in the second edition of Giorgio Vasari's *Lives,* published in 1568. But three years earlier, Vasari himself, commissioned by Duke Cosimo de' Medici and with the consent of the Dominican friars of Santa Maria Novella, had already undertaken a substantial restructuring of the church. By the end of 1569 – a year after publication of the *Lives* – Vasari announced that he had completed painting the altarpiece of the *Madonna of the Rosary* for the church.[13] Vasari's altarpiece was installed in 1570, concealing Masaccio's fresco from view.[14] The *Trinity* was not seen again until another campaign of

"restorations and renewals" completed on the altars of Santa Maria Novella in 1861.[15]

The fresco's condition at the moment of its rediscovery was described in some detail by the Italian art historian Giovanni Battista Cavalcaselle and his English colleague, Joseph Archer Crowe. They found that the *Trinity* confirmed Vasari's gravest, most unpardonable sin: "after having uttered many praises of the fresco, especially in regard to its perspective," Vasari had concealed it from the study and admiration of others, covering it with one of his own paintings. "The damages and the alterations due to the discovery," Cavalcaselle and Crowe continued, "were as follows: it was missing the accessory parts, as for example, the color together with some pieces of the *intonaco* in the fictive enframement; the mantle of God the Father had in part lost color and in part had become obfuscated and dark; the garments of the Madonna have also become darkened. Also the color of the arms and even more of the hands of the Christ were here and there either entirely lacking or faded, as are likewise faded the lower parts of the donors' garments."[16]

The installation of Vasari's altar was certainly the primary cause of the losses of the marginal areas on the sides of the *Trinity*, especially on the left, and the painting of the connection between the upper and lower sections (between the personages of the Trinity with its worshipers and the skeleton beneath the altar table). These areas of loss are readily apparent even in photographs (Figs. 1, 3, 6–7, 10–11, 14–17, 19). But in criticizing Vasari's procedure again today we must at least acknowledge that he demonstrated a certain respect for the fresco in renouncing the possibility of centering his own altar on the aisle wall. Vasari displaced his altar so that he could contain within its dimensions the essential parts of Masaccio's painting, which is slightly to the left of the axis of its bay. Thus Vasari did not in fact ruin that "half-barrel vault drawn in perspective, and compartmentalized in coffers containing rosettes that diminish and foreshorten so well that this wall seems punctured," as he had written admiringly in his life of Masaccio.[17]

Unlike Vasari's, the nineteenth-century redecoration of the church was intended to observe the rules of symmetrical centrality. Consequently, not wishing to leave the nave wall deprived of an altar, the Dominicans decided to have Masaccio's fresco transferred.

The task was assigned to the restorer Gaetano Bianchi. Bianchi's methods are fully described in the two most important nineteenth-century restoration manuals, both published in 1866, one by Giovanni Secco-Suardo (in Milan) and the other by Ulisse Forni (in Florence). Both author-restorers were concerned with explaining painting techniques and finding appropriate methods of conservation. In regard to fresco technique, they refer in particular to Cennino Cennini's *Craftsman's Handbook.*[18] Despite the rules outlined in the manuals, however, when Secco-Suardo and Forni discuss the practices then used by the most accredited restorers for the transfer of fresco paintings, they left these procedures shrouded in mystery. Indeed, all restorers kept their most personal methods of working and problem solving more or less secret.

Although Gaetano Bianchi, "painter and restorer," was perhaps the most famous and admired of the emerging forces in restoration, Giovanni Rizzoli was also much esteemed in mid-nineteenth-century Florence. Rizzoli was known throughout Italy as a specialist in detaching frescoes, transferring them to canvas. In 1842, for example, Rizzoli had detached various frescoes in the Cathedral in Florence, among them *Sir John Hawkwood* by Paolo Uccello and *Niccolò da Tolentino* by Andrea Castagno.[19] In 1850, Rizzoli detached another work by Castagno, the fresco cycle of *Famous Men and Women* (*Uomini illustri*), then in the Villa Pandolfini, now in the Uffizi Gallery.[20] Despite these conspicuous achievements, however, Rizzoli was not awarded the commission to detach Masaccio's *Trinity*. The Florentines turned instead to Bianchi, who had convincingly demonstrated his abilities in 1857, having found a way to transfer and incorporate detached frescoes together with their *intonaco,* that is, in blocks (*a massello*), and not in thin strips containing the color layer and very little plaster (*a strappo*). Once detached, the frescoes were mounted onto framed stretchers, connected with crossed bolts, and soaked with gesso and glue; on these stretchers, the frescoes "are conserved more solidly than on canvases."[21]

According to nineteenth-century thinking, the system of detaching the fresco with its *intonaco* – which is still preferred in Florence as opposed to detaching only the pigment layer – better guaranteed the integrity of the work that would thereby remain "in its true state" without need of additions and thus with no artificial reinforcing of the colors. Moreover, it was believed that the protec-

tive canvasing of the painted surface could be achieved with weaker glue and with thinner canvas, which, once removed, was attached to a wood stretcher. When the protective canvas cover had dried, the restorer began the actual phase of the detaching per se, pulling the *intonaco* all around the edges. Using a wooden mallet lined with leather or with large canvas, he would strike the mural on the front and below, moving slowly upward. These "blows" did not damage the color layer, and the *intonaco* was detached bit by bit from the *arricciato*. If areas of greater resistance were encountered, they would be further detached with the use of steel spatulas or saws, entering the surface from the sides in order to meet those resistant zones and thus to separate them from the wall.

When it was completely detached, the fresco was laid out gradually on a flat surface or directly on the pavement. The detached fresco was smoothed out from the back and reduced to a thickness of less than half a centimeter, bathed repeatedly with milk that served to harden it. Always working from the back, the restorer plastered the fresco with sand, lime, and casein. Then the fresco was left to dry. The result was a strong, thin, and flat *intonaco*.[22]

The *Trinity* underwent just this type of procedure. After the transfer was completed, however, Bianchi had to intervene again on the painted surface with additional recleanings followed by a consistent pictorial restoration – and unfortunately also by a final varnishing. Cleaning could involve an entire series of varying procedures depending on the nature and consistency of the dirt. In general, the painted surface was washed with water and ammonia. But in order to remove the smoke of candles or of oil lamps, the restorer used instead boiled concoctions of root of soapwort, alcohol distillate (spirit) of soap or Greek wine (preferred to Italian wine for this purpose), *acqua maestra,* onion, urine, or cooked potatoes. The whole was then completely rewashed with distilled water, and the drying process furthered with soft, clean white cloths.

According to nineteenth-century taste, pictorial restoration was necessary to reorder colors and forms. In reality, so-called restoration was often accomplished with arbitrary reconstructions. After the washing and drying procedures came the final varnishing. Varnish could maintain the brightness of the colors and at the same time "nourish them," as one said. It could also help bind the colors to the wall surface.[23] Needless to say, the *Trinity* did not undergo

this operation unharmed, and indeed the painted surface continues to suffer today from the process, notwithstanding another restoration completed in 1950. At that time, the presence of a *beverone* of oily glue was recorded, a veritable brew on a base of organic substances fundamentally of proteinaceous type (egg yolk mixed with albumin, milk, or casein), which was found again on the walls of the Carmine. The nineteenth-century restorer Forni had recommended the application of such concoctions: "With a gentle brush one applies on the surfaces of the painted *intonaco* a coat of caseous tempera diluted with water; when this is dry, one applies above it a second coat of the same tempera, crossing with the first. In the course of a few days, this hardens and consolidates the colors . . . and can serve to hold the painting stable by itself when the *intonaco* does not require other provisions."[24]

Bianchi's transfer of the *Trinity* was considered necessary because the fresco in situ, in its bay now deprived of Vasari's altar, interrupted the rhythm of the entire nave wall. According to mid-nineteenth-century taste, the wall had to be harmonized with the cadence of the new Neo-Gothic altars. In the "restored" architectonic order, this wall remained bare – "nude," as it was then described – and so it "was thought to remove [Masaccio's fresco] from where it was, in order to be able to decorate that space."[25] The detached *Trinity* was placed on the entrance wall, a choice that had historical precedence in the Cathedral of Florence where the two fresco equestrian monuments by Uccello and Castagno (mentioned earlier) were likewise installed in the entrance wall following their detachment in 1842 by Rizzoli. (They have since been re-installed on the north wall.)

Masaccio's fresco thus came to be paired with the fourteenth-century fresco of the *Annunciation* by Pietro di Miniato discovered beneath the *intonaco* and restored by Bianchi himself in 1858, the same year as the detachment of the *Trinity*.[26] Cavalcaselle, who bore witness to the condition of the *Trinity* at the time of its rediscovery, deplored this operation in the *Storia della pittura:*

> But instead of wisely leaving it in situ, and not concealing it from the scholar's view once Vasari's panel had been moved, it was decided to do a complete restoration in colors, in order to detach the fresco and transfer it to another wall near the main portal of the church. It is in terrible condition, in which state it has been thus reduced, and everyone must deplore this transfer

who, like us, had occasion to see the fresco and study it in its original location during the renovations in the church. . . . And it is truly a grave damage to art that the alterations suffered and the repaintings superimposed have rendered this fresco dark, spotty in its colors, changed in its forms, and without anything of its original character. Moreover, the loss of pigment is threatened in various places.[27]

In addition to this severe evaluation of Bianchi's intervention, the analysis by Cavalcaselle and Crowe provides an interesting description – certainly completed before the restoration – of the manner in which Masaccio executed his fresco:

As usual Masaccio painted on an *intonaco* that was smooth and flat, on which surface it seems that he traced his design with a broad and suitable brush, sketching the entire composition rather rapidly with gray-green colors, and trying with large areas of color to follow as a sculptor would the movement and round-ness of the forms, signaling the sinuousity and the relief of the bones. And making use of the underlying light ground in the flesh and of the dark preparation in the shadows, he worked with warm, transparent hues to give greater body of color to those parts more exposed to light over which he then painted again with lighter tones. Shadows he reinvigorated with dark, warm colors, but always transparent, reinforcing the strongest shadows with more darks and passing over some contours. He warmed the cheeks and lips with colors that are more or less strong but always reddish, making much use of these in the half-tones of the underlying preparation, finally passing over every-thing here and there with brushstrokes of warm or cool, lighter or darker, tones, according to need.

The red of the garments, although of lively and brilliant tone, is worked over a clear preparation and treated in the same man-ner as the flesh areas. If then the hue was to be stronger and almost dark, he gave to these areas more substance of color, diminishing the lively dominance with veilings of neutral tints, as he did in the garments of Saint John and of the male donor. The azure mantle of God the Father is painted in tempera [*sic*] over a warm preparatory layer, and the cobalt of the garment of the donatrix is handled in the same way. The violet color with

warm shadows of the Virgin's mantel is sketched with a peacock blue tint and then worked with cool color in the half tones, with stronger tones in the shadows, and with a warm, clear color in the highlighted parts. The drawing seems very confident and the work was executed with much swiftness, so that it seems almost more a thought in the mind than the product of the hand. And considerable rapidity of execution one can very well understand when one thinks how he condensed all his attention and skill in the expression and movement of the figure. And in being completely preoccupied with this, one still agrees as on the example of Giotto he too must show himself heedless of the parts and of small details, which, if they are of use to the high finish of the work, add nothing in art, for that which concerns the exact representation of the subject, which has flashed in the mind of the artist who conceived it.[28]

Returning to Bianchi's procedure and observing the present condition of the fresco surface of the *Trinity*, we can believe that at the time of removal of the canvases glued on during the detaching process, the restorers must certainly have checked the *strappi* of color that are easily visible even today, especially in the abraded and weakened garments of the figures (Fig. 15). But the greatest damage, likewise still quite evident on the surface, must have occurred during the very moment of detaching the fresco. Although Bianchi had made provisions to leave a fairly thin *intonaco* – in keeping with practice and also so as not to make the detached mural too heavy – something unexpected must have happened, and the fresco must have slipped out of his control. Either falling to the ground, onto the scaffold, or onto the altar table, the fresco must have become folded over, because the surface area 50 to 60 centimeters from the base is so cracked and shattered that great chips of *intonaco* must have been lost. As for the rest, we can also deduce from the testimony of Cavalcaselle and Crowe that this procedure was poorly done.

The lower part of the fresco was not included in the process of transfer, that is, the part with the skeleton at the foot of the *Trinity*, that "very beautiful death," as Antonio Billi describes it in his *Libro* (Fig. 5).[29] In fact, no one spoke of the skeleton's rediscovery, not even Cavalcaselle and Crowe, who even so indicated that one also saw the adjacent fragmentary frescoes that appeared on the wall "when it [the *Trinity*] was placed on view."[30] And if we also con-

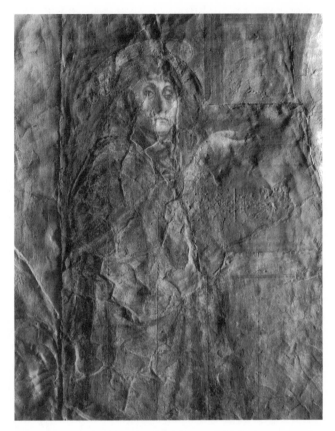

Figure 15. Masaccio. Detail of *Trinity* (Virgin Mary in rak-
ing light). (Photo: Courtesy Ornella Casazza)

sider that at the time of the discovery of Masaccio's fresco, Billi's
Libro was unknown to scholars,[31] the fact that no one mentioned
the skeleton leads us to think that the restorers did not proceed
immediately to dismantle the altar table when the *Trinity* reap-
peared within the aedicola of Vasari's altar. Having preserved the
altar table, they were able to use it as a working surface during the
preliminary procedures and first aid on the surface of the *Trinity*
before its transfer to the entrance wall of the church.

There it remained until 1954, when, reversing the nineteenth-
century operation, the *Trinity* was returned to the precise place
where Masaccio had originally painted it. This homecoming was

accomplished after Leonetto Tintori's restoration of Masaccio's
fresco in 1950, and after Ugo Procacci's rediscovery in 1951 of the
large fragment of the lower part of the fresco with the figure of the
skeleton reclining on its bier, which had been concealed under the
nineteenth-century altar table. By now, restoration could no longer
be postponed because of the ever more intense chromatic weaken-
ing that the fresco revealed and the partial loss of color that
appeared truly alarming. Regarding the procedure of intervention,
"suppositions" – as Tintori pointedly called them –

> were most disparate, sharing only alarm for the serious losses
> already incurred and the fear of something irreparable. The
> restoration was begun cautiously with small test areas in various
> parts of the fresco. By means of deeper observations during the
> testing it was possible to determine with certainty that the decay
> was due to extraneous material superimposed on the painting
> and that it did not derive from alterations of the *intonaco*. In
> [Bianchi's] transfer of the *Trinity*, the entire depth of the *intonaco*
> had been conserved and connected to a grate or lattice sup-
> ported by a wooden cradle. . . .
>
> [A]ccording to the taste of his time, [Bianchi] had greatly
> retouched the whole and varnished everything with an emul-
> sion of egg and oil to reconfer what he considered to be digni-
> fied old-age to the work.
>
> In some zones where the color was more fragile, in addition
> to the egg and oil *beverone* there was also glue, a residual of the
> provisional support used in the [nineteenth-century] transfer. In
> a site more protected from changes of humidity and temperature
> than that between the two portals of the church, this extraneous
> material probably would have limited its negative influence to
> the aesthetic aspect, without so seriously compromising the con-
> servation of the fresco.
>
> Having established the cause of the damage and the possibil-
> ity of intervening constructively, limiting the intervention to a
> revision of the surfaces, and avoiding later dilutions of the old
> mortar, it was possible to obtain authorization of the Soprinten-
> denza and the Consiglio Superiore to proceed [with the restora-
> tion]. . . .
>
> [T]he beginning was cautious and directed primarily toward
> determining the nature of the harmful materials and toward

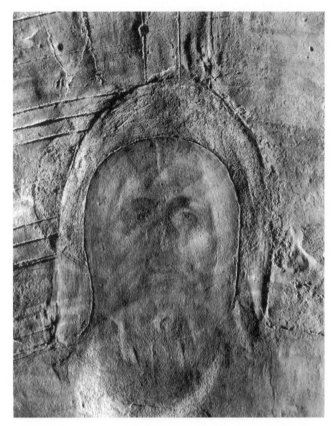

Figure 16. Masaccio. Detail of *Trinity* (head of God the Father and coffers of vault in raking light). (Photo: Courtesy Ornella Casazza)

determining the correct method to remove them. The oily emulsion, little affected by water, had to be softened with poultices or compresses applied for long periods, until the layer became re-swollen and gelatinous. To facilitate the softening, a solution was used composed of distilled water, pyridine,[32] and pepsin, and was held in contact with the surface with various layers of absorbent paper. Sometimes a half hour was sufficient, other times much longer periods were needed. But the paper could not be touched until it showed itself to be uniformly soft. At that point, it was removed with a blunt file and, at the points

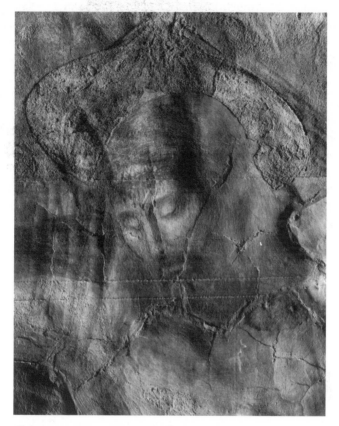

Figure 17. Masaccio. Detail of *Trinity* (head of Christ in raking light). (Photo: Courtesy Ornella Casazza)

weakened by preceding contractions, with slender sharpened sticks of wood.

The poultices could rarely be of dimensions greater than 5 × 10 centimeters, to prevent having part of the already softened emulsion become dry, thereby rendering later treatment even more difficult. The cleaning was completed by passing and re-passing moist cotton over the surface, as though to massage the fresco.

The original surface to be liberated was very large and required time and diligence. In compensation, the results answered the most optimistic hopes, and the slow progression of the work on every centimeter of the fresco made possible the

gathering of much information about the painter's technique. We were able to take photographs with raking light to document the *graffiti,* the lines incised on the wet *intonaco,* the reliefs of the *giornate,* indications of *spolvero,* so as to give an idea of Masaccio's procedure [Figs. 14–17].[33]

Drawing from a tracing executed directly on the fresco, it was possible to reconstruct a full-scale diagram or chart, which has since been destroyed.[34] A photographic reproduction of the diagram exists, however (Fig. 18). It indicates the *giornate* in green outlines, *graffiti* or direct incisions in red, line snapping in an earth tone, *spolvero* in black. The graph also indicates all the reworkings of areas that were not original or were in any case lost, thus eliminating them from the composition.

"In the interpretation of the chart," as Tintori explained,

a precise meaning can be given to every single projection on the surface, so as to see how the painter proceeded in his work. The *giornate* reveal the great certainty of the master who, with only the aid of a general project and of various studies of details, formulated his work without hesitation. *Spolvero,* identified with certainty only in some parts of the architecture, seems perhaps to have been used to entrust to an assistant the realization of such recurring motifs as the ovoli, dentils, and the Greek meander of the frieze.

The *graffiti* and the line snapping are signs of the relation between two pre-determined points marked on the fresh *intonaco* with the point of a nail. Given the assurance with which these points are transferred to the fresco, without many pentimenti, we must imagine a prior preparatory drawing to scale [a cartoon], not necessarily in one sheet, but as individual studies brought together on the wall in the general perspective.

The technique of outlining the Madonna's head is a considerable modification of the use of *graffito* [Fig. 19]. The head is inscribed in a perspective veil lightly traced on the *intonaco,* as though to transfer onto the wall an analogous figure of different dimensions.

More directly related to the problem of conservation were the data emerging in relation to the color. Masaccio, like all fresco painters of his time, believed it useful for the *giornata* or "day's work" to continue also the following day, and sometimes later, adding milk to the color that within a single *giornata* could

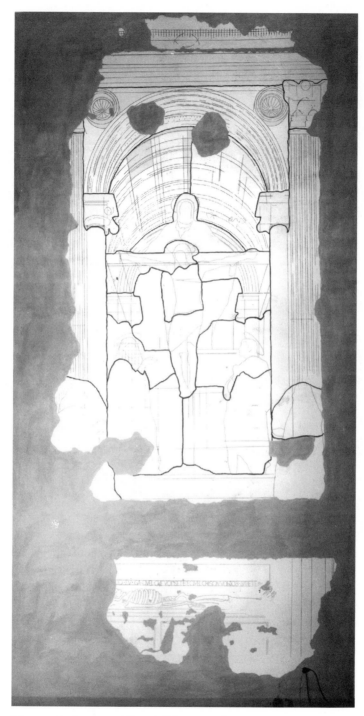

Figure 18. Leonetto Tintori. Diagram of Masaccio, *Trinity*. (Photo:
Courtesy Ornella Casazza)

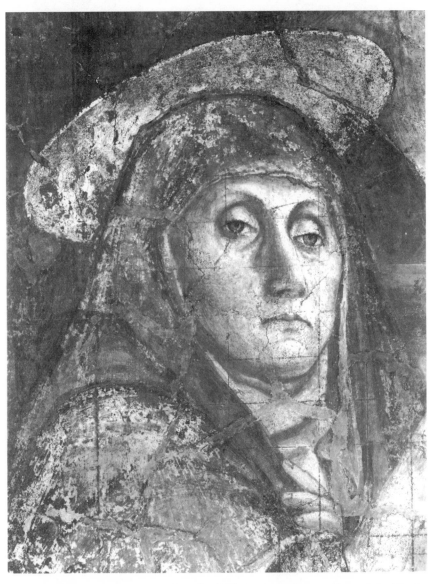

Figure 19. Masaccio. Detail of *Trinity* (squaring on face of the Virgin Mary). (Photo: Alinari/Art Resource, New York)

be used only with water. Because the *intonaco* would still be damp, the resistance and the effect turn out to be almost equal to those of the well carbonated fresco [fresco converted to carbonate]. Milk could be added to these late passages, or alternately light casein in a quantity in proportion to the lime [a component of the *intonaco*]. The difference that distinguishes this technique from *buon fresco* is produced by a greater covering of the color and by a light translucent enameling. This method of painting was rarely used in heads and hands, and almost never in the backgrounds; more often than not, it was employed in the garments and in corrections.

Masaccio did not renounce the technical accommodations that allowed longer *giornate* and greater mastery over chromatic harmonies. In various parts of the architecture and in the draperies of the *Trinity,* colors are frequently present, the nature of which is not that of *buon fresco* [painted on wet plaster], even though they are not yet the result of painting *a secco* [on dry plaster]. The garments of the donors and of Saint John can be counted among later elaborations [Figs. 7, 10–11]. There are traces of painting *a secco,* more precisely, azurite with glue, on the garments of God the Father and in the backgrounds of the coffers of the vault [Fig. 16].

The *beverone* has easily taken hold on this "mixed-media painting," "late additions painted half *a secco,*" or however one wishes to define it, with greater repercussions than in its contacts with the *buon fresco.*

With the removal of the oily glue *beverone,* the original color reassumed the clear and luminous tone of mural painting. But the most important thing was that the fresco was liberated from the unfortunate action of the incautious application of the *beverone.* The zones where the fallen, small, dry incrustations had left the painting abraded and clearer were lightly veiled with water color.[35]

Because of the difference that emerged between the original painting and the nineteenth-century additions, pictorial intervention was limited to minimizing the evidence of this repainting, without entirely removing indications of it. The favorable outcome of the work on the painted surface encouraged completion of the restoration with the fresco's return to its original site.

Fortunately, various fresco fragments of the *Trinity* were found in the process of dismantling the sixteenth-century stone altar. Among these fragments were the central part of the pediment that furnished precise data for the reinstallation, and the fictive altar front with the skeleton of Adam.[36] The fresco's height from the ground became 38 centimeters higher than when it had been placed on the entrance wall.

Among other difficulties in the course of this somewhat uneasy "homecoming," we found that a part of the nineteenth-century completion had been frescoed directly on the wall. It was therefore decided to detach these areas to free the stretcher fixture in a niche carved into the stone wall. An analogous tampering with the old stone wall, where Masaccio had laid the *intonaco* for his fresco, was necessitated by the wooden depth of the support. Accurate examination showed the stretcher to be in optimum condition, and thus it was possible to avoid the torment of additional handling. With the replacement of the painting on the wall, the monumental work rediscovered its point of view and its lighting.[37]

This is the gist of Tintori's report. It is a careful report, informed by his extensive technical knowledge. But it can and must be verified today in light of all the analyses that science now makes possible. Indeed, at almost fifty years' distance from Tintori's important intervention, it is imperative to study the *Trinity*'s present condition and maintenance in order to assure its proper conservation in the future. To verify its condition, the *Trinity* must be reexamined by means of analyses and diagnoses following the example of the extraordinary experience of working on the scaffolding in the Brancacci Chapel. (During his restoration, Tintori himself had already felt the need for reassurance by "scientific institutions.")

On the occasion of the nineteenth-century detaching and transfer to the entrance wall, the *Trinity* had undergone the classic "varnishing" to reenliven its colors, with a blend of egg, oil, and glue, according to the method described in detail in recipes of the time. To remove such a varnishing, which was causing great damage to the original underlying pigment, Tintori made use of an aggressive solvent such as pyridine, distilled water, and pepsin (dissolved in water). Pyridine is particularly dangerous for colors painted *a secco:* It destroys the proteinaceous binders and, if a trace of the substance

remains, it reacts with the salts in the masonry. Tintori's solvent admittedly diluted the *beverone* of organic substances, but this same solvent has certainly interacted with such inorganic substances as gesso and salts.[38]

Masaccio's frescoes in the Brancacci Chapel had also been completely covered with the same egg-based blend that had darkened and degraded with time, to the point of forming fungi and molds. But in this case, as we have explained, the egg mixture was removed after detailed analyses, documentation, and inspection. This procedure made possible removal of this substance from the Brancacci frescoes, without, however, removing the sense of time from the color that has preserved in large part its natural crystallization.

The church of Santa Maria Novella is situated near the railroad station of Florence, in an area of constant and considerable automobile traffic. Consequently, in the almost fifty years since Tintori's restoration of the *Trinity,* a thick layer of atmospheric particulate has been deposited on the fresco, which certainly must be removed from the surface. The degree of pollution present within the church interior of Santa Maria Novella should be immediately and accurately measured, as was done in the Brancacci Chapel, so that appropriate preventive measures may be taken to combat the indisputable danger for color of such external agents as ozone and bisodium of nitrogen.

Examination and study of substances that have been placed or deposited on the surface of the *Trinity* can give an exact measure of their potential danger to the fresco and thus guide the first phase of conservation. In addition to documenting individually each aspect of the painted surface, it will also be extremely important to examine the stratum of the underlying support with the most up-to-date scientific methods to evaluate the support's behavior in the half century since the fresco's return to its original location. Once the facts have been obtained from a complete programmatic analysis, it will then be the responsibility of the conservation commission to determine what is to be done to restore Masaccio's *Trinity.*

NOTES

1. Editor's note: See Procacci, 1984; Baldini, 1984; Baldini and Casazza, 1990; and Pandimiglio. In English, N.B. Joannides, pp. 313–49. For technical terms used in this chapter, see the Glossary, this volume.

2. In addition to Baldini and Casazza, 1990, see also Zorzi, who brings together the operative technical aspects that emerged during the long campaign, specifying means and materials necessary for conservation of the walls and the ambience. (Editor's note: For such noninvasive techniques of photogrammetry, thermography, echography, holography, and others, employed in the Brancacci Chapel to study the topography of the surface and of underlying structures, see Casazza and Giovannoni, pp. 14–16.)

3. Baldinucci, s.v. Rifiorire.

4. See Brandi; Casazza, 1981; and Baldini and Casazza, 1983, a catalogue published in connection with the exhibition of the *Crucifix* at the Metropolitan Museum of Art, New York. In the Brancacci Chapel, we used the system of chromatic selection that by now all conservators apply to avoid falsifying the image. (One would be constrained to falsification by the desire to annul the passage of time, which is not always positive and which changes and degrades the work of art.) In addition, we also preserved all those figural integrations completed in the restoration executed after the chapel had been damaged by fire in 1771. Although these eighteenth-century additions are not considered to be the fruit of the Renaissance artists' invention, they have been historically credited as being faithful to the pictorial text that had been complete before the fire. On the other hand, in areas rediscovered to be without formal delineation, we proceeded with the system of chromatic abstraction. Allowing for an optical association with the surrounding areas, this system has reduced the negativity of losses in the original tissue, in contrast to the neutrality of taste that always appears empirical and reveals defects but that in fact represents an intervention no less arbitrary than the completion of fantasy. See Brandi, pp. 46 ff.

5. See Casazza in Baldini and Casazza, 1990, pp. 17 ff., 348–63. Polzer, 1971, p. 19, gives a day-by-day account of Masaccio's painting the fresco, or more precisely a *giornata*-by-*giornata* account, noting that an artist might in fact complete more than one *giornata* in a twenty-four-hour period. He estimates a total of twenty-four *giornate*.

6. See Baldini in Baldini and Casazza, 1990, pp. 291–2.

7. In the *Tribute Money*, corresponding to the little walls and the steps leading to a landscape with a bridge at the extreme right of the scene; in the *Original Sin*, above, in the right angle corresponding to the branches of the tree; in *Saint Peter Healing with the Fall of His Shadow*, corresponding to the zones of the *bugnato* (stonework) of the palace on the left; in the *Healing of the Cripple*, below to the left, corresponding to the figure seated on the stool. No such evidence has been found in the details and episodes painted by Filippino Lippi, given the complete preservation of the surface *intonaco*.

always the splendid protector of artists, especially in times when fate tyrannized them), and under the direction of the architect Enrico Romoli," workers dismantled the Vasarian altars considered not to be consonant "with the architectonic order of the Temple," replacing them with new altars "in stone in a style analogous to the Gothic character of the church." See Lunardi, 1988, pp. 403, 419.

16. Cavalcaselle and Crowe, 2 (1883): 316–17. They added that "Masaccio had executed his painting on top of a preexisting work that represented the *Adoration of the Shepherds....* This part of the fresco had the characteristics of the preceding century," that is, the Trecento. The passages quoted here were not included in the English edition of the *Storia, A History of Painting in Italy,* published in London in 1864 and listing Crowe's name first.

17. Vasari–Milanesi 2: 291.

18. Cennino Cennini's book on painting was published for the first time, with annotations by Cavaliere Giuseppe Tambroni, in 1821 (Rome, Salviucci). Tambroni transcribed the *Codice Ottoboniano* of the Vatican Library which had been discovered by Angelo Mai. A new edition was published in Florence in 1859 by Gaetano and Carlo Milanesi, with numerous corrections and with the addition of chapters drawn from two Florentine codices, the *Laurenziano* and the *Riccardiano,* considered to be older and more correct editions than the Vatican codex. In 1913 and again in 1943, the text of the codices was read again, emended, and republished by Renzo Simi. In 1971, an Italian edition with commentary by Franco Brunello and a preface by Licisco Magagnato was published in Vicenza; and another in 1975 edited by Fernando Tempesti (Milan). Among the English translations, we note the following: P.A. Merrifield (London, 1844), based on the Italian text edited by Tramboni in 1821; C. Herringham (London, 1899); and especially the edition by D.V. Thompson (most familiar to readers in the United States). N.B. also the recent critical edition in French by Déroche with very rich commentary, notes, and bibliography.

19. Editor's note: On these frescoes, see Marita Horster, *Andrea del Castagno* (Ithaca, N.Y., 1980), and John Pope-Hennessy, *Paolo Uccello, Complete Edition,* 2d ed. (London, 1969), p. 141.

20. Editor's note: See Josephine Marie Dunn, "Andrea del Castagno's 'Famous Men and Women,'" Ph.D. dissertation, University of Pennsylvania, 1990.

21. Forni, p. 23.

22. Bernardi, pp. 14 ff.

23. One recalls Bianchi's "pictorial restoration" in 1841 and 1851 of the frescoes by Giotto rediscovered in the Peruzzi and Bardi chapels in the church of Santa Croce in Florence, the result of which was stigmatized by Cavalcaselle and Crowe, 1 (1875): 520.

24. Forni, p. 38. Regarding the presence of this substance in the Brancacci Chapel, see Perrini and Pizzigoni, pp. 123 ff.

8. This technique is seen only in the foliate dec
 splays of the fourteenth-century window and
 the blue garment of the standing figure in the
 there only in parts, painted by Masolino. The d
 however, has been lost, perhaps because it was p
 a secco. See Baldini and Casazza, 1990, pp. 293, 29

9. This happened when the pictorial surface bec
 wall in minute particles (in Italian slang, *spolv*
 dust"). But other methods also existed, as F
 restorer Botti. Charged with consolidating Ben
 in the Camposanto of Pisa, Botti referred, in a let
 having used an encaustic of wax melted with
 then with a moving, perhaps vibrating, brush, h
 the encaustic so that the wax amalgamated and c
 See Forni, p. 38. (Editor's note: For the "disruptive
 the various kinds of salts that harm wall painti
 140–2. Matteini, p. 141, defines sulfation as the crys

10. This *beverone* consisted of a base of organic substan
 proteinaceous type (egg yolk, mixed with albumin
 uct). Its characteristics have been identified by phys
 by the Syremont Company of Milan, under the di
 rini; see Parrini and Pizzigoni, pp. 123–9. An accura
 surfaces under Wood lamp revealed that a subst
 brushed on to all the frescoes had contributed to
 colors. An analysis by Fourier's infrared spectropho
 shown that the substance was mixed with sulphates,
 and that these substances were applied in comparativ

11. On the question of the leaves and their removal
 Casazza in Baldini and Casazza, 1990, pp. 19, 29, 307.

12. Editor's note: Matteini, p. 138, observes that the co
 paintings differs from conservation of panel or canv
 fundamental regards: "their constituent materials hav
 porosity, and they are essentially open physical system
 perforce bound to their environment.

13. Vasari-Milanesi 7: 709–10.

14. "Record of how at the end of this year [1569] the
 Rosary was completed, which is to be placed in the
 Maria Novella"; see Vasari's *ricordi,* no. 348, in Hall, p. 1
 cal record of the occasion is provided by Lunardi, who
 evant information from the *Cronaca manoscritta di M. B*
 the Archives of Santa Maria Novella; see Lunardi, 1988 a

15. In 1861, "under the direction of the pharmacist of the I
 vent of Santa Maria Novella, the worthy Fra' Damiano

25. G. Garinei, "Descrizione della chiesa di S. Maria Novella," MS dated 1905 in the Archives of Santa Maria Novella, cited by Lunardi, 1990, pp. 251 ff.

26. Giannini, p. 93.

27. Cavalcaselle and Crowe, 2 (1883): 316–17. [Editor's note: precise passages are not included in the English edition, *A History of Painting in Italy,* but cf. vol. 1, p. 543.] Accusations of a bad intervention are found also in Garinei's testimony. He speaks of the real disgrace purpetrated on Masaccio's fresco, which suffered the same fate as other works ruined by Bianchi, such as the frescoes of the Cortile of the Palazzo Vecchio and those of the facade of the Loggia del Bigallo. For Garinei, see Lunardi, 1990.

28. Cavalcaselle and Crowe, 2 (1883): 317–18 [Editor's note: not in the English translation, but cf. p. 545*n*2]. The author was mistaken about Masaccio's use of tempera in the *Trinity,* which is painted entirely in fresco.

29. Billi, ed. Frey, p. 16.

30. Cavalcaselle and Crowe, 2 (1883): 316. [Editor's note: W. Kemp, p. 53, publishes a photograph of the wall illustrating the fragmentary frescoes and the skeleton – likewise fragmentary – after the removal of Vasari's altar.]

31. It was discovered and made public for the first time in 1891 by Fabriczy, p. 29. See also the edition by Frey.

32 Pyridine (C_5H_5N), an odorific, colorless liquid that resembles benzene in structure, is produced during the distillation of coal. I thank Professor Theodore E. Madey of the Department of Physics at Rutgers University for this information. (Editor's note.)

33. Tintori, pp. 261–2.

34. The graph was placed on the right wall of what was then the back room of the Uffizi Gallery ticket booth, which was later destroyed in the recovery of the still existing spaces of the old church of San Pier Scheraggio (the structure of which is incorporated into the gallery).

35. Editor's note: These areas of repaint are visible in the lower parts of the donor's garment, for example (Figs. 1, 10).

36. To Leonetto Tintori we also owe, notwithstanding its poor condition, the detaching in 1964 of the rediscovered fragment with the skeleton, its transfer to a new stretcher, and its replacement on the wall.

37. Tintori, 1990, pp. 262–3.

38. Editor's note: The preferable modern procedure for removal of such proteinaceous coatings is described by Matteini, pp. 143–5. For pyridine, see n. 32 this chapter.

THE PERPSECTIVE CONSTRUCTION OF MASACCIO'S *TRINITY* FRESCO AND MEDIEVAL ASTRONOMICAL GRAPHICS

To James S. Ackerman

Quite beyond the solemn reality brought to bear on the central mystery of the Christian faith, Masaccio's *Trinity* fresco has played a pivotal role in the history of art as both a definitive example of early Renaissance linear perspective and as a kind of prophetic forerunner of the perspective method discussed nearly a decade later by Leon Battista Alberti.[1] Whereas Alberti's *Della pittura* of 1435–36 may be the first written document to articulate a new Humanist ideal of painting in which visual appearances are controlled by geometric principles embedded in nature, Masaccio's fresco of the *Trinity* is the first extant painting fully informed by that ideal.[2] The magnificent vault arching over the austere figures in Masaccio's fresco of the mid-1420s is an utterly convincing illusion of architectural form extending into space, and for centuries it has been justly celebrated on that account (Fig. 1). Yet it is not a historical exemplar devoid of uncertainties. It has been difficult, for instance, to determine exactly where the figures of the Virgin and Saint John stand with respect to the projected ground plane, and

Parts of this chapter were previously published in *Artibus et Historiae,* no. 31, vol. 16 (1995): 171–87. That article is a revised version of a paper presented at the annual meeting of the College Art Association, Boston, 1987. I wish to thank Lilian Armstrong, Peter Fergusson, Miranda Marvin, and Loren Partridge for their helpful suggestions. I am also immensely grateful for the guidance and support of James S. Ackerman.

ascertaining the position of God the Father's feet has proved a particularly mystifying problem. So far as the perspective construction itself is concerned, there is little agreement among scholars about either the vertical position of the projected centric point on the wall or the distance of the viewer from the painting.[3]

These are important issues for art historians to resolve, and much time has been spent in considering them within the context of the Renaissance awakening. Yet having succumbed to the fascinating pursuit of Albertian consistencies, are we really any closer to understanding the method and conceptual framework of Masaccio's perspective scheme except in the limiting terms proposed by Alberti? Was Masaccio simply unable to master the difficult *di sotto in sù* projection that would have successfully foreshortened the awe-inspiring figures in the foreground of his fresco? Is it because the fresco has been moved several times that we are unable to decode Masaccio's perspective projection?[4] Or is the stringently rational context of Alberti's *Della pittura* really appropriate for understanding a painting created in Florence during the 1420s, when one might still expect to find a fluid dialogue between reason and faith in an image of the *Corpus Domini* executed for the conservative Dominican church of Santa Maria Novella?

Certainly Joseph Polzer's detailed photographs of the points and lines embedded in the fresh plaster provide strong evidence that the illusionistic impact of the vault depended on many different artistic techniques.[5] It needs now to be said that this diversity of techniques includes orthographic, conical, and stereographic methods made familiar to late medieval painters through instructive working drawings of architects and instrument makers as much as through practical geometry texts that had governed the artist's early education.[6] If the very complexity of the *Trinity* fresco vault projection has long encouraged art historians to conjecture Filippo Brunelleschi's involvement in its planning, the diversity of the projection techniques discovered there would seem all the more to confirm the architect's participation in this complex project.[7] Perhaps more importantly, as Polzer has shown, that diversity of means is compellingly unified both pictorially and theoretically at the level of mathematics and measurement. The imaginative sweep of Masaccio's accomplishment is not to be found solely in the precise ordering of lines and planes, however, for he (or more likely Brunelleschi)

discarded earlier and more tentative experiments in favor of a ratio-
nally consistent method of structuring his own arching sepulchral
vault that drew on and mirrored the mathematically defined coordi-
nates of the vault of the heavens.

The one preexisting graphic tradition of great authority for pro-
jecting these mathematically regulated and symbolically charged
spatial coordinates was the tradition of medieval astronomical dia-
grams. This tradition was not only useful in practical detail, but it
was also intrinsically suggestive to early perspectivists and probably
determinative with respect to the special viewing circumstances pre-
sented by the *Trinity*. Not only did this graphic tradition take into
account the position of the viewer looking intently upward; its most
familiar projections were ordered according to the exemplary sym-
metries of a divinely created cosmos. The orthographic and stereo-
graphic projections of medieval astronomers and the common
ground they shared with mathematical diagrams provided a readily
available source to Masaccio and Brunelleschi of a full range of nec-
essary diagramming techniques at the same time that they affirmed
the mathematical order believed to control all of nature. To draw on
such a tradition was not only an act of great practical consequence
for painters; it was an affirmation of great conceptual force.

Masaccio planned the entire structure of the *Trinity* fresco in a
most deliberate and mathematical way. As Polzer has shown, Masaccio
controlled the composition through the rational forces of measure-
ment and geometry by initially dividing the principal pictorial field
into three squares averaging approximately 211 cm wide and 207 cm
high, the skewing from perfect squares being accounted for by the
moving of the fresco or by the difficulty of maintaining constant pres-
sure on ropes when snapping lines or describing arcs over a consider-
able distance (Fig. 20).[8] The bottom two squares are made to come
out right within the rectangular field of the composition by overlap-
ping them from the base of the ledge on which the donors kneel to
the edge of the painted chapel floor. Finally, the top square is inscribed
with the illusionistically receding semicircular ribs of the barrel vault.

What distinguished Masaccio's squares and circles from those
commonly used by medieval predecessors and set painting on a
new path was his insistence that the surface divisions be linked to
the projection establishing the apparent recession of a barrel vault
(Fig. 21).[9] As Polzer has pointed out, the bond between surface

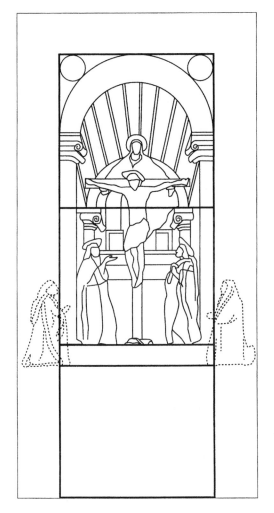

Figure 20. Diagram of *Trinity* surface geometry according to Joseph Polzer, redrawn by C. Gorman, Photographic Services, VPI&SU, Blacksburg, Virginia (Photo: Courtesy Jane Andrews Aiken)

geometry and the illusion of recession was accomplished by having the baseline of the top square delimit the springing of the barrel vault in the distance and by further subdivision of the top square at its midline, marking the springing of the barrel vault in the extreme foreground.[10] From a further study of the vault, it becomes clear that Masaccio, despite the perceived regularity of the apparent recession, deliberately adjusted the standard (that is, Albertian) components of a Renaissance perspective construction

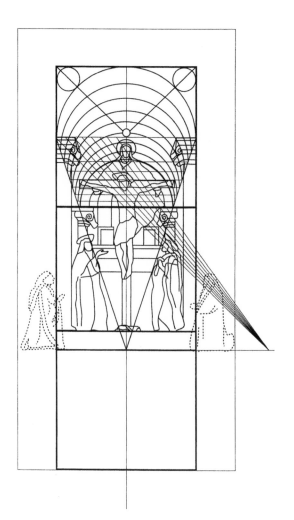

Figure 21. Perspective Projection of *Trinity* according to Joseph Polzer, redrawn by C. Gorman. (Photo: Courtesy Jane Andrews Aiken)

to achieve maximum visual appeal as well as to assert the power of the surface grid.[11] The eye level and the horizon line, for instance, coincide with the base of the middle square, and the "viewer's eye" (or centric point of the projection) is located at the base of the central axis of the composition. Moreover, Masaccio insisted on the formal control of the basic square module by calculating a "viewing distance" equal to the length of the side of a square. Thus the

"viewer" in Masaccio's perspective scheme was fully integrated into the overall surface geometry of the composition, and the hypothetical person stationed in front of the painting with one eye closed was, in fact, reduced to a potent mathematical entity.

Whereas Polzer has shown that the precise confluence of circle, square, and projection of the vault in depth restricts the perspective projection to the basic square module, I hope to show that the artist's surface geometry was joined in both a practical and symbolically provocative way to a rigorous, mathematical interpretation of how points, lines, and planes behave in the ideal worlds of Euclidean geometry and medieval mathematical astronomy.

Masaccio's combination of squares, double squares, circles, and semicircles frankly invokes the traditional values ascribed to these presumably perfect forms in medieval as well as Renaissance aesthetics and theology. As Rona Goffen has argued, "it seems likely that Masaccio's architecture is intended as a mathematical expression of God's perfection and harmony, worthy of the 'real tabernacle' of the Lord."[12] Perhaps more appropriate for the growing secular tastes of the Renaissance, this overlapping combination of squares and circles also alludes to the almost irresistible Vitruvian symbol of a man contained in the circle and the square and thus to the assumed affinity between microcosm and macrocosm.[13] The rhetorical intent of Masaccio's geometry is further suggested by the location of the incised centric point, denoting the height of the "viewer," at 172 cm above the church floor. This is almost three *braccia,* a measure that carries with it the same connotations of the ideal as the circles and squares of the surface geometry.[14] The height Alberti recommends for his "well-proportioned man" in both *De pictura* and *De statua* to express the "perfect beauty distributed by Nature" is also three *braccia.*[15]

The "average" height Alberti speaks of and Masaccio apparently uses in the perspective scheme of the *Trinity* should be regarded as denoting the typical in the quantitative sense and also, and more emphatically, the ideal and essentially true in the qualitative sense.[16] That Masaccio distinguished between the viewer standing in front of the fresco and the truly average man is suggested by the height of the recumbent skeleton beneath the vaulted space, which is 160 cm.[17] Redemption is potentially his; however, he cannot stand for the perfect man, and his height is one indication of that lesser status.[18]

Alberti would maintain that three *braccia* was the height of the average viewer, giving it a seemingly practical sanction, and this fits neatly into the Vitruvian scheme of ideal human proportions. In addition, it is a commonly known symbolic height in late medieval guidebooks to Jerusalem, where three *braccia* is proclaimed to be the height of the perfect man, Christ.[19] Despite the fact that the location of the centric point coincides with a reasonable viewing height, its placement confirms Masaccio's attention to nonphysical and nonvisual considerations associated with the time-honored symbolic power of numbers as well as the purity of mathematical relations and analogues. That one should find such doubly potent symbols of perfection in an image of the Trinity in Santa Maria Novella is in keeping with the central role played by the *Corpus Domini* in the sacerdotal life of this Dominican church.[20] If Masaccio's fresco was adventurous, even radical, in its aggressive imitation of a powerful, physically present nature, the intellectual context of his grid and projection systems, as well as the newly rationalized aesthetic on which they depended, remained firmly linked to a traditional and highly suggestive religious interpretation of natural order in which mathematics functions as a bridge between concrete, sensible reality and universal or divine truth.[21]

Quite beyond shape and measure conveying meaning in an obvious and frankly didactic way, the points, lines, and planes that make sense to many as surface geometry would have been understood by medieval mathematicians within the broader context of a mathematical graphics tradition intent on explaining another kind of absolute perfection: the continually changing relations among the coordinate systems of a vast and earth-centered universe as those systems were projected onto a plane surface. These projections were a part of an unbroken tradition of mathematical diagramming techniques dating back at least to the fourth century B.C.E. The many different diagrams bound by this tradition were found in widely circulated copies of ancient texts by Euclid, Archimedes, and Ptolemy, medieval commentaries by Messahalla, Jordanus de Nemore, and Campanus of Novara, as well as in the practical geometrical tracts that formed the foundation of an artist's education in the Florentine *abbaco* schools.[22] The precision with which some of the still visible construction lines were scratched into the wet surface of the *Trinity* offers some proof that Masaccio

Figure 22. Astrolabe. Washington, D.C., Smithsonian Institute. (Photo: © Smithsonian Institute, Washington, D.C.)

– or more likely Brunelleschi – was not only familiar with this graphic tradition but even painstakingly followed its rules. As a trained goldsmith and someone interested in clock making, Brunelleschi would have known how to execute all the basic projections found on the astrolabe, the most popular astronomical siting device of the late Middle Ages (Fig. 22).[23] Brunelleschi's interest in surveying would also have taught him some of the down-to-earth uses of the astrolabe. Finally, the creative architect would have known the architectural rendering practices of his day.[24]

Not merely the result of convenience, the compositional grid of the *Trinity* is the product of a highly conflated application of different lines of mathematical reasoning to a spatial problem whose main features derive directly from the astronomical conventions of the day. First of all, Masaccio's apparent use of a centric point to designate the projection of a ray (in this case, the principal line of sight) onto the plane of projection, together with the right angle relation of ray to plane, were not only defined by Alberti in 1435 but were typical aspects of medieval astronomical projections.[25] Also, certain lines, generally regarded as mere surface marks by art

historians, would have been interpreted by mathematicians and anyone familiar with the astrolabe as projections of planes perpendicular to the plane of representation.

There should be little mystery surrounding Masaccio's use of these lines, called trace lines by present-day mathematicians, for they appear commonly in ancient and medieval diagrams of cones and pyramids. In astronomical projections, trace lines indicate critical celestial relations, the most important for the artist being the projection of the horizon plane as a trace line.[26] Accordingly, in Masaccio's fresco the baseline of the middle square forms not only a segment of the surface grid but also a trace line designating the horizon plane rotated 90° with respect to the fresco surface.[27] In addition, when working out the proportionate diminution of the spaces between the ribs of the barrel vault, Masaccio can be shown to have regarded the central vertical axis of the plane of representation as a trace line of the plane of projection (or picture plane) rotated 90° relative to the physical surface of the fresco.[28] Finally, to think of the plane of projection as coincident with, but separate from, the plane of representation is another familiar and fundamental characteristic of ancient and medieval mathematical graphics.[29]

Aside from depending on geometrically obvious relations (such as right angles) and ancient graphic protocols (like trace lines) to effect his projection in depth, Masaccio developed the rate at which the ribs of the barrel vault appear to diminish according to standards and practices familiar to his contemporaries from the stereographic projections found on the astrolabe. These more elaborate projections are also dependent on the simple graphic formulations just described.[30] Although in 1435 Alberti claimed to have "invented" a newly rigorous method of perspective projection, in the 1420s Masaccio had already developed a mathematically consistent way to project apparent diminution and, like Alberti, had arrived at an understanding of the function of the so-called distance or lateral vanishing point construction from the diagrammatic techniques of mathematical astronomy.[31]

The several interrelated projection systems of the astrolabe and the literature describing both the theory and construction of this astronomer's siting instrument could be of special interest to the art historian for many reasons, the most verbally suggestive of which is that texts on astrolabic projection assigned to the projection point

"the capacity to see," and characterized it as an "observing point," thus implying a consonance between abstraction and actual viewing that would have appealed to the artist interested in quantifiable realities.[32] Equally interesting for the art historian, two of the projections on the surface of the astrolabe appear to be foreshortened illusions of three-dimensionally extended spatial coordinates. Although they are not actually foreshortened, all the astrolabic projection systems together produce a visually cohesive, triumphantly coherent, and formally consistent analysis of geometrically controlled spatial relations.[33]

Masaccio could not have been alone in his admiration of this *geometricum instrumentum,* generally acknowledged by medieval astronomers to be the mirror of a geometrically perfect universe, because the astrolabe became the habitual attribute of Painting as symbolically personified by other Florentine artists seeking to represent rational order.[34] Long before such Renaissance representations, however, the astrolabe had become a symbol of the divinely ordered universe, as the seraphic beings holding astrolabes and encircling the archivolts of the Royal Portal of Chartres attest.[35]

More technically, and beyond the felicities of symbol and metaphor, the projection of the semicircular ribs of the *Trinity* barrel vault is directly analogous to the astrolabist's method of projecting almucantars (circles of celestial latitude) ranging above the observed horizon. In both cases, circular and equally spaced coordinate divisions of a spherical surface are projected onto a plane surface, and in each case a precisely located observer is involved. Finally (and most characteristic of stereographic projection), in both fresco and astrolabe, the construction determines the relative position of projected centers and radii of the circular divisions along a line ultimately falling on the central axis of the plane of representation.[36]

Anyone who attempts to analyze what for Masaccio were the measured certainties of the *Trinity* is quickly brought to an appreciation of the difficulty of the task by being confronted with disagreement among scholars as to the actual measurements and their meaning. Because the recently executed measurements taken by Field, Lunardi, and Settle do not confirm all of Polzer's dimensions, it has seemed prudent to rework the latter's proposed construction method using the numbers of Field and her colleagues. The resulting diagram (Fig. 23), showing distances between the vault ribs and

the distance of the eye to the central axis or intersection (D1 to D3), was generated by computer. Although absolute agreement is not obtained between the hand-generated and computer-generated measurements, the coincidence between them is compelling. Where, for instance, Field, Lunardi, and Settle found a measure of 42.55 cm, the computer established a distance of 44.85 cm (A1 to vii in Fig. 23). Where the measurements by hand established a distance of 19.05 cm, the computer determined the distance to be 19.49 cm (vii–vi in Fig. 23).[37] The measurements are strongly suggestive of the probability that Masaccio and Brunelleschi constructed the apparent diminution of the vault ribs using a relatively simple projection technique dependent on the surface grid and directly derived from the astrolabe.[38]

The relation between Masaccio's projection of the arched ribs of the *Trinity* and the astrolabe is clarified when the projection techniques found on the popular instrument are followed step by step.[39] I have presented in separate steps what medieval treatises on the construction of the astrolabe commonly showed in a single drawing, where all the steps were integrated as in Masaccio's construction, with the central vertical axis representing simultaneously the plane of projection perpendicular to the plane of representation and additionally a vertical division of the surface composition. Diagrams like that in a fourteenth-century copy of Messahalla's treatise on the astrolabe were a clear demonstration of the principles involved in developing information about curved spatial coordinates in a single drawing or representational field and could easily be used by painters and architects (Fig. 24). This simultaneous presentation of projected planes rotated 90° with respect to the plane of representation was, however, pointedly rejected by Alberti, who drew the lateral section in a "separate space." By this separation Alberti freed the projection from the constraints of the circle and the square, something the astrolabist could not do and Masaccio was apparently unwilling to do.[40]

Although the perspective projection of the *Trinity* "was easily constructed within the surface geometry," as Polzer has maintained, that geometry derived from the live tradition of astronomical graphics, where the viewer and the viewed had long been subject to the "right reason" of geometrical analysis so admired by Alberti and where the integration of the visual and the geometrical had been effected in a

Figure 23. Computer analysis of the projection of the *Trinity* vault ribs, using Joseph Polzer's method of projection and the measurements of J.V. Field, R. Lunardi, and T. B. Settle; computed and drawn by T. Slater. (Photo: Courtesy Jane Andrews Aiken)

Figure 24. Messahalla's projecton of almucantars. Cambridge University Library, MS I, i.III.32, fol. 67v. (Photo: Reproduced by permission of the Syndics of Cambridge University Library)

way directly useful to the early perspectivists and in keeping with their understanding of the highest and most inclusive truth.

In the projection of the interior architectural space of the *Trinity,* Masaccio sought instruction from the many projection techniques enjoying particular popularity among late medieval astronomers because they recorded celestial phenomena with mathematical certainty. These refined and illusionistically suggestive constructions presented space according to a series of set coordinates specifically useful to the perspectivist and directly applicable to the *Trinity* fresco. In the astrolabe, planar coordinates were organized around a single point and, as in linear perspective, that point was associated with the act of seeing. In addition, many of the analytic conventions and construction techniques presented in medieval manuals on the astrolabe were critically important to the formulation of linear perspective. These include the definition of the projection surface as a plane, the distinction between the plane of projection and the plane of representation, the rotation of coordinate planes with respect to the plane of representation, and the systematic transfer of projected coordinates from one plane to another. Moreover,

through a knowledge of astrolabic construction techniques, Masaccio and Brunelleschi could easily understand how the surface geometry of medieval paintings might be joined to a more strictly mathematical definition of how points, lines, and planes function. This new articulation of the artist's basic formal means became explicit in Alberti's later treatise and is fundamental to the success of linear perspective.

All of us can be awed by the solemn humanity of Masaccio's images. Although few are likely to be stirred by the minute perfections and careful consistencies of the perspective method he used to make this humanity possible, perhaps we can see how this early Renaissance artist applied to humankind and earthbound works the mathematical truths of a purposeful nature as he believed they existed and as they were presented to him by the ceaseless revolutions of the heavens.

NOTES

1. Studies devoted exclusively to the perspective projection of the *Trinity* fresco include, in order of publication: Kern, Schlegel, Coolidge, Janson, Polzer, 1971, and most recently the essay by Field, Lunardi, and Settle. Among other discussions of the *Trinity* are those of Mesnil and Hertlein. See also Kim H. Veltman's impressively complete bibliography on perspective and its sources (forthcoming). For Alberti's treatise *On Painting* of 1435–36, in which he formulates the rules and method of artist's perspective as deriving from the principles of Euclidean optics, see the Grayson ed.; and for Alberti and the abacus, see Field.

2. On the assumption that the San Giovenale triptych (dated 1422 by inscription) was executed by Masaccio, this work would be the earliest extant painting to display a "geometrically" correct perspective construction in that there is one centric point to which all orthogonals converge and a mathematically controlled diminution of the spaces between the horizontal lines (transversals) on the floor. Was Masaccio already savvy about the most radical and theoretically complicated ideas concerning vision, space, and pictorial illusion investigated before 1422 by Brunelleschi and Donatello? See Gioseffi, p. 141 and pl. 120, and Berti. The recent cleaning of the Brancacci Chapel frescoes has shown that Masaccio used two different methods for projecting the building and steps on the right in the *Tribute Money,* thus creating a loosely constructed space in keeping with the narrative intent of the whole. The presence of two vanishing points gives clear evidence of Masaccio's willingness to experiment with projection techniques; see Christiansen.

3. The spatial peculiarities and inconsistencies of scale are summarized by Janson. It is generally agreed that the centric point (also called a central vanishing point) is placed at the eye level of the average viewer. An area about 2 cm across with its center at 172 cm has recently been established by the careful measurements of Field, Lunardi, and Settle, p. 37.

4. See Polzer, 1971, p. 18, regarding the "many buckles and repairs, surely scars of the many moves and injustices the fresco has suffered." [Editor's note: For the fresco's travels and travails, see also the Introduction, pp. 12–16, and Casazza, pp. 71–4 this volume.]

5. Polzer, 1971, p. 21 and passim.

6. For a discussion of this un-Albertian mix of stereographic, orthographic, and planimetric projection techniques found in the fresco, see Aiken, 1986, especially chs. 4 and 5. See also Johannsen and Marcussen; Kemp, 1984.

7. Many of the questions surrounding Brunelleschi's panels have been carefully considered by Kemp, 1978.

8. The width of the composition ranges from 210.5 to 211.8 cm, according to Polzer, 1971, pp. 47–8. This measurement has been recently confirmed by Field, Lunardi, and Settle, p. 52. They determined the diameter of the arched molding, which can be taken as the diameter of the vault, to be 211.55 cm or 3.625 Florentine *braccia*. However, Field, Lunardi, and Settle, p. 52*n*39, also found that the distance between the outer edge of the columns was 205.1 cm or 3.514 *braccia;* this finding would seem to strengthen Janson's idea, pp. 83–4, that Masaccio had built up his composition in seven surface units of one-half *braccia*. That Masaccio would have scaled his composition in standard Florentine measurements is not only reasonable, it is also consistent with contemporary artistic practice as shown by Zervas, 1976. Although the Florentine artist's general interest in meticulous measurements and instruments of measure does not become explicit until Alberti's writings of the 1430s and 1440s, this interest is well established by the beginning of the century. See Edgerton, 1980.

9. To the Gothic artist, the measuring and proportioning of a painting was a practical necessity for creating a level and square compositional field. See Cennini, ed. Thompson, ch. 67. In ch. 30, Cennini is particularly concerned with establishing a module that will tie together figure, building, and space. Other uses of measure and geometry relating to structural stability and symbolic efficacy are discussed in Frankl, White, and Zervas, 1975.

10. Polzer, 1971, pp. 47–8.

11. Alberti presents his perspective projection in *De pictura* 1.19–20; ed. Grayson, pp. 54–7.

12. Goffen, 1980, pp. 498–9, and p. 53 this volume. For the fullest account of the possible secular associations of Masaccio's profoundly religious work, see also Hertlein, especially pp. 177–84, 193–5, 205–7. See also Simson.

13. Vitruvius's formulaic image of the perfectly proportioned man (*De archi-*

tectura iii.1.3) remained popular during the entire fifteenth century. Examples include Leonardo da Vinci's drawing (R343) in Venice, Gallerie dell' Accademia, and a sketch by the Sienese engineer Mariano Taccola from the early 1430s. See Prager and Scaglia, pp. 42, 167–9, and fig. 7. Numerous medieval images link the cosmic man to Christ and to the Christian cosmos. This connection was a subject of much interest to medieval mystics like Hildegard of Bingen; see Torp, pp. 134–47, figs. 39–43. See this volume, p. 92, for the possible significance for Masaccio. For the common associations existing among art, mathematics, and religion, see also Wittkower, 1965, especially pp. 24–7, and Edgerton, 1975, pp. 16–21.

14. For the measurements, see Field, Lunardi, and Settle, p. 37. Masaccio's probable use of local standard measurements is consistent with Florentine workshop practice of the 1420s.

15. Alberti, *De Pictura,* bk. 1, ch. 19, and *De Statua,* ch. 11, ed. Grayson, pp. 55, 135.

16. See Wittkower, 1960; Michele, pp. 181–9.

17. As determined by Janson, p. 85.

18. See Dempsey. Field, Lunardi, and Settle, pp. 57–8, found the painted height of God the Father to be 155 cm and, because of his distance from the picture plane, assumed his "true" height to be three *braccia.* This consonance of measurements would seem to be simply another aspect of the *Trinity,* which, as Goffen has asserted, 1980, pp. 497–8, shows Masaccio equating the principal viewer of the fresco with the priest who celebrates the Eucharist, this priest being God the Father who presents the Son as Eucharist. Kemp, 1990, pl. 24, would seem to agree with the possibility of a consonance existing between the three *braccia* measure and the figure of Christ.

19. See Zervas, 1975, n. 24, for the religious significance of the three *braccia* measure, derived from the "legal Palestinian *braccio*," the measurement used "to calculate the length of the body of Christ." Certainly Alberti was aware of this tradition. In addition, four columns formerly in the *aula del Concilio* of the Lateran in Rome were believed in Masaccio's time to establish the height of Christ at approximately 1.78 m. Surely the Dominican friars of Masaccio's time would have been aware of this traditional measurement. In any event, the centric point of the *Trinity* is much too high to represent the height of the average Florentine. That "Christ is both sacrifice and priest," as Goffen has said, 1980, p. 504, is confirmed here in the typically Renaissance dependence on measure and quantity.

20. For the Dominicans and *Corpus Domini,* see Borsook, pp. 49, 58, and Trexler, pp. 9–11.

21. The prologue to Campanus of Novara's *Theorica planetarum,* one of the most popular astronomical texts of the fifteenth century, explains how geometry met the demands of both theology and nature. See Benjamin and Toomer, pp. 136–9.

22. For the possible influence of Ptolemy's *Geographia* on early perspective experiments, see Edgerton, 1975, pp. 91–123. On the impact of Messahalla's treatise on constructing the astrolabe, see Thomson, pp. 53–4. Aiken, 1986, chs. 1 and 2, evaluates ancient mathematical diagramming conventions. For the relevant history of mathematics, see Neugebauer, Knorr, Murdoch, and Eastwood. In relation to art history, see Edgerton, 1975, and Johannsen and Marcussen for a review of some earlier studies. Kemp, 1990, considers the probable influence of medieval surveying techniques on Brunelleschi's perspective experiments. Kuhn thoughtfully evaluates Brunelleschi's practical, theoretical, and conceptual environment. See Arrighi, 1966 and 1980, and especially Zervas, 1975, on an artist's education. Most pertinently, in my view, Veltman, 1980, pp. 403–7, has lectured on the points of correspondence existing between Alberti's perspective construction and Ptolemy's method of projection. See also Veltman's review of Edgerton's *Renaissance Rediscovery.*

23. See Prager.

24. A construction technique known well to Brunelleschi may seem arcane to the uninitiated. See Saalman, p. 16. I submit that the same is true of astrolabic projections. For Brunelleschi's understanding of technically advanced diagramming protocols, see also Arrighi and Sanpaolesi.

25. See Thomson, pp. 28–9, on projection techniques of astronomers from before Ptolemy and on into the fifteenth and sixteenth centuries. Any person who picked up an astrolabe would understand that a point signified a line of sight. Alberti, for instance, is simply stating a generally accepted practice of medieval astronomers and their instrument makers in *De Pictura,* bk. 1, ch. 19, when he says of the centric point: "it occupies the place where the centric ray strikes" (ed. Grayson, p. 55).

26. For the function of trace line projection in the ancient diagrams of sterea (three-dimensional bodies), see Neugebauer, pp. 860–1. All medieval diagrams of celestial phenomena use trace lines in the same way as their ancient forebears.

27. The principle that the arc of a curved plane (the plane of the observed horizon) appears as a straight line when in the same plane as the eye (and thus perpendicular to the plane of representation, according to the specific conditions of artist's perspective) was established by Proposition 22 of Euclid's *Optics.* This principle must have been a commonplace of the fifteenth century.

28. Although the rotation of planes in Masaccio's fresco is not unlike Brunelleschi's method of projection in his experimental panels, perhaps dated as early as 1413, as characterized by Krautheimer and Krautheimer-Hess, vol. 1, pp. 237–40, the principle and method of rotating the plane of projection 90° with respect to the plane of representation was so firmly

established in contemporary astronomical graphics that they were not even discussed by late medieval astronomers. See Thomson, pp. 58–60.

29. Although artists would have been schooled in the understanding of the function of the plane of projection through less elevated means, an unequivocal presentation of these essential assumptions of ancient diagrammatic techniques is found in the writings of Archimedes; see Heath, pp. 222–6. Archimedes's writings on conics were especially important to the thirteenth- and fourteenth-century scholars who studied optics.

30. For geometry and astronomy as "the context of perspective," see Veltman, p. 407; also Johannsen and Marcussen, pp. 217–23; ten Doesschate, pp. 143–54 and n. 17; and Field, Lunardi, and Settle, p. 115. On the widespread use of the astrolabe, see H. L. L. Busard, "The *Practica Geometriae* of Domenicus of Clavasio," *Archive for the History of Exact Science* 11 (1965), p. 522; also Hartner; North, p. 96; and by Geoffrey Chaucer, the "Miller's Tale" in the *Canterbury Tales* and his little manual on the astrolabe, *Bread and Milk for Children.* Many late medieval academics tinkered with astronomical instruments; see L. White, 1978. For the interrelation of late medieval astronomical instruments, applied science, and artist's perspective, see Aiken, 1994.

31. For Alberti's perspective construction and how it depends on, differs from, and refines that of the *Trinity* fresco, see Aiken, 1986, ch. 3.

32. For the highly suggestive language of medieval astronomical texts, see ten Doesschate, pp. 143–54, and Thomson, pp. 146–50.

33. North, p. 100, describes the principal plate of the astrolabe and its projections. An example of Brunelleschi's connection to astronomical images (though it is an ex post facto example) is the painted zodiac in the dome over the altar of the architect's Old Sacristy in the church of San Lorenzo in Florence. See Murdoch, p. 249, and Beck, 1989.

34. Ettlinger, pp. 258–61.

35. Mâle, figs. 27–28. L. White, 1978, was particularly concerned with the astronomical clock, which usually included an astrolabe among its dials and became a prime attribute of Temperance during the fourteenth and fifteenth centuries. At this time Temperance was newly associated with *Sapientia* (Wisdom) and the *Logos* (the Word). White's point is that instruments of measure were perceived as operating at a high moral level.

36. See Neugebauer, p. 219, on stereographic projection.

37. See Field, Lunardi, and Settle, p. 96, Table 2. For the coincidence between their measurements and those in Fig. 23 this volume, see Aiken, 1995, n. 38.

38. See Aiken, 1995, n. 38.

39. See Aiken, 1995, pp. 179–80.

40. Alberti, *De pictura*, bk. 1, ch. 20, ed. Grayson, p. 57.

TIME AND THE TIMELESS IN QUATTROCENTO PAINTING

P ainting contains time in several ways.

First, through the process by which a painting impinges on us, or rather recreates itself within us. Our awareness of a work of art evolves in time. In order to coincide utterly with the act of vision the mind needs time – as it encounters obstacles, interprets, rejects, then repudiates or transcends its rejection; a certain lapse of time is necessary if the painter's essential proposition is to be resurrected in us as a way of being to which we eventually give our assent. As Plotinus says of a higher object in his treatise *On Intelligible Beauty,* our self-awareness must be surrendered if we are truly to possess the object we wish to see; yet it must also be maintained so that our vision itself can reach fruition. Accordingly, in our apprentice-ship to the work we go back and forth between separation and union, passivity and attentiveness, or waking and dreaming, until we achieve that improbable total experience that would be the fruit of a synthesis of the nocturnal path of dreams and the lucidity of waking life. A study should be made of this period of time in which we draw nearer to the work, and also of the depth it explores – a depth of reading where one goes from sign to sign, from this patch of blue to the idea of a coat, from the coat to the discovery that it signifies the Madonna, then on to a particular

Translated by Michael Sheringham. This chapter is excerpted from the essay with the same title, published in *Calligram: Essays in New Art History from France,* ed. Norman Bryson (Cambridge University Press, 1988), pp. 8–26.

nuance in her smile or a particular formal feature, and from these to some kind of absolute. But my concern is not this semantic space, the temporality of signs, so to speak. I should like to attend to another time, retained within the image itself as an aspect of what it says. Consider this *Virgin,* of the Byzantine school, the Madonna in mosaic from the apse at Murano. Am I not right in saying that nothing, or scarcely anything, in this exalted figure bears the countenance of time, and by this word I now refer to that real factor of our existence that can sometimes be the object of our attention, and to which a painter as much as a philosopher may pay heed? More precisely, we cannot imagine a past or a future for this gesture, this moment. That is why we cannot fit them into any duration and why we decide that they are timeless. In the face of such figures, we ourselves, by the same token, elude for a while the many blandishments of the daily time that makes up and undermines our existence. The act of reading the work, a desire time has ripened, an act that has taken time and structured our time, has led us *outside time.* And we take satisfaction in this. It seems logical to us that the materiality of such objects – mosaics or altarpieces – and their more or less perennial nature, should be reaffirmed by a more fundamental immobility, and that the place of images, as well as being outside all space, should dwell outside time.

It is by no means true, however, that every image is an *icon.* Consider another, later, Madonna, painted in Tuscany in the thirteenth century. There can be no doubt that the painter, like the maker of the mosaic at Murano, sought to conquer the time that marks our ordinary life. But here, against a background that remains timeless we can see the beginnings of looks and gestures, and in the Child who is moving and starting to laugh we can perceive localized yet unmistakable signs of living time. Should we nonetheless recognize that painters invariably desire the timeless, if not always consciously or consistently? But think of Paolo Uccello's *The Profanation of the Host:* Its whole essence is temporal. Not because it dramatizes an action, and the moment, of a grave crisis. It could have done that in the detached manner, serene in the face of horror, that characterizes so many archaic *Martyrs.* If the *Profanation* "is" time, it is because this painting expresses, in the trembling of fingers or in frozen looks, anxious concern at an imminent future and its tragic outcome, and because it conveys in its very essence that network of

projects and anxieties that our individual time consists of. This is a painter who has *loved* time. And he has found ways of giving it expression through the means of painting itself.

Painting is capable of suggesting time in a more intimate way through its most celebrated but also most equivocal feature, often rather hastily called *depth*.

It has been claimed that depth was invented, little by little, to render space: This is not the right way to pose the problem. In fact, the plane in painting is no more than the manifestation, and hence the locus, of Form, of what is essence and timelessness. Even if it accommodates a movement or an action – as in Romanesque art, at Saint-Savin for example, where myth is figured with such vehemence – the movement will be essentialized, archetypal: a sacred act that dispels profane time. What the indication of depth can contribute, therefore, is the dimension of matter, the obscurity of the tangible world. It replaces proof by doubt, and substitutes the existential dimension of time for the divine. Yes, the work of art renders time only by conferring depth on movement, by a dense layer of hesitations, ambiguities, contradictions: That is the difference between the figures at Saint-Savin, just mentioned, and Tintoretto's *Discovery of the Body of Saint Mark*. Conversely, the figure "in space" is no nearer the object than the one-dimensional figure. It is simply the figure of *something else;* the figure, in a word, of existence and not of God.

The question of space arises because fifteenth-century Italian art found, in perspective, a way of formulating with admirable clarity several metaphysical views of time.

The ground was well prepared. Ancient works of art had, over a considerable period, been retrieved from the earth and from ruins, revealing, all the more vividly in their mutilated state, a new conception of time. At Siena, for example, around 1340, a statue "of Lysippus" is discovered and greatly admired – until it is destroyed for superstitious reasons during a period of unrest. Yet barely fifty years earlier Duccio had painted the Rucellai *Madonna*. What are the two mentalities that come into conflict? On the one hand, that Greek sense of duration that endures in the tranquility of these resurrected figures as if it were their very soul. A time that seems, as Henry Corbin puts it, "the natural, mechanical time of movement in space, of biology, and of physics." There is nothing existential about it

since, as Corbin emphasizes, the individual tends, in this case, to
coincide with the most generalized notion one can have of human-
ity: his soul being conceived in terms of Ideas, pure forms. Accord-
ingly, the finest statues of the Hellenic period seem steeped in the
flow of nature, the eyes half-open, half-closed like those of animals,
the mind free of all aims, worries, or concerns for the future, free to
participate in an unbroken inner communion with the eternal.
Which of us is not fascinated by this physical time in which the
pulse of the timeless seems perceptible in human gestures, like sap
universally present in each plant? Death seems dissolved in nature,
and the human image, which is elsewhere scattered or incomplete,
seems mysteriously *whole*. This is indeed the secret need of great
anthropomorphic art. If the true nature of the human being is to be
encompassed in an image of physical presence, and find complete
expression within the limits of this form, and in spatial terms, it is a
precondition that our inner sense of the human should be experi-
enced as an essence; it must be free from that inner abyss, that sense
of division and fracture that accompanies the aberrant and troubled
temporality – aspiring to transcend its limits but incapable of reach-
ing outside itself, to which the early centuries of Christianity made
a decisive contribution.

For there were already, it is true, manifold signs in Greek art that
it was only a dream, that it lacked total conviction. As illustration I
shall cite only its growing melancholy, which closely resembles that
of epitaphs. "O Charidas, how is it down below? – Dark night. –
And do the shades return? – That is a lie. – And Pluto? – A fable. –
We are lost!" Such is the complexion of Callimachus's thought. On
all sides, in mystery religions as well as in the Jewish tradition, were
signs of a new spirit, increasingly torn by contradictions. It is the
spirit Plotinus expresses when he violently condemns the idea, so
deeply rooted in the ancient world, that beauty is συμμετρία har-
mony, a two-way correspondence between the parts and the whole.
Harmony, says Plotinus, implies parts, which means divisions.
Whereas it is the One, participation in the One, which constitutes
beauty. So that art is summoned to take as its object – its object – a
transcendent reality. If it devotes itself to imitating things, to the por-
trait for instance, it will be lost. It follows that art must turn away
from the material, or rather – since it is not true that "Plotinian" art
is immaterial, on the contrary it is more hospitable than any other

to the absolute in simple form, and to the radiance of stone – away from all figurative constraints in order to grasp, through the fundamental sympathy that unites the image and its model, that reflection of the Intellect, the Νδυς that is the only true reality. André Grabar has demonstrated the close links between the ideas of Plotinus and early Christian art. He shows how, in late antiquity, certain techniques served to draw the absolute into the work: the denial of space, reversed or radiating perspectives, simplified modeling, the subordination of natural forms to regular geometric schema: All these were logically implied by the ideas of Plotinus. But the Middle Ages in their entirety, the whole of Italy until the time of Cimabue, drew on this art and its sense of the timeless. What it did – and this is what is essential – was confront, face to face, eternity and time. These two, which had once been extensions of one another, like nature and the realm of Ideas, are now opposed, though they may be reunited in the ecstasy of God or of mystery cults. In the Mystery, time involves error, hope, distress: This is existential time – at last accorded its own distinct nature, even if its value remains unrecognized. In the face of those lofty figures in the apse, its only wish is to be dispersed. Seeing will lead to healing.

Of course, this sense of time originated in a conception of death. It resembles a *vanity,* a *memento mori,* those medieval forms in which the concern for transcendence and salvation distorted techniques the Greeks had slowly evolved: The canon of Polyclitus is given a mystical significance, number takes on symbolic value, geometry becomes trance rather than thought, the principle of symmetry is boiled down to its starkest form, at Ravenna for example where two peacocks are set on either side of a chrisma: immortality within death.

What this resembles, it must be said, is the birth of a new kind of joy.

At the origin of the Quattrocento, then, two conceptions of time, and two fundamental modes of creation, stand opposed. But this great moment would not have been what it was had it not been for a third element which, by around 1400, had grown to become a powerful, and critical, factor. The new element is the importance conferred on a sort of time previously maligned: It lies in a revaluation of finitude.

This ought to be traced historically through the thirteenth and

fourteenth centuries, when an increasingly lively interest in the constituents of profane time nevertheless did little to alter its discredited status. Art was learning to represent human vicissitudes once again.

The phrase "impossible synthesis" has usefully been coined to describe the vain efforts of the scholastics to think of man simultaneously in terms of the singular and the universal. The same applies to Gothic art, where human gestures always remain virtual, belied by the impractical synthesis of sacred archetypes.

In the work of Dante, too, in the circles of Hell, human time is imprisoned or disabled, reduced to projecting itself endlessly, like Tantalus, into actions it sketches but never accomplishes.

The same is true of Giotto. He is said to be the painter who discovered the tangible world, but I do not really concur with this view. There is no horizon in his work, merely a decorative setting. What he [Giotto] truly rediscovers are human gestures and human time. Always what exists only in time, only by virtue of time. And time is always the sole horizon. Of course this does not mean that Giotto confers supreme value on profane time. He simply draws, with admirable logic, the inference that follows from the thought that Jesus made himself incarnate *in time:* the implication that, if God took on this aspect, within a temporality of finitude and death (and even of error and sinfulness), it was in order to conquer death and nevertheless also conquer time. But to say that it takes a God to abolish it is inevitably to enhance time, even if the point is to assert that time is one of God's mysteries. Giotto gave the vanquished party a decisive force. Henceforth time is *visible* and the problem now is whether to consent to it.

Two parties will emerge. On the one hand those who will try to save – who will save – the conception of an unmediated timelessness. Are these the best Christians? Not always, as I shall show; if one accepts that the timeless, in the forms in which it was perpetuated, gradually changed its meaning, becoming once more the *Idea,* the intelligible kingdom of the spirit. Christianity has a Greek, a Pelagian, pole. It involves forgetting rather than healing what is believed to be the wound. But there were other painters who would, for better or worse, choose to love time. They appealed to subjective experience, to the passions, they looked to antiquity for "pagan" ways and fables. Should we think of them as "secular" spir-

its? Perhaps ultimately they were – after much anguish, in the reaffirmation of their initial choice, out of resolution rather than inclination. But first they sought, more rigorously and more honestly than the scholastics, to irradiate moral time with the lightning-flash of divine freedom.

However, for these two parties, or vocations, to become conscious of one another, it was essential for time to become central to the most specific concerns of painting, and this through something as equivocal, ambiguous, and vulnerable as time itself. Perspective was to be the agent of this transformation.

Misled by the notion that the main concern of perspective was to depict space, people have I think failed to emphasize its principal characteristic, which I would call *conceptual*. Prior to perspective – which is a hypothetical way of reducing the object to its position in space – the way of representing things was metaphorical and mythical. I mean that the painter would evoke the object through some aspect of its appearance, freely chosen for its analogical character, the resemblance it bore to the essence he attributed to the object. A rapid sketch of a bird's profile seemed a legitimate way of naming it, just as the Egyptian hieroglyph was assumed to have done. The stone-mason's scroll-work rendered, through analogy, far more than the external appearance of the vine: It conveyed its inner movement, its temporal *élan,* in short, its "soul." And the colors themselves, which derived a spiritual and symbolic aura from the gold background, signified not the accidental, fleeting aspect which is no more than a phantom, but the specific virtue of the thing, the invisible core that even in day to day life, is the only reality. Is this not, after all, the way we see? We do not see the qualities of a thing, but its totality, its look. We latch on to aspects of its appearance that we like or dislike, and then, like the painters of old, we make our own fable of its reality in the space of our minds. But perspective denies this. The effect of bringing precision to the category of space – or perhaps, simply, the concern to *think* space, separating out spatial perception from our global intuition of reality – is to foster an equally futile precision in all aspects of external appearance. In a word, the analysis of sensory qualities replaces the intuition of a fundamental unity. The relation of the image to the model it imitates is reduced to that between a definition, or concept, and a thing. An art of the manifest gives way to conceptual

speculation, certainty gives way to hypothesis forever in search of ultimate confirmation. This is perspective's dilemma, and suddenly that of art itself: Able to render the multiple aspects of a thing, it is, in a sense, the harbinger of the real; but it also immediately loses track of reality.

And this applies just as much to that dimension of the real that is time. I said a moment ago that it was above all through "depth" that painting gave expression to time. Does this mean that perspective made it easier to study? In a sense, yes. It gave actions a broader horizon, rendered simultaneity, manifested the complexity of the causes and constituents of events in time, showing their context and their consequences, effortlessly transforming allusion into historical representation. Perspective, as has often been remarked, leads inevitably to history. But once again, being eludes it. While the simple tremor of a line, or a blurred profile, can grasp the essence of living time, exact perspective, which, in presenting the reciprocal relation of one thing to another, always relates to just one specific state, offering a cross section, at one precise moment, of the visible, can retain only *vestiges* of the moment, petrifying human gestures so that they become, with regard to the lived instant, what the concept is in relation to being.

Great art has to do with being. Should we conclude that the fifteenth-century perspectivists failed to create great art? The truth is that, if it deprived these painters of a true encounter with *what is,* perspective offered two possible remedies. After all, we know why the Quattrocento cherished, and in such noble fashion, this technique: The checkerboard of perspective, with its calculated scaling-down of the figure, offers not only precision, but also, potentially, harmony. The numerical relationships it establishes can articulate the underlying "Number," believed to be inherent in the universe. And so, "knowing" that the world was rational, and musical, and that they themselves were the microcosm in which the world's order was mirrored, many painters cherished in perspective a new-found key to the rationality of space, and a means of restoring man to his place in the universal harmony. A painting that uses perspective is conceived for a spectator around whom everything falls into place. It places him at the center of all representations and meanings. It enables him, if not to banish God – the Quattrocento was Christian – to locate God within himself and all around him, as his

own glorious possibility, scarcely tainted by sin. No epoch was ever more joyfully optimistic than the mid-fifteenth century, when the rediscovery of antiquity gave man his form once again, while at the same time Christ guaranteed his salvation.

It is clear, then, that perspective was at the heart of a vast intellectual and moral project. And this by virtue of the fact that, simply by becoming an exploration of Number, it too is capable of metaphorical and mythical expression. Through Number and harmony; through what the Renaissance, following Greco-Latin antiquity, called *symmetry* – the quest for latent Number, the unequivocal reciprocity of part and whole – through a coherent web of metaphor that constituted the entire visible world as a network of proportions assumed to be real and divine, perspective could lift the curse of representation, capable of mere exactitude, and become a myth expressing analogically, in other words directly, totally, the very soul of *what is*.

But there remains nonetheless an essential difference between the failing I noted initially and this possible remedy, between perspective as measure and perspective as Number, between its Aristotelian nature, so to speak, and its Pythagorean ambitions. The former is inherent in perspective as an instrument; the latter requires conviction, will, and choice.

It takes a fundamentally metaphysical decision to make Number shed its purely external quality, to go beyond appearance, to escape from the mirage of mere aspects. And something else besides: It requires spiritual resolution to maintain it. There will be lapses, errors, moments of disgust and disavowal. Between the two poles of the new art there will be hesitation and disquiet – and this is precisely where the other possible remedy I mentioned becomes apparent – the possibility of a subjective art. There is no doubt that it was Brunelleschi's quasi-subjective mechanical invention that introduced subjective thought into painting. Because, in place of the received methods that enabled earlier generations of painters to produce images, it provides a universal instrument whose inherent purpose is undisclosed: Each painter will grapple with it in his own fashion, betraying his most intimate nature by the way he uses it and, as a result, being *is* to be found in these paintings, if we look for it in the artist's manner. A sense of being that does stem from real existence; anxious, troubled, pre-Copernican beneath the

Humanist self-confidence: Here Leonardo will lose his way, Mannerism will find delectation, El Greco will derive new strength. One can see why, as the dialectic of styles takes on a spiritual character of the purest kind, painters will henceforth be sharply opposed, and their work mutually illuminating. Some will find in Number a simple reflection of their wisdom. Others, reluctant to relinquish their own passionate relation to time, will cling to the enigma of the instant. Is this not the conflict between glory and life that Giotto had already sought to resolve? But, before looking more closely, let us note that it will not be lasting. It made sense only in the fifteenth century, before the Copernican revolution, when man could believe that he was at the center of the structure of the cosmos. Soon this confidence will vanish; time will stand, as it were, naked. This is why perspective was to tend, inevitably, towards mere illusion, and also why, once its ambiguous lesson had been given, it would come to be abandoned by the painter.

I can evoke only in broad outline here how Quattrocento painting evolved.

A first generation furnished two men who, without dedicating themselves to a truly coherent use of perspective, witnessed the emergence of the two paths I mentioned. One fervently embraced the scope it offered for glory, the other its darker dimension. They were Masaccio and Paolo Uccello. In Masaccio there is sufficient perspective to lower the horizon, to dispense with the décors of the Giotto tradition, and to create a space favorable to human actions. Moreover, the perspective remains too vague to function conceptually and lead actions into the trap of the instant. Masaccio was thus free to dedicate himself to the true face of temporality. And yet no sooner does he become aware of human actions than he draws them towards the timeless. Not that his figures are inactive. But in their actions they affirm the absolute coincidence of act and intent, past and future. The image they present of themselves resembles a sphere, and this, coupled with the poise inherited from an older hieratic art, but with the retention of the factor of mass, so to speak, serves to confer on lived time, now granted responsibilities, heroism and seriousness, the timelessness of law and of an established conception of grandeur. Masaccio formulates the essential thesis of heroic Humanism. Through him, all those intimations of solemnity that Florence provides, whether in the statuary at

Orsanmichele or in the architecture of Brunelleschi, begin to crystallize in the more intelligent, more speculative realm of painting. It was clearly Brunelleschi's buildings, with their clear, coherent structure, their unity, their sense of the major metaphorical role of a central plane, that inspired Masaccio's seriousness. And throughout the early Renaissance, architecture, which in the course of the Middle Ages by its incarnation of form in stone, of the intelligible in the sensible, had kept alive in Italy a latent sense of the dignity of earthly life, was something the painter understood. But can we say that Masaccio was faithful to this spirit? If he restates it he spares himself the effort it cost. Architecture has to be achieved by overcoming the inertia of stone. The reaffirmation of the timeless must follow an encounter with the resistance of time. Masaccio was not wholehearted enough a perspectivist to be well and truly caught in the conflict between the spatial and the temporal. His is an art of directions, peremptory and allusive; it puts forward timelessness as a program, an ideal . . . it offers no proofs.

MASACCIO'S SKELETON: ART AND ANATOMY IN EARLY RENAISSANCE FLORENCE

In the Museum of the Baths of Diocletian in Rome, a first-century mosaic shows a cadaverous figure reclining above the Greek phrase, "Know thyself" (Fig. 25).[1] This figure differs markedly from the skeleton in the bottom segment of Masaccio's *Trinity;* decaying rather than fully decomposed, its viscera vaguely visible beneath its ribs and its head raised to confront the viewer, it has a gruesome vitality that is lacking in Masaccio's inert and fleshless carcass (Fig. 5). Yet the message of Masaccio's image is very much the same. The Italian inscription over his life-size skeleton, in what passed in the 1420s for Romanizing capitals, is a medieval gloss on the mosaic's philosophical motto: "I was once what you are, and what I am, you also shall be."[2] This reminder of human mortality lay at the center of what it meant to know oneself in early fifteenth-century Christian spirituality, in which a pervasive emphasis on the transitory nature of human rank, fortune, beauty, and pleasure had been reinforced by repeated visitations of plague.

Art historians have investigated these moral and religious meanings of Masaccio's skeleton since it was rediscovered by Ugo Procacci in 1951, after being hidden by an altar for almost four hundred years.[3] On the most literal level, the skeleton belongs to Adam and refers to the tradition according to which the Crucifixion took place on the site of Adam's tomb; the blood of the crucified Jesus in the upper portion of the fresco seeps down toward Adam, who will ultimately be saved when baptized by Christ's blood. Metaphorically, the skeleton is Everyman; Masaccio's

Figure 25. Anonymous Roman. *Death (Know Thyself)*. Mosaic. Rome, Baths of Diocletian. First century. (Photo: Alinari/Art Resource, New York)

inscription reinforces this point, alluding to the story of the Three Living and Three Dead, in which three kings or nobles encounter one or more decaying corpses that remind them of the fleeting nature of earthly life and the inevitability of death.[4] The image is thus simultaneously a memento mori and a promise of bodily resurrection and salvation for those who take its message to heart.[5]

But self-knowledge has an additional dimension, focused not on the eventual fate of the soul and body after death but on the earthly body's physical structure and operation. In this area, the meanings of Masaccio's skeleton are still unresolved. Scholars have portrayed it as an icon of contemporary natural knowledge, an emblem of recent advances in Italian medical learning, rooted in the experience-based practice of human dissection, as well as of the expanding anatomical interests of early Renaissance artists. The art historian Charles de Tolnay praised it as the "first known scientifically exact representation of a human skeleton, a half-century before the anatomical drawings of Leonardo."[6] Historians of science have echoed this general view: Alistair Crombie has described

the "rational experimental scientist" and the "rational artist" – by which he meant the artist who, like Masaccio, had mastered the geometrical system of perspective – as "exemplary products of the same intellectual culture."[7]

As Bernard Schultz has already pointed out, Tolnay greatly exaggerated Masaccio's anatomical knowledge. Masaccio's skeleton contains gross errors – no sternum, missing ribs, mistakes of length and proportion – that show he cannot have based his representation on the study of a whole skeleton. In Schultz's words, the image shows Masaccio's commitment to "illusory naturalism," based on the perspective system, rather than "anatomical realism."[8] James Ackerman has reinforced Schultz's general distinction: The rules of perspective, so carefully applied in the *Trinity* fresco, "did not and were not intended to increase verisimilitude in representation. The standard perspective construction was an abstract technique that produced an initially uninhabited spatial box viewed strictly on axis. It was not hospitable to the irregularities of the actual world; few Renaissance pictures were done from nature."[9]

Schultz and Ackerman are certainly correct in this matter: Masaccio's image bespeaks only a limited familiarity with actual skeletons. The natural knowledge it displays is more mathematical than anatomical, though Masaccio's painting was certainly more accurate than any previous image of a skeleton in European art, including illustrations in anatomical textbooks (Figs. 26, 27). Yet the fact that contemporary anatomical illustrations were less rather than more literally accurate than Masaccio's image, despite the currency of human dissection in Italian anatomical study, suggests that it may be necessary to rethink the entire nature of anatomical knowledge in this period, for both artists and medical writers: of how one learned, what it meant to know, and the role of images in both learning and knowing.

In her study of the art of memory in medieval culture, Mary C. Carruthers has described that culture as "fundamentally memorial," organized around ideas and techniques focused on remembering, where modern Western culture is "documentary," organized around techniques of accurate description.[10] Building on the recent work of Jole Agrimi and Chiara Crisciani, I would amplify this contrast, characterizing medieval and early Renaissance culture as not only memorial but doctrinal – from the Latin *doctrina* (teaching) – based on remembering what one has been taught and teaching what one

has committed to memory, rather than on inquiring in order to describe what one does not yet know.[11] Documentary culture was an invention of the later Renaissance, the work of artists like Leonardo, as well as Humanist historians, collectors, and naturalists, committed to meticulously inventorying and depicting the physical world.[12] But Masaccio lived in an earlier era, and his work, like that of contemporary anatomists and medical writers, cannot be understood through the anachronistic lens of the documentary ideal. It corresponds rather to an earlier model of knowledge, including medical and anatomical knowledge, in which images were equally important but had a different meaning and functioned in a different way. Masaccio's skeleton – a memento mori as well as a funerary memorial – provides a window through which to explore this use of images and with it the relations between artistic and anatomical practice in fourteenth- and fifteenth-century Italy.

Human dissection was not a novelty in Masaccio's time, nor is there evidence that it was treated as illegal anywhere in Italy.[13] Despite the pervasive historical myth associating the appearance of the practice with secularization and the Humanist revival of ancient medical learning (or with the rise of a violent and coercive political culture), human dissection was neither a Renaissance invention nor the revival of a well-established ancient Greek practice.[14] A medieval innovation, it first emerged as an enduring technique for understanding the human body in late thirteenth-century and early fourteenth-century Italy, where private individuals and municipal and ecclesiastical authorities began to conduct autopsies of people who had died under unusual or unexplained circumstances: a victim of a mysterious epidemic in Cremona in 1286; two suspected murder victims in Bologna in the first decade of the thirteenth century; a Paduan apothecary who had accidentally drunk a bottle of mercury; a woman who had died in the odor of sanctity in 1308.[15] Simultaneously, lecturers on medicine started opening human bodies as part of a far-reaching reform in medical learning associated with the universities of Padua and Bologna and modeled on the work of the Hellenistic medical author Galen (who had in fact dissected only animals).[16]

Well into the fifteenth century, autopsy and dissection were largely confined to Italy. In 1299, Pope Boniface VIII issued his bull *Detestande feritatis,* which prohibited a funerary practice current

primarily in northern Europe, in which corpses were dismembered and boiled so the bones could be transported for burial.[17] Although some evidence indicates that this decree retarded the development of human dissection beyond the Alps, reinforcing characteristic northern attitudes toward the recently dead body,[18] it had relatively little effect in Italy, where the study of anatomy based on human dissection quickly became an established part of university medical education; Mondino de' Liuzzi's *Anatomy* (1316), written at the University of Bologna and organized around the dissection of a cadaver, remained the principal anatomical textbook in Italy for almost two hundred years.[19] During this period, dissection gained increasing currency as a technique of medical instruction not only for students of physic and surgery at Italian medical faculties, but also, beginning in the 1360s and 1370s, for members of municipal colleges and guilds of surgeons and physicians.[20]

In view of this gradual spread of human dissection in Italy, the backwardness of Italian anatomical illustration relative to its northern European counterpart seems paradoxical. Before the late fifteenth century, in fact, it is hard to find any Italian images created to aid in the teaching of anatomy and based unambiguously on inspection of an opened human cadaver[21] – and indeed, Italian medical manuscripts contain relatively few images of any sort. Most Italian anatomical illustrations from the fourteenth century belonged to a more general European tradition, often called by modern scholars the *Fünfbilderserie,* or five-figure series. These images typically appeared in series of anywhere from five to nine and entered the Latin tradition through Arabic sources. The figures, portrayed in a characteristic squatting pose, depict schematically the various systems of the human body described by Galenic medical theory: the arteries, veins, bones, nerves, muscles, and – in the case of extended series – certain of the internal organs as well.[22] The two best known Italian examples of this genre both date from the mid-fourteenth century.[23] The most detailed, from a compilation of surgical works by William of Saliceto, Bruno of Longoburgo, and the eleventh-century Persian author Avicenna, comprises the five standard images, including one labeled "History of the Bones" (Fig. 26). Like other images of this type, the figure intended to illustrate the human skeleton is too schematic to convey any useful information. The Latin captions on the body identify a few bones, apparently chosen

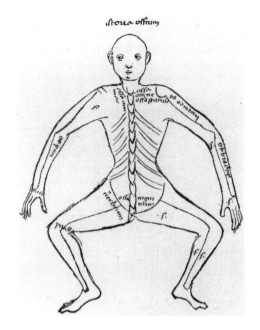

Figure 26. Anonymous Italian. *"History of the Bones" (Bone-Figure).* Milan, Biblioteca Trivulziana. Codex Trivulziano 836, first unnumbered folio. Mid-fourteenth century. (Photo: From Luigi Belloni, "Gli schemi anatomici trecenteschi (serie dei cinque sistemi e occhio) del Codice Trivulziano 836.") *Rivista di storia delle scienze mediche e naturali* 40, 1949.

at random, and the image as a whole is clearly a cursory and an entirely bookish production, a diagram with no pretense to naturalism and no reference to contemporary dissecting practices.

Indeed, the currency of human dissection in fourteenth- and early fifteenth-century Italy may have stunted the development of Italian anatomical illustration, which lagged behind its northern European counterpart in naturalism and detail.[24] The first signs of an original postclassical tradition of European anatomical illustration appeared in France rather than Italy; the two earliest examples of this tradition were a 1314 French translation of the *Surgery* of Henry of Mondeville, a Frenchman who had studied medicine and surgery at Bologna in the years around 1300, and a collection of Latin medical works compiled in 1345 by an Italian physician, Guido of Vigevano, for Philip VI of France.[25] Both of these men acted as cultural emissaries, bringing the new medical learning of northern Italy to France, where dissection was not yet common practice.[26] Both illustrated their anatomical works with carefully executed images, which were designed not only to appeal to the tastes of their wealthy patrons but also to substitute for the cadavers that might otherwise have been used in Italy to supplement the text.

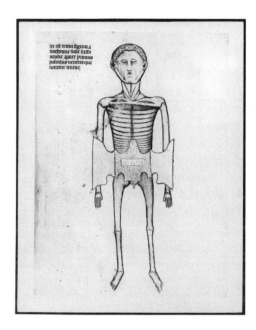

Figure 27. Guido da Vigevano. *Anatomia.* Chantilly, Musée Condé, MS 344, Third figure. 1345. (Photo: From Ernest Wickersheimer, *Les Anatomies de Mondino dei Liuzzi et de Guido de Vigevano,* Paris, 1926. By permission of the Houghton Library, Harvard University.)

The images in the Mondeville manuscript are more decorative than informative, but the ones that accompany Guido's own treatise on anatomy contain considerably more detail (Fig. 27). In his text, Guido explicitly discussed these images and the conditions under which they were produced. Referring with some exaggeration to Pope Boniface VIII's 1299 decree forbidding the boiling of human bodies – and emphasizing his own experience as a dissector (presumably in Italy) – Guido explained his reasons for presenting his material in this way:

> Since it is prohibited by the Church to dissect a human body [*anothomiam facere in corpore humano*], and since the art of medicine cannot be fully known, unless one first knows anatomy, as Galen indicates in the first section of *On the Internal Parts,* . . . I, Guido – to render more useful this book of notable things I have extracted from the books of Galen – will demonstrate the anatomy of the human body clearly and openly, through figures rightly depicted, just as the members appear in the human body, as will appear below, even better that can be seen in the human body, since, when we perform a human dissection, we must proceed quickly on account of the stink, so that it suffices only to

allow medical men to see the interior parts, and how they lie, in a general way.[27]

Although the quality of Guido's eighteen anatomical images was unprecedented, there is nothing to show that the anonymous artist had ever seen a dissected body. Rather, the images reflect the purely artistic conventions that governed the depiction of decaying corpses in contemporary Italian art, such as those in the altarpiece (c. 1340–50) attributed to the Florentine Jacopo del Casentino, which illustrates the story of the Three Living and Three Dead (Fig. 28): Both artists have shown the bones of the forearms and lower legs as undivided, and they have depicted the sternumless rib cage, the knee and shoulder joints, and the cadaver's male genitals in ways that are virtually identical.[28] Before the advent of printing in the mid-fifteenth century, furthermore, anatomical images of this artistic quality were fated to remain extremely rare. Guido himself explained the problem, noting that "it will be difficult for any medical man to have this illustrated anatomy book transcribed, first on account of the expense, and then because it is not easy to find painters who know how to draw the figures." Thus, he concluded, "it will be enough for [readers] only to have seen those anatomical figures often, and to have learned them by heart [*mente incorporari*]."[29]

Guido's emphasis on learning by heart underscores the cognitive function of images of this sort. They were intended as memory aids, helping their viewers master the texts with which they were associated, rather than as the source of separate and independent visual knowledge taken directly from cadavers. The anatomical details contained in Guido's images further reinforce this point. Rather than direct descriptions of a dissected corpse, they are illustrations of a dissection manual, most likely Mondino's, as would accord with Guido's Italian origins and training. The sequence of the images reproduces exactly the sequence of dissection in Mondino's *Anatomy* – abdomen, thorax, and finally head – beginning, as Mondino put it, with the "lowermost venter, so that the organs there, being most corruptible, may be the first cast aside."[30] Furthermore, the images accord well with Mondino's descriptions of particular organs, as is apparent in the artist's careful depiction of a seven-celled womb;[31] they are clearly *not* based on Guido's text, which consists of abbrevi-

Figure 28. Jacopo del Casentino (attributed). Triptych. Detail of *Madonna and Child with Nativity and the Three Living and Three Dead and Crucifixion with Virgin Mary, Saint Mary Magdalene, and John the Evangelist.* Berlin, Gemäldegalerie, Staatliche Museen. C. 1340–50 (Photo: Foto Marburg/Art Resource, New York)

ated descriptions of the figures themselves. Thus Guido's *Anatomy* is a textual description of a set of images, which are themselves illustrations of yet another text, by Mondino, itself based partly on Mondino's own experiences as a dissector but at least as clearly on his reading of works attributed to Galen and Avicenna.

This complex set of verbal and visual dependences, in which the actual human corpse played only a marginal role, reflects the essentially textual character of the fourteenth-century anatomical tradition. As Nancy Siraisi has noted, "The objective of the dissections conducted as part of medical or surgical training in the fourteenth and fifteenth centuries was not investigation but instruction. In this context, dissection seldom functioned as a means of controlling or correcting the written word and certainly not as an independent research tool. . . . Rather, the practice of dissection served primarily as a visual aid to the understanding of physiological and anatomical doctrines found in texts."[32]

The authors of fourteenth-century anatomical texts did not see themselves as engaged in anatomical research intended to challenge the authority of Greek and Arabic authors; rather, they aimed to confirm that authority and to present the teachings of those authors in compact and memorable form. Several of Guido's own images dramatize this set of intentions. In them, the surface of the cadaver's abdomen opens like the covers of a book to reveal lettered labels that stand in for key organs (*mirac* in the third, for example, *sifac* in the fourth), so that the human body itself does not appear as an independent object, but as just another text, to be committed to memory by the aspiring physician or surgeon (Fig. 27). Mondino emphasized the memorial function of his own treatise, describing it, using the words of Galen, as "a remedy for the forgetfulness of old age."[33]

As I have already suggested, the skeleton in the lower register of Masaccio's *Trinity*, painted eighty years after Guido's manuscript, is a memory image as well, a point to which I shall return. In addition, however, it reflects the direct observation of at least fragments of a human skeleton or skeletons, in a way that the images produced by Guido's artist and by Jacopo del Casentino did not. It will not do to overstate Masaccio's novelty, however: An early fourteenth-century fresco in the Lower Church of San Francesco in Assisi shows Saint Francis with a crowned and decaying corpse – very possibly another reference to the story of the Three Living and Three Dead – whose half-revealed skeleton has a number of strikingly realistic details.[34]

Nor does Masaccio's depiction prove that he had witnessed an anatomical dissection, although this was theoretically possible at the time. The 1372 statute of the Florentine Guild of Doctors and Apothecaries, in which Masaccio later matriculated, stipulated that the guild sponsor an annual dissection on the model of other Italian medical guilds, but the frequency with which this provision was repeated – including in 1417 – suggests that its observance was erratic at best.[35] Similarly, the 1388 statute of the University of Florence mandated two dissections a year, one of a male and one of a female, from the ranks of executed foreign criminals; although the supply of women hanged for capital crimes was small, records show that at least three male cadavers were anatomized in the first half of the fifteenth century, including the locksmith Baltassar di Giovanni

of Ferrara in 1421.[36] But apart from doubts as to whether more than a few such dissections actually took place – in 1422, when Masaccio established himself in Florence, the fiscal demands of the war with Milan had decimated the ranks of medical lecturers – it is unlikely that Masaccio would have been eligible for admission because places in the audience were strictly limited and reserved for medical students and practitioners.[37]

Finally, as far as the *Trinity* fresco is concerned, it is ultimately irrelevant whether Masaccio attended a dissection, for no dissection could yield a clean and fleshless skeleton, which required time for burial and decomposition. The papal prohibition on boiling human bones, though it did not hamper dissection in Italy, seems effectively to have prevented even Italian anatomists from making articulated skeletons throughout the fourteenth and fifteenth centuries; it was not until c. 1510 that Leonardo da Vinci produced a series of draw-ings suggesting that he had articulated a partial human skeleton.[38]

Compared to Leonardo's drawings, Masaccio's skeleton has a primitive and preliminary feeling. Like Leonardo, Masaccio clearly had access only to fragments of a skeleton – the right arm, with its divided forearm, is particularly well realized – probably taken from a cemetery or ossuary. Unlike Leonardo, he filled in the missing pieces, most notably the rib cage, by drawing on contemporary artistic convention: His skeleton's flat ribs, wholly lacking a ster-num, closely resemble those of the corpses in the foreground of Jacopo del Casentino's altarpiece and in the Pisa Camposanto fresco of the *Three Living and Three Dead,* or *Triumph of Death* (Figs. 12, 28).[39] Thus, despite its remarkable naturalism, Masaccio's skele-ton is in fact a patchwork, drawn partly from contemporary artistic practice and partly from observation. Even as such, however, it con-stitutes a significant step beyond the images in fourteenth- and early fifteenth-century Italian anatomical codices, which were uniquely products of a textual tradition.

The bookish quality of contemporary anatomical illustration suggests a deeper relationship between it and Masaccio's work, focused on the theme of memory. The images in anatomical man-uscripts, like visual spectacle of the dissected cadaver, functioned largely as adjuncts to the text, helping the student to master and commit to memory its details. Memory was also central to Masac-cio's skeleton, itself a memento mori, as the inscription above it

made clear. Thus it makes sense to relate the skeleton, the anatomical illustrations, and indeed the dissected cadaver to the visual images that formed the core of the contemporary art of memory. Derived from the pseudo-Ciceronian treatise *Ad Herennium* and elaborated and disseminated by Dominican masters beginning in the mid-thirteenth century, this technique allowed students and preachers to memorize large amounts of material by using a system of mental images superimposed on a framework of architectural niches or some other sort of grid.[40]

According to both theorists and practitioners of the art of memory, one of the most important requirements for memory images was that they be visually striking and emotionally charged. Thus Albertus Magnus recommended the use of vivid, shocking, and unusual images, because "what is marvelous [*mirabile*] is more moving than what is ordinary, . . . affect[ing] memory more than commonplace literal matters."[41] The examples he quoted from the *Ad Herennium* included images of "exceptional beauty or singular ugliness; if we dress some of them with crowns or purple cloaks so that the likeness may be more distinct to us; or if we somehow disfigure them as by introducing one stained with blood or soiled with mud or smeared with red paint, so that its form is more striking."[42] Like the sequence of frog-like images in the five-figure series of anatomical manuscripts, or the decaying cadavers in their tombs in contemporary depictions of the story of the Three Living and Three Dead, Masaccio's skeleton, placed in a niche of the sort described by the *Ad Herennium,* demands that its viewer commit its lesson to heart. Even the fresco's inscription accords with this intention: Bono Giamboni, the thirteenth-century Florentine translator of the *Ad Herennium,* inserted an injunction that memory images must speak, an addition Carruthers associates with the use of voice-scrolls and banners in contemporary book illustration and painting.[43]

I do not mean to argue that Masaccio explicitly intended his skeleton as a memory image, but rather that his contemporaries accorded great power to images – especially unusual, disturbing, or striking images, like a skeleton or a decaying cadaver – in mobilizing affect and in helping the viewer to learn. For this reason, the same attributes that made an image an effective tool of memory also rendered it a proper object of religious meditation, combining

a visual and emotional charge.[44] This set of associations appears clearly in the *Three Living and Three Dead* in the *Triumph of Death* fresco in Pisa (Fig. 12), where the Italian verse inscription beneath the tombs holding the three decaying corpses once stressed the power of the visual image to effect religious conversion:

> You who regard me and look on me so fixedly [*mi guardi e si fiso*
> *mi miri*],
> See how I mark the end of your sight [*son ladio al tuo conspecto*].
> Although you are a fair youth,
> Think on this before death takes you.
> In the world I had many vain desires,
> And I did not think about my present plight. . . .
> Now turn yourself immediately to him
> Who constantly calls you to the highest good,
> If you wish to avoid cruel and eternal pain.[45]

The scroll held over the corpses by the hermit also stressed the redemptive power of meditation on a visual object:

> If your mind is wise,
> Holding your sight [*vista*] fixed here,
> Your vainglory will be defeated
> And your pride dead, as you see [*come vedete*].[46]

As these inscriptions emphasize, fourteenth- and fifteenth-century Italians lived in a culture in which images were an explicit and highly theorized tool for meditation as well as memory – a discipline for the mind and eye.[47] This discipline flourished not only in contemporary schools and universities but was particularly associated with the preaching of the friars.[48] Like the painter of the Camposanto fresco and like Mondino in his anatomy textbook, written to accompany an actual dissection, Masaccio used a visual object to convey useful knowledge concerning the human condition – to allow his viewers to know themselves. But whereas Mondino's lesson had to do with the construction of the living human body, Masaccio used his skeleton to remind his viewer of the fate of the body after death.

As embodied in Masaccio's skeleton, the intersections between early fifteenth-century painting and the medical discipline of anatomy were important but indirect: Both formed part of a single

culture which emphasized the image as an instrument of memory and a focus of meditation. To serve these purposes, the image had to be unusual and striking, rather than accurate in a documentary way. Both Guido of Vigevano's anatomical figures and Masaccio's skeleton fulfilled these criteria – much of the skeleton's effect came from its unprecedented naturalism, based in part on direct observation – but neither shows the creative symbiosis between the artist's and the anatomists' knowledge that was to mark the sixteenth-century work of Leonardo and Michelangelo among artists and Andreas Vesalius and Juan Valverde among anatomists. There is no evidence that Masaccio was influenced in any significant way by contemporary anatomical learning and practice. Indeed, the influence, such as it was, flowed in the other direction: Beginning in the early fourteenth century, anatomists like Henry of Mondeville and Guido of Vigevano, who hoped to raise the level of anatomical illustration, drew on the expertise of contemporary artists rather than the other way around. Thus it is perhaps most accurate to describe Masaccio as lying on the cusp of the slow transition from a memorial to a documentary culture – from a culture in which both artists and anatomists looked to the pictorial and textual tradition to one in which they privileged the dissected body itself. It was only in the decades after Masaccio's early death that this situation began to change, and this time the impetus came not from anatomists but from artists, who began to study anatomy long before anatomists began seriously to study art.

The first explicit signs of this interest appeared in prescriptive works rather than in artistic practice. In his treatise on painting, composed in the 1430s, Leon Battista Alberti indicated the importance of anatomical knowledge to the artist: "when painting living creatures," he recommended, "first . . . sketch in the bones, for, as they bend very little indeed, they always occupy a certain determined position. Then add the sinews and muscles, and finally clothe the bones and muscles with flesh and skin. . . . As Nature clearly and openly reveals all these proportions, so the zealous painter will find great profit from investigating them in Nature for himself."[49] In *On Sculpture,* Alberti further observed, "Who would dare claim to be a shipbuilder, if he did not know how many parts there are in a ship, how one ship differs from another, and how the parts of any construction fit together?" and he noted that "it would

also be extremely valuable to know the number of bones and the projections of muscles and sinews."[50] But it was Lorenzo Ghiberti, in the first book of his *Commentaries* (c. 1447), who took the next step by recommending that artists witness actual dissections. "It is not necessary to be a physician like Hippocrates or Galen or Avicenna," he wrote, "but it is necessary to have seen their works, to have seen a dissection [*notomia*], to know how many bones there are in the human body, to know its muscles, and to know all the nerves and all the ligaments [*legature*] that are in the male figure [*statua virile*]."[51]

In these passages, Alberti and Ghiberti articulated the transitional position represented in practice by Masaccio's skeleton, advocating a patchwork of observed reality and earlier tradition, of what one sees and what one knows. On the one hand, they emphasized the importance of "investigating . . . in Nature for oneself," as Alberti put it, and of witnessing dissections, as Ghiberti prescribed. At the same time, however, they described knowledge of the human body in essentially bookish terms: Both stressed the mental acts of enumeration and of comprehensive recall – the number of bones in the human body, of "all the nerves and all the ligaments" – that belonged to the memorial model of knowledge. This memorial orientation informs a later passage from Ghiberti's *Commentaries*, where he lists in Latin the names, number, and positions of the bones, taken not from his own experience but from the Arabic medical authorities Avicenna and Averroes.[52]

Despite Ghiberti's explicit recommendation, none of his own works offers clear evidence that he had in fact attended dissections. The first unambiguous evidence of this sort relates rather to Donatello, who had been in Ghiberti's workshop and who was a friend of Masaccio. Donatello's relief, the *Heart of the Miser* (c. 1447), from the high altar he created for the church of Sant'Antonio in Padua, is exactly contemporary with Ghiberti's *Commentaries* (Fig. 29).[53] It shows the saint at the foot of the dead miser's bier, pointing to the corpse's chest, which another man, standing behind the body, has just opened with a vertical slit. At the same time, another group to the left of the relief has opened the miser's money chest and is lifting out his heart, still attached to what looks like his trachea, thereby demonstrating the truth of the scriptural

Figure 29. Donatello. *Saint Anthony and the Miracle of the Miser's Heart.*
Bronze relief. Padua, Basilica di Sant'Antonio. 1446–50. (Photo:
Alinari/Art Resource, New York)

precept, "Where your treasure is, there will your heart be also"
(Luke 12:34).

Donatello was not the first Florentine artist to represent this
scene, which was based on a pseudo-Bonaventuran sermon: It
appears on the vault of the chapter room in the convent of San
Francesco in Pistoia (fourteenth century, possibly by Antonio Vite)
and on a fragment of a predella attributed to Bicci di Lorenzo in
the Pinacoteca Vaticana.[54] Neither of these two versions bears
much resemblance to anatomical dissections as practiced in the
later fourteenth and earlier fifteenth centuries. A painting of the
same story by Francesco Pesellino (c. 1445), however, suggests a
closer link: Instead of a simple deathbed scene, the surgeon inserts
his hands into the opened chest of the miser's corpse, overseen by
an older man standing beside him with a cane, while Saint
Anthony lectures on the moral of the scene from a raised pulpit,
echoing the traditional division of labor in a public dissection
between dissector, ostensor, and reader of the anatomical text.[55]

The case for Donatello's having actually witnessed a dissection
seems even stronger, based both on his representation of the scene
(where the miser's body is shown, for the first time, as almost
entirely naked) and on its location in the principal church in
Padua, seat of the leading medical faculty in Europe. Paduan med-

ical professors were performing dissections on a fairly regular basis in the mid-fifteenth century: Leonardo of Bertipaglia indicated in his notes that he often opened cadavers with his own hands and referred to two dissections he performed at Padua in 1430, for example, while Bartolomeo of Montagnana mentioned at least fourteen postmortems in his *Consilia* of 1444.[56] Donatello may well have attended public dissections while staying in Padua. Certainly his relief clearly shows the distinct roles of dissector and ostensor, and it suggests as well the growing audiences of students and other notables at spectacles of this sort.[57]

In other respects, however, even Donatello's relief hardly reflected a deep involvement in anatomical study. It was not until the late fifteenth and early sixteenth centuries that artists and anatomists began to interact in a sustained and meaningful way, as both began to focus on describing and exploring the deep structures of the human body as they presented themselves visually rather than illustrating and explicating earlier accounts. Starting in the last decades of the fifteenth century, Leonardo and Michelangelo personally dissected bodies, and Leonardo seems to have worked in 1510 and 1511 with Marcantonio della Torre, who taught theoretical medicine at the University of Padua, though the nature of their joint project is unclear.[58] Three Italian printed medical texts from this period also contain illustrations that suggest at least a limited collaboration between artist and anatomist: the 1493 edition of the *Fascicle of Medicine,* which includes a woodcut of the female body with a uterus drawn (according to the caption) "from nature" (*dal naturale*);[59] and the *Commentary on the Anatomy of Mondino* (1521) and *Brief Introduction* (1522 and 1523) of Berengario of Carpi, who taught medicine at the University of Bologna.[60] Although copious and striking, the woodcuts in the latter two books are hardly impressive from the point of view of either anatomy or art.

It was only in the years after 1535 that artists and anatomists began to work intensively together in Italy on illustrated anatomy texts. The most productive such collaboration was that between Andreas Vesalius, a young professor of anatomy at the University of Padua, and Jan Stephan of Calcar and possibly other artists in the circle of Titian. Their collaboration bore magnificent fruit in a series of volumes published by Vesalius: the *Six Tables* (1538), the

Epitome of the Fabric of the Human Body (1543), and the great *Fabrica* itself (1543, with a second edition in 1555).[61]

These books mark a watershed in the relations between anatomists and artists. Vesalius and his artistic collaborators clearly worked together on every aspect of the project, recording the results of dozens of dissections in both verbal and visual form. Vesalius managed to articulate a complete skeleton, probably the first one ever, which appeared in the *Six Tables* and then again in the *Fabrica*. Despite minor inaccuracies, the three principal views of the skeleton in this latter work are remarkable for their beauty, their realism, and their detail. Yet even in these views, clearly documentary in intention, the memorial spirit persists, at least in superficial form. In one of them, the skeleton is leaning on a plinth or tomb, pensively meditating on a skull (Fig. 30). His melancholy and contemplative pose reinforces the tomb's Latin inscription: "One lives by genius [*ingenio*]: all else will die." Despite the secular and classicizing aspect of this image – pelvis in correct proportion, sternum and rib cage accurately rendered – the sentiment of Masaccio's skeleton lives on.

NOTES

1. See Premuda, pp. 11–12.
2. The skeleton lies on the picture plane in Masaccio's elaborate perspective construction and is thus lifesize (Jehane Kuhn, personal communication). On the style of the inscription, see Covi.
3. See Joannides, pp. 356–68. I am grateful to Frédéric Cousinié for help in researching these issues.
4. On these allusions, see Schlegel, especially pp. 26–31; Simson; Dempsey; and Hertlein, pp. 51–72. The most comprehensive discussions of these traditions in the context of contemporary symbolism are found in Cohen, pp. 33–37, 104–12. On pictorial and literary representations of the Three Living and Three Dead, see Rotzler; Chihaia, chs. 3 and 6; and Tenenti, pp. 228–44.
5. On this double message, see Goffen, 1980, especially pp. 492–94, and ch. 2 this volume.
6. Tolnay, p. 38.
7. Crombie, pp. 15–16.

(Opposite) **Figure 30.** Jan Stephan of Calcar, after Titian (attributed). *Skeleton Contemplating a Death's Head.* From Andreas Vesalius, *De humani corporis fabrica*, Second skeletal figure. Basil, Oporinus, 1543. (Photo: Visual Image Presentations, Bladensburg, Maryland)

HVMANI COR- **PORIS OSSIVM CAE**
TERIS QVAS SV- *STINENT PARTIBVS*
LIBERORVM, SVAQVE SEDE POSITORVM EX
latere delineatio.

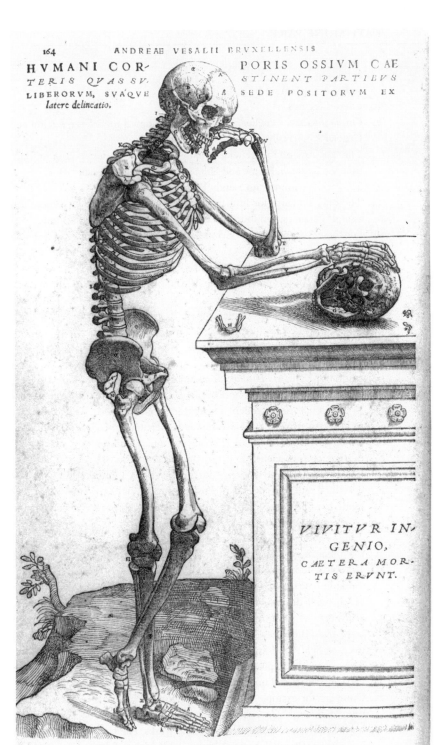

*VIVITVR IN-
GENIO,
CAETERA MOR-
TIS ERVNT.*

8. Schultz, p. 46.

9. Ackerman, p. 101.

10. Carruthers, p. 8.

11. On *doctrina* as an intellectual and epistemological model, see Agrimi and Crisciana, especially ch. 2.

12. The literature on this general development is enormous; for an introduction, see Cropper, Perini, and Solinas; and Findlen, especially ch. 4.

13. See Park, "Criminal and Saintly Body," 1994.

14. The only evidence for human dissection among the Greeks comes from a single generation in fourth-century B.C.E. Alexandria; see Staden.

15. For these cases, see Park, "Criminal and Saintly Body," 1994, pp. 1–6 and the references therein.

16. Siraisi, 1981, pp. 110–13; idem, 1990, pp. 86–97.

17. Discussions of this prohibition in Alston; Brown; and Park, "Criminal and Saintly Body," 1994, pp. 10–11.

18. See Park, "Life of the Corpse," 1994.

19. An early printed edition and translation appears in [Ketham], ed. Singer.

20. Ciasca, 1927, pp. 278–9.

21. The first such image is the woodcut depicting the uterus in the 1493 edition of Ketham's *Fasciculo di medicina,* which is frequently reproduced, most notably in Roberts and Tomlinson, pl. 8. The text of this last book, as opposed to its excellent illustrations, must be used with care; a far more informative and reliable survey is Herrlinger, 1967, and ibid., 1970, for an English translation. The only manuscript image that might rival the *Fasciculo* woodcut for priority is an illustration in a manuscript of William of Saliceto's *Surgery* in the Marciana Library, Venice, briefly described and reproduced in Premuda, p. 35 and fig. 18; although the rendering of the outside of the opened body in this image is striking, the representation of the internal organs is unconvincing, and the manuscript's dating is in any case uncertain.

22. On these images, see Herrlinger, 1967, pp. 10–14, and French, 1984, pp. 143–5 (including references). Another type of anatomical illustration found in Italian medical manuscripts, of less relevance to this essay, consists of schematic diagrams of internal organs; for an example, see Maccagni.

23. University of Oxford, Bodleian Library, Codex e Museo 19, fol. 165v; and Milan, Biblioteca Trivulziana, MS Trivulziano 836, described respectively in Seidel and Sudhoff, pp. 165–7 and table 3, no. 1; and in Belloni. The geographical provenance of the series in the Vatican Library (MS Pal. Lat. 1110) is still undetermined; see MacKinney and Hill.

24. Compare, for example, the fifteenth-century images in a German translation of Bruno's *Great Surgery* from 1452, or a contemporary English translation of two medieval anatomical works. The German translation is in London, British Library, Additional MS 21618, fol. 1v, reproduced in

Jones, fig. 15; and the English translation is in London, Wellcome Institute for the History of Medicine, Wellcome MS 290, reproduced in color and discussed in Getz. According to Premuda, p. 36, there are no illustrated Italian copies of Mondino's *Anatomy* before the late fifteenth century.

25. Paris, Bibliothèque Nationale, MS fr. 2030 (Henry), reproduced and discussed in Sudhoff, pp. 82–9 and table 24; Chantilly, Château de Chantilly, Musée Condé, MS 334, reproduced and discussed in Wickersheimer, 1913 and 1926.

26. See Herrlinger, pp. 46–8.

27. Guido of Vigevano, *Anothomia Philipi septimi, Francorum regis, designata per figures,* Preface, transcribed in Wickersheimer, 1913, p. 5. The king to whom Guido referred as Philip VII is better known as Philip VI Valois; Guido was the personal physician of Philip's wife, Jeanne of Burgundy.

28. The altarpiece is illustrated in Offner, 1930, pl. 51. For this and other contemporary Italian depictions of the story, see Guerry, especially pp. 118–71; Rotzler, pp. 125–66; and Tenenti, pp. 428–48.

29. Guido, *Anothomia,* Preface, quoted in Wickersheimer, 1913, pp. 23–24*n*1.

30. Mondino, p. 32.

31. Wickersheimer, 1913, fig. 10; cf. Mondino, p. 91. See in general Kudlien.

32. Siraisi, 1990, p. 89. See also French, 1979.

33. Mondino, p. 23.

34. Poeschke, pp. 44, 104, and pl. 240.

35. Ciasca, 1927, p. 278; texts in idem, 1922, pp. 280, 290, 409–10. On Masaccio's matriculation in this guild, which also included painters, presumably because the pigments they used were related to the items sold by apothecaries, see Joannides, p. 29, and the Introduction, at n. 20 this volume. On the guild, see Ciasca, 1927, and Park, 1985, ch. 1.

36. Florence, Biblioteca Nazionale, MS II, I, 138, ad annum 1421 (no. 25). See Park, 1985, pp. 60–1.

37. At the University of Bologna, for example, the number of students attending dissections in the early fifteenth century was limited to twenty (thirty in the case of a female cadaver), meticulously distributed among the various "nations" of students; see Carlo Malagola, ed., *Statuti delle università e dei collegi dello studio bolognese* (Bologna, 1888), pp. 189–90, trans. in Thorndike, p. 283. On the fortunes of the University of Florence in the 1420s, see Park, 1980, pp. 280–3.

38. See, for example, the skeletal images in Leonardo da Vinci, especially pl. 1. Mondino refers explicitly to the papal prohibition on boiling, noting that it prevented him from revealing some of the smaller bones in the ear; see Mondino, p. 185.

39. For bibliography regarding the date and attribution of this fresco, see Goffen, ch. 2, n. 20, this volume.

40. Details of this system in Carruthers, chs. 3–4; for its Dominican associations, see ibid., pp. 101, 154.

41. Albertus Magnus, *De bono* 4.2.2, trans. Carruthers, p. 279.

42. Carruthers, pp. 273–7.

43. Ibid., pp. 229–30.

44. On this aspect of memory images, see among others ibid., pp. 173–5, and Freedberg, ch. 8, especially p. 167.

45. Cited in Guerry, pp. 126–7. These inscriptions were retouched in 1420; see ibid., p. 125, n. 1.

46. Ibid., p. 127.

47. See, e.g., Freedberg, pp. 168–9; Belting, ch. 17.

48. As Rubin has documented, the friars laid particular emphasis on the eucharistic host as a visual object in connection with the growing cult of Corpus Christi, for which Santa Maria Novella served as the Florentine center; see Rubin, pp. 133–43, 288–9. On the eucharistic associations of the *Trinity*, see Goffen, 1980, pp. 500–3, and ch. 2 this volume.

49. Alberti, ed. Grayson, pp. 73–5. On the discussion of anatomy by fifteenth-century art theorists, see Schultz, ch. 2; on Alberti's role in particular, ibid., pp. 27–32.

50. Alberti, ed. Grayson, pp. 129, 139.

51. Ghiberti, vol. 1, p. 6. See in general Schultz, pp. 35–8.

52. Ghiberti, vol. 1, pp. 222–6.

53. On this work, see Rosenauer, pp. 232–40. On its relationship to anatomical practice, see Schultz, pp. 48–51.

54. Wolf-Heidegger and Cetto, pp. 142–4 (figs. 30–1). On the literary sources for this scene, see Mandach, pp. 188–9 and 224–30.

55. Wolf-Heidegger and Cetto, pp. 143–4 (fig. 31). On these three figures and the early iconography of dissection scenes in illustrated medical texts, see Bylebyl.

56. Ongaro, p. 95. Schultz, p. 48, errs in saying that Padua legalized human dissection only in 1429; accounts of postmortems appear in Paduan documentation beginning in the early fourteenth century.

57. See Ferrari; and Park, "Criminal and Saintly Body," 1994, p. 14.

58. On the evidence for this collaboration, which rests mainly on Vasari's account, see Leonardo da Vinci, pp. 24–5; Schultz, pp. 96–7, and the references therein.

59. See above, n. 21.

60. On this aspect of Berengario's work, see Lind, "Introduction," in Berengario, pp. 23–7; Putti, pp. 165–9; and Roberts and Tomlinson, pp. 70–82.

61. The bibliography on Vesalius and his work is enormous. For a general introduction, see O'Malley. The woodcuts are reproduced in O'Malley and Saunders. Additional references in Roberts and Tomlinson, p. 204. In 1547, Michelangelo met Realdo Colombo, then teaching anatomy at the University of Pisa, and the two made plans, never realized, to collaborate on an illustrated anatomy text; Schultz, pp. 101–4.

GLOSSARY

A secco. Dry, referring to painting on dry plaster, rather than plaster that is still wet (see *buon fresco*).

Arriccio. The rough layer of plaster made of lime (calcium oxide) and sand; it is applied directly onto the masonry of a wall as the base of the finer, finishing layer (see *intonaco*), which is to be painted (see *a secco* and *buon fresco*). The roughness of the *arriccio* helps the *intonaco* to adhere to the surface.

Beverone. Literally, "big drink," an organic mixture applied to fresco surfaces by eighteenth- and nineteenth-century restorers to give the surface "finish," but which accumulates soot and other filth to become a layer of decaying grime.

Braccio (plural, ***braccia***). A Florentine measurement equivalent to 57.33 cm or almost 23 inches.

Buon fresco. In this technique of wall painting, the pigment and plaster dry together, forming a chemical bond. See *giornata* and *intonaco*.

Cartoon. Preliminary scale drawing made for a wall or panel painting and representing either the entire composition or particular sections of it. The cartoon can be transferred to the surface to be painted by one of two means. The artist can place it on the panel or wall and incise its outlines into that surface with a stylus (a procedure that destroys the drawing). Alternately, the artist can prick the cartoon outlines with a stylus and then transfer them to the wall or panel by pouncing or dusting, which leaves a "dotted line" of dust on the surface. See *spolvero;* cf. *sinopia*.

Di sotto in sù. From below, up; that is, foreshortening figures and other elements of a composition to take (illusionistic) account of a viewer's low vantage point.

Giornata (plural, ***giornate***). "A day's work" in *buon fresco,* that is, the area

of freshly applied fine plaster (*intonaco*) that can be painted before it dries. The word is a metaphor and not necessarily a twenty-four-hour day. *Giornate* constitute in effect a jigsaw puzzle of differently sized areas, painted one after the other.

Graffito (plural, **graffiti**). A line scratched or incised into the surface of plaster or panel to guide the artist's application of color. *Graffito* does not involve the use of a cartoon.

Intonaco. A fine layer of plaster (lime and sand) applied to the *arriccio* and then painted, either while still wet (*buon fresco*) or after drying (*a secco*).

Sinopia (plural, **sinopie**). A red ochre pigment used to sketch a composition directly on the *arriccio* (as opposed to transferring a composition to the wall by means of a cartoon); the *sinopia* is concealed by the application of the *intonaco* and the fresco itself. A *sinopia* can be recovered (or uncovered) if a fresco is detached, that is, if the *intonaco* – which contains the pigment – is stripped away from the underlying *arriccio*.

Spolvero. Dusting or pouncing. In one technique of fresco painting, a cartoon or scale drawing with pricked outlines was placed on the wall and its contours transferred to the *intonaco* by pouncing with a bag filled with colored material or powdered charcoal.

Stacco. Literally, "detached." One process used to detach both the *intonaco* and the color layer from a wall.

Strappo. Literally "strip," referring to the thin strip(s) of pigment layer on the *intonaco* that are peeled from the wall in another process used to detach a fresco, especially when the plaster is in poor condition. The strips of pigment layer that are removed by the *strappo* process are sometimes so thin that they leave behind a second, faint color imprint on the wall.

SELECTED BIBLIOGRAPHY

Ackerman, James. "The Involvement of Artists in Renaissance Science." In *Science and the Arts in the Renaissance,* ed. John W. Shirley and F. David Hoeniger, pp. 94–129. Washington, D.C., 1985.

Agrimi, Jole, and Chiara Crisciana. *Edocere medicos: Medicina scolastica nei secoli XIII–XV.* Naples, 1988.

Aiken, Jane Andrews. "Renaissance Perspective: Its Mathematical Source and Sanction." Ph.D. dissertation. Harvard University, 1986.

"The Perspective Construction of Masaccio's *Trinity* Fresco and Medieval Astronomical Graphics." *Artibus et Historiae* 31 (1995): 171–87.

"Truth in Images: From the Technical Drawings of Ibn al-Razzaz al-Jazari, Campanus of Novara, and Giovanni de' Dondi to the Perspective Projection of Leon Battista Alberti." *Viator* 25 (1994): 325–59.

Alberti, Leon Battista. *On Painting.* Trans. and ed. John R. Spencer. New Haven and London, 1966.

On Painting and On Sculpture: The Latin Text of De Pictura and De Statua. Trans. and ed. Cecil Grayson. London and New York, 1972.

Alston, Mary Niven. "The Attitude of the Church toward Dissection before 1500." *Bulletin of the History of Medicine* 16 (1944): 221–38.

Ammirato, Scipione. *Istorie fiorentine.* Ed. F. Ranalli. Florence, 1848.

Aquinas, Saint Thomas. *Summa Theologiae* 1. Ed. and trans. C. Velecky. New York and London, 1965. *Summa Theologiae* IIIa. Trans. T. Gilby. New York and London, 1975. *Summa* 6 and 7. Ed. and trans. T.C. O'Brien. New York and London, 1976.

Arrighi, G. "Il codice L.VI.21 della Biblioteca degli Intronati di Siena e la 'Bottega dell'Abbaco' a Santa Trinità in Firenze." *Physis* 7 (1965): 369–400.

"La matematica del Rinascimento in Firenze: L'eredità di Leonardo Pisano e le 'botteghe d'abbaco.'" *Cultura e Scuola* 18 (1966): 287–94.

"Le scienze esatte al tempo del Brunelleschi." In *Filippo Brunelleschi: La sua opera e il suo tempo,* ed. G. Spadolini, pp. 93–103. Florence, 1980.

Baldini, Umberto. "Le figure di Adamo ed Eva formate affatto ignude in una cappella di una principale chiesa di Fiorenza." *Critica d'arte* 16 (1988): 72–7.

Masaccio. Florence, 1990.

"Prime risultanze per il restauro." In *La Cappella Brancacci nella Chiesa del Carmine a Firenze,* ed. Ugo Procacci and Ugo Baldini, pp. 21–7. Quaderni del restauro 1. Milan, 1984.

The Crucifix by Cimabue. Milan, 1983.

and Ornella Casazza. *La Cappella Brancacci.* Milan, 1990. English trans., Lysa Hochroth with Marion L. Grayson, ed. Marion L. Grayson. London, 1992.

Baldinucci, Filippo. *Vocabolario toscano dell'arte del disegno.* Florence, 1681.

Bandmann, Günter. "Zur Deutung des Mainzer Kopfes mit der Binde." *Zeitschrift für Kunstwissenschaft* 10 (1956): 153–74.

Battisti, Eugenio. *Filippo Brunelleschi: The Complete Work.* Trans. Robert Erich Wolf with Eugenio Battisti and Emily Lane. New York, 1981.

Beck, James. "Leon Battista Alberti and the 'Night Sky' at San Lorenzo." *Artibus et historiae* 19 (1989): 9–34.

with Gino Corti. *Masaccio: The Documents.* New York, 1978.

Belloni, Luigi. "Gli schemi anatomici trecenteschi (serie dei cinque sistemi e occhio) del Codice Trivulziano 836." *Rivista di storia delle scienze mediche e naturali* 40 (1949): 193–207.

Belting, Hans. *Likeness and Presence: A History of the Image before the Age of Art.* Trans. Edmund Jephcott. Chicago, 1994.

Benjamin, F. S., and G. J. Toomer. *Campanus of Novara and Medieval Planetary Theory, Theorica planetarum.* Madison, Milwaukee, and London, 1971.

Berengario de Carpi, Jacopo. *A Short Introduction to Anatomy (Isagogae Breves).* Trans. L[evi]. R[obert]. Lind. Chicago, 1959.

Bernardi, V. *Rimozione, consolidamento, restauro dei dipinti a fresco.* Bergamo, 1988.

Berti, Luciano. *Masaccio.* Florence, 1988.

"Masaccio, 1422." *Commentari* 12 (1961): 85–107.

Bilioctus, Modestus. *Chronica pulcherrimae aedis magnique coenobii S. Mariae Cognomento Novellae Florentinae Civitatis.* Florence, 1586.

Billi, Antonio. *Il Libro.* Ed. Annamaria Ficarra. Collana di studi e testi per la storia dell'arte 3. Naples, n.d. [c. 1970].

[Billi, Antonio.] *Il libro di Antonio Billi.* Ed. Carl Frey. Berlin, 1892.

Biliotti, Modesto. *See* Bilioctus, Modestus.

Bizzocchi, Roberto. *Chiesa e potere nella Toscana del Quattrocento.* Bologna, 1987.

Borsook, Eve. *The Mural Painters of Tuscany from Cimabue to Andrea del Sarto.* 2d rev. ed. Oxford, England, 1980.

 and Johannes Offerhaus. *Francesco Sassetti and Ghirlandaio at Santa Trinita, Florence.* Doornspijk, 1981.

Brandi, Cesare. *Teoria del restauro.* Rome, 1963.

Braunfels, Wolfgang. *Die heilige Dreifältigkeit.* Düsseldorf, 1954.

Brown, Elizabeth A. R. "Death and the Human Body in the Later Middle Ages: The Legislation of Boniface VIII on the Division of the Corpse." *Viator* 12 (1981): 221–70.

Brucker, Gene. *The Civic World of Early Renaissance Florence.* Princeton, 1977.

 ed. *The Society of Renaissance Florence.* New York, 1971.

Bylebyl, Jerome J. "Interpreting the *Fasciculo* Anatomy Scene." *Journal of the History of Medicine and Allied Science* 45 (1990): 285–316.

Camporeale, Salvatore I., o.p. *Lorenzo Valla, Umanesimo e teologia.* Florence, 1972.

 Rev. of Alberto Tenenti, *Il senso della morte e l'amore della vita nel Rinascimento (Italia-Francia)* (Turin, 1957; rpt. 1977). *Memorie Domenicane* N.S. 8–9 (1977–78): 439–50.

Carruthers, Mary J. *The Book of Memory: A Study of Memory in Medieval Culture.* Cambridge, England, and New York, 1990.

Casazza, Ornella. *Il restauro pittorico nell'unità di metodologia.* Florence, 1981.

 and Sabino Giovannoni. "Preliminary Research for the Conservation of the Brancacci Chapel, Florence." In *The Conservation of Wall Paintings,* ed. Sharon Cather, pp. 13–19. Marina del Rey, Calif., 1991.

 See also Baldini, Umberto.

Cavalcaselle, G[iovanni]. B[attista]., and J[oseph]. A[rcher]. Crowe. *Storia della pittura in Italia dal secolo II al secolo XVI.* 3 vols. Florence, 1875–85.

 See also Crowe, J[oseph]. A[rcher]., and G[iovanni]. B[attista]. Cavalcaselle.

Cennini, Cennino d'Andrea. *The Craftsman's Handbook, The Italian "Libro dell' arte."* Ed. and trans. Daniel V. Thompson, Jr. New Haven, 1933. Rpt. New York, 1960.

 Il libro dell'Arte. Ed. Franco Brunello with preface by Licisco Magagnato. Vicenza, 1971.

 Le livre de l'art. Ed. Colette Déroche. Paris, 1991.

Chambers, David, ed. *Patrons and Artists in the Italian Renaissance.* Columbia, S.C., 1971.

Chihaia, Pavel. *Immortalité et décomposition dans l'art du Moyen Age.* Madrid, 1988.

Christiansen, Keith. *Gentile da Fabriano.* Ithaca, N.Y., 1982.

"Some Observations on the Brancacci Chapel Frescoes after Their Clean-ing." *Burlington Magazine* 133 (1990): 5–20.

Ciasca, Raffaele. *L'Arte dei medici e speziali nella storia e nel commercio fiorentino dal secolo XII al XV.* Florence, 1927.

ed. *Statuti dell'arte dei medici e speziali.* Florence, 1922.

Cohen, Kathleen. *Metamorphosis of a Death Symbol: The Transi Tomb in the Late Middle Ages and the Renaissance.* Berkeley, 1973.

Cole, Bruce. *Agnolo Gaddi.* Oxford, England, 1977.

Coolidge, John. "Further Observations on Masaccio's *Trinity.*" *Art Bulletin* 48 (1966): 382–4.

Covi, Dario. "Lettering in Fifteenth-Century Florentine Painting." *Art Bulletin* 45 (1963): 1–17.

Crombie, Alistair C. "Science and the Arts in the Renaissance: The Search for Truth and Certainty, Old and New." In *Science and the Arts in the Renaissance,* ed. John W. Shirley and F. David Hoeniger, pp. 15–26. Washington, D.C., 1985.

Cropper, Elizabeth, Giovanna Perini, and Francesco Solinas, eds. *Documentary Culture: Florence and Rome from Grand-Duke Ferdinand I to Pope Alexander VII.* Bologna, 1992.

Crowe, J[oseph]. A[rcher]., and G[iovanni]. B[attista]. Cavalcaselle. *A New History of Painting in Italy from the Second to the Sixteenth Century.* Vol. 1. London, 1864. *See also* Cavalcaselle, G[iovanni]. B[attista]., and J[oseph]. A[rcher]. Crowe.

Davies, J.H. *A Letter to Hebrews.* The Cambridge Bible Commentary. Cam-bridge, England, 1967.

Delcorno, Carlo. *Giordano da Pisa e l'antica predicazione volgare.* Florence, 1975.

Dempsey, Charles. "Masaccio's 'Trinity': Altarpiece or Tomb?" *Art Bulletin* 54 (1972): 279–81.

Doesschate, Gezienus ten. *Perspective Fundamentals, Controversials, History.* Nieuwkoop, 1964.

Eastwood, Bruce S. *Astronomy and Optics from Pliny to Descartes: Texts, Diagrams and Conceptual Structures.* London, 1989.

Edgerton, Samuel Y., Jr. "The Renaissance Artist as Quantifier." In *Alberti's Window: The Projective Model of Pictorial Information,* vol. 1 of *The Percep-tion of Pictures,* ed. M. A. Hagen, pp. 179–211. New York and London, 1980.

The Renaissance Rediscovery of Linear Perspective. New York, 1975.

Eisenberg, Marvin. *Lorenzo Monaco.* Princeton, 1989.

Esche, S. *Adam und Eva, Sündenfall und Erlösung.* Düsseldorf, 1957.

Ettlinger, L. D. "Pollaiuolo's Tomb of Sixtus IV." *Journal of the Warburg and Courtauld Institutes* 16 (1953): 258–61.

Fabriczy, Cornelius von, ed. "Il Libro di Antonio Billi." *Archivio storico italiano,* ser. 5, 7 (1891): 300–61.

Ferrari, Giovanna. "Public Anatomy Lessons and the Carnival: The Anatomy Theatre of Bologna." *Past and Present* 117 (1987): 50–106.

Field, J[udith].V., "Alberti, the Abacus and Piero della Francesca's Proof of Perspective, *Renaissance Studies* 11 (1997): 61–88.

R[oberto]. Lunardi, and T[homas]. B. Settle. "The Perspective Scheme of Masaccio's *Trinity* Fresco." *Nuncius* 4, pt. 2 (1989): 31–118.

Findlen, Paula. *Possessing Nature: Museums, Collecting, and Scientific Culture in Early Modern Italy.* Berkeley, 1994.

Forni, Ulisse. *Manuale del pittore restauratore.* Florence, 1866.

Frankl, P. "The Secret of the Medieval Masons with an Explanation of Stornoloco's Formula by Erwin Panofsky." *Art Bulletin* 27 (1954): 46–60.

Freedberg, David. *The Power of Images: Studies in the History and Theory of Response.* Chicago, 1989.

Freiberg, Jack. "The *Tabernaculum Dei:* Masaccio and the Perspective Sacrament Tabernacle." Master's essay. Institute of Fine Arts, New York, 1974.

French, Roger K. "A Note on the Anatomical Accessus of the Middle Ages." *Medical History* 23 (1979): 461–8.

"An Origin for the Bone Text of the 'Five-Figure Series.'" *Sudhoffs Archiv* 68 (1984): 143–58.

Frutaz, A. Pietro. *Enciclopedia cattolica* 12 (1954): cols. 530–44, s.v. Trinità, Santissima. Vatican City, 1954.

Gavitt, Philip. *Charity and Children in Renaissance Florence: The Ospedale degli Innocenti, 1410–1536.* Ann Arbor, 1990.

Geisenheimer, H. "Fra Modesto Biliotti, cronista di S. Maria Novella (nato nel 1530, morto nel 1607)." *Il Rosario, Memorie Domenicane* 2 ser., 7 (1905): 306–14.

Getz, Faye M.H. "Anatomia del Medioevo." *Kos* 4 (1984): 36–46.

Ghiberti, Lorenzo. *Lorenzo Ghibertis Denkwürdigkeiten.* 2 vols. Ed. Julius von Schlosser. Berlin, 1912.

Giannini, Cristina. "Restauro e direzione museale a Firenze fra amministrazione Lorenze e Sabauda (1846–1864)." *Critica d'arte* 19 (Jan.–March 1989): 87–93.

Gill, J. *The Council of Florence.* Cambridge, England, 1959.

Ginzburg, Carlo. *The Enigma of Piero.* Trans. M. Ryle and K. Soper. London, 1985.

Gioseffi, Decio. "Prospettiva." In *Enciclopedia universale dell'arte* 11 (1963): 116–59.

Goffen, Rona. "Masaccio's Trinity and the Letter to the Hebrews." *Memorie Domenicane* N.S. 11 (1980): 489–504.

"Nostra Conversatio in Caelis Est: Observations on the *Sacra Conversazione* in the Trecento." *Art Bulletin* 61 (1979): 198–222.

Piety and Patronage in Renaissance Venice: Bellini, Titian, and the Franciscans. New Haven and London, 1986; rpt. 1990.

Spirituality in Conflict: Saint Francis and Giotto's Bardi Chapel. University Park and London, 1988.

Goldthwaite, Richard. *The Building of Renaissance Florence.* Baltimore, 1980.

Private Wealth in Renaissance Florence. Princeton, 1968.

Guerry, Liliane. *Le thème du "Triomphe de la Mort" dans la peinture italienne.* Paris, 1950.

Gurrieri, Francesco. "La cappella Cardini di Pescia, pienezza di diritto nel catalogo brunelleschiano." *Bollettino d'arte* ser. 6, anno 70, no. 31–32 (1985): 97–124.

Hackel, A. *Die Trinität in der Kunst: Eine ikonographische Untersuchung.* Berlin, 1931.

Hall, Marcia B. *Renovation and Counter-Reformation: Vasari and Duke Cosimo in Sta Maria Novella and Sta Croce 1565–1577.* Oxford, England, 1979.

Hartner, Willy. "The Principle and Use of the Astrolabe." In *A Survey of Persian Art from Prehistoric Times to the Present,* ed. Arthur Upham Pope and Phyllis Ackerman, vol. 6, pp. 2530–54. Oxford, England, 1938–39. Rpt. 1967.

Heath, Thomas Little, ed. *The Works of Archimedes.* Cambridge, England, 1897.

Herlihy, David, and Christiane Klapisch-Zuber. *Tuscans and Their Families: A Study of the Florentine Catasto of 1427.* New Haven, 1985.

Herrlinger, Robert. *Geschichte der medizinisschen Abbildung, I: Von der Antike bis um 1600.* Munich, 1967.

History of Medical Illustration from Antiquity to A.D. 1600. Trans. Graham Fulton-Smith. London, 1970.

Hertlein, Edgar. *Masaccios Trinität: Kunst, Geschichte und Politik der Frührenaissance in Florenz.* Florence, 1979.

Humberti de Romanis, Fr. [Humbert of Romans]. "De Eruditione Praedicatorum." In *Maxima Bibliotheca Veterum Patrum, et Antiquorum Scriptorum Ecclesiasticorum* 25, pp. 424–56. Ed. Margarino de la Bigne. Loudon, 1677.

[Umberto de Romans]. *Istruzioni per i predicatori.* Trans. and ed. G. Mosca. N.p. 1966.

Janson, H[orst]. W. "Ground Plan and Elevation in Masaccio's *Trinity* Fresco." In *Essays in the History of Art Presented to Rudolf Wittkower,* pp.

83–8. Ed. Douglas Fraser, Howard Hibbard, and Milton J. Lewine. London, 1967.

Joannides, Paul. *Masaccio and Masolino: A Complete Catalogue.* London, 1993.

Johannsen, B. B., and M. Marcussen. "A Critical Survey of the Theoretical and Practical Origins of Linear Perspective." *Acta ad Archaeologium et Artium Historiam Pertinentia.* Institutem Romanum Norwegiae. Series Altera in 8. 1 (1981): 191–229.

Jones, Peter Murray. *Medieval Medical Miniatures.* Austin, 1984.

Kanter, Laurence B., et al. *Painting and Illumination in Early Renaissance Florence 1300–1450.* Exh. cat. New York, 1994.

Kemp, Martin. "Geometrical Perspective from Brunelleschi to Desaurges: A Pictorial Means or an Intellectual End?" *Proceedings of the British Academy* 70 (1984): 89–132.

 "Science, Non-Science and Nonsense: The Interpretation of Brunelleschi's Perspective." *Art History* 1 (1978): 131–61.

 The Science of Art: Optical Themes in Western Art from Brunelleschi to Seurat. New Haven and London, 1990.

Kent, Dale. *The Rise of the Medici: Faction in Florence 1426–1434.* Oxford, England, 1978.

Kent, F. W[illiam]. *Bartolomeo Cederni and His Friends: Letters to an Obscure Florentine.* Florence, 1991.

 Household and Lineage in Renaissance Florence: The Family Life of the Caponi, Ginori and Rucellai. Princeton, 1977.

 "Palaces, Politics and Society in Fifteenth-Century Florence." *I Tatti Studies: Essays in the Renaissance* 2 (1987): 41–70.

Kern, G. F. "Das Dreifaltigkeitsfresco von S. Maria Novella, eine perspektivisch-architekturgeschichtliche Studie." *Jahrbuch der Königlich preuzischen Kunstsammlungen* 34 (1913): 36–58.

[Ketham, Johannes de]. *The Fasciculo di medicina, Venice, 1493.* 2 vols. Ed. and trans. Charles Singer. Florence, 1925.

Kirshner, Julius, and Anthony Molho. "The Dowry Fund and the Marriage Market in Early Quattrocento Florence." *Journal of Modern History* 50 (1978): 404–38.

Knorr, W. *The Evolution of Euclidean Elements: A Study of the Theory of Incommensurate Magnitudes and Its Significance for Early Greek Geometry.* Boston and Dordrecht, 1975.

Krautheimer, Richard, and Trude Krautheimer-Hess. *Lorenzo Ghiberti,* 2 vols. Princeton, 1970.

Kudlien, Fridolf. "The Seven Cells of the Uterus: The Doctrine and Its Roots." *Bulletin of the History of Medicine* 39 (1965): 415–32.

Kuhn, Jehane. "Measured Appearances: Documentation and Design in Early Perspective Drawing." *Journal of the Warburg and Courtauld Institutes* 53 (1990): 114–32.

Lasareff, Victor. "Studies in the Iconography of the Virgin." *Art Bulletin* 20 (1938): 26–65.

Leonardo da Vinci. *Leonardo on the Human Body.* Trans. and ed. Charles D. O'Malley and J.B. de C.M. Saunders. New York, 1952. Rpt. 1983.

Lieberman, Ralph. "Brunelleschi and Masaccio in Santa Maria Novella." *Memorie Domenicane* N.S. 12 (1981): 127–39.

Lind, Levi Robert. *Studies in Pre-Vesalian Anatomy.* Philadelphia, 1975.

——. "Linguaggi storiografici sulla Firenze rinascimentale." *Rivista storica italiana* 97 (1985): 143–7.

Lunardi, Roberto. *Arte e storia in Santa Maria Novella.* Florence, 1983.

——. "Note sulla 'Trinità' Affrescata da Masaccio nella chiesa di Santa Maria Novella in Firenze, II. La Scomparsa e il ritorno." In *Le pitture murali: Tecnico, problemi, conservazione,* pp. 251–60. Ed. Cristina Danti, Mauro Matteini, and Arcangolo Moles. Florence, 1990.

——. "La ristrutturazione vasariana di Santa Maria Novella: I documenti ritrovati." *Immagine e parola: Retorica filologica – Retorica predicatoria (Valla e Savonarola). Memorie Domenicane* N.S. 19 (1988): 403–19.

See also Field, J. V.

Maccagni, Carlo. "Frammento di un codice di medicina del secolo XIV (manoscritto N. 735, già codice Roncioni N. 99) della Biblioteca Universitaria di Pisa." *Physis* 11 (1969): 311–78.

MacKinney, Loren C., and Boyd H. Hill, Jr. "A New Fünfbilderserie Manuscript –Vatican Palat. Lat. 1110." *Sudhoffs Archiv* 48 (1964): 322–30.

Malagola, Carlo, ed. *Statuti delle università e dei collegi dello studio bolognese.* Bologna, 1888.

Mâle, Emile. *Chartres.* New York, 1983.

Mandach, Conrad de. *Saint Antoine de Padoue et l'art italien.* Paris, 1899.

Manni, D. M. *Prediche del Beato Giordano da Rivalto.* Florence, 1739.

Marin, Louis. "Narrative Theory and Piero as History Painter" (1985). Trans. Gred Sims. *October* 65 (Summer 1993): 107–32.

Martines, Lauro. *Lawyers and Statecraft in Renaissance Florence.* Princeton, 1968.

Matteini, Mauro. "In Review: An Assessment of Florentine Methods of Wall Painting Conservation Based on the Use of Mineral Treatments." In *The Conservation of Wall Paintings,* ed. Sharon Cather, pp. 137–48. Marina del Rey, Calif., 1991.

Meiss, Millard. "An Early Altarpiece from the Cathedral of Florence." *Metropolitan Museum of Art Bulletin* 12 (1954): 302–17.

Francesco Traini. Ed. and intro. Hayden B.J. Maginnis. Washington, DC, 1983.

"Light as Form and Symbol in Some Fifteenth-Century Paintings." *Art Bulletin* 27 (1945): 43–68.

Painting in Florence and Siena after the Black Death: The Arts, Religion and Society in the Mid-Fourteenth Century. Princeton, 1951; rpt. New York, 1964.

The Painter's Choice, Problems in the Interpretation of Renaissance Art. New York, 1976.

"Toward a More Comprehensive Renaissance Paleography." *Art Bulletin* 42 (1960): 97–112.

Merriell, D. Juvenal. *To the Image of the Trinity: A Study in the Development of Aquinas' Teaching.* Toronto, 1990.

Mesnil, Jacques. "Die Kunstlehre der Frührenaissance im Werks Masaccios." *Vorträge der Bibliothek Warburg, 1925–26* 5 (1928): 122–46.

Michel, A. *Dictionnaire de théologie catholique* 5, 2me partie, s.v. Trinité, cols. 1594–95. Paris, 1950.

Michel, Paul Henri. "L'esthétique arithmétique du Quattrocento: une application des médiétés Pythagoriciennes à l'esthétique architecturale." In *Mélanges offerts à Henri Houvette,* pp. 181–9. Paris, 1934.

Molho, Anthony. *Marriage Alliance in Late Medieval Florence.* Cambridge, Mass., 1994.

Mondino de' Liucci. *Anatomia, riprodotta da un codice bolognese del secolo XIV e volgarizzata nel secolo XV.* Ed. Lino Sighinolfi. Bologna, 1930.

Offner, Richard. *A Critical and Historical Corpus of Florentine Painting.* Sec. III, vol. 2, pt. 2. New York, 1930. Sec. III, vol. 5. New York, 1947.

"Light on Masaccio's Classicism." In *Studies in the History of Art Dedicated to William E. Suida on His Eightieth Birthday.* London, 1959.

Murdoch, J. E. *Album of Science: Antiquity and the Middle Ages.* New York, 1984.

Najemy, John. "The Dialogue of Power in Florentine Politics." In *City States in Classical Antiquity and Medieval Italy,* ed. Anthony Molho et al., pp. 269–88. Stuttgart, 1991.

"Linguaggi storiografici sulla Firenze rinascimentale." *Rivista storica italiana* 97 (1985): 143–7.

Neugebauer, O. *A History of Ancient Mathematical Astronomy,* 3 vols. Berlin, Heidelberg, and New York, 1975.

The Exact Sciences in Antiquity, 2d ed. New York, 1969.

North, J. D. "The Astrolabe." *Scientific American* 230 (Jan. 1974): 96–106.

Nucci, E. *Piccola Guida storico-artistica della chiesa di S. Francesco in Pescia*. Pescia, 1915.

O'Carroll, Michael. *Trinitas: A Theological Encyclopedia of the Holy Trinity*. Wilmington, 1987.

O'Malley, Charles D. *Andreas Vesalius of Brussels, 1514–1564*. Berkeley, 1964.
and J.B. de C.M Saunders. *See* Leonardo da Vinci.

Ongaro, Giuseppe. "La medicina nello studio di Padova e nel Veneto." In *Storia della cultura veneta*, vol. 3, pt. 3, pp. 75–134. Ed. Girolamo Arnaldi et al. Vicenza, 1981.

Orlandi, Stefano, o.p. *"Necrologio" di S. Maria Novella, Testo integrale dall'inizio (MCCXXXV) al MDIV.* With notes by Innocenzo Taurisano. 2 vols. Florence, 1955.

"Nota circa l'altare della SS. Trinità in S. Maria Novella di Firenze." *Memorie Domenicane* 64, N.S. 28 (1952): 271–73.

Pacciani, Riccardo. "Ipotesi di omologie fra impianto fruitivo e struttura spaziale di alcune opere del primo rinascimento fiorentino: il rilievo della base del 'S. Giorgio' di Donatello, la 'Trinità' di Masaccio, l''Annunciazione' del convento di S. Marco del Beato Angelico." In *La prospettiva rinascimentale: codificazioni e trasgressioni,* ed. Marisa Dalai Emiliani, vol. 1, pp. 73–92. Florence, 1980.

Pandimiglio, Leonida. *Felice di Michele "vir clarissimus" e una consorteria: I Brancacci di Firenze*. Milan, 1987.

Panofsky, Erwin. "Once More the Friedsam Annunciation and the Problem of the Ghent Altarpiece." *Art Bulletin* 20 (1938): 419–42.

Parente, Pietro. *Enciclopedia cattolica* 12, cols. 529–41, s.v. Trinità, Santissima. Vatican City, 1954.

Park, Katharine. *Doctors and Medicine in Early Renaissance Florence*. Princeton, 1985.

"The Criminal and the Saintly Body: Autopsy and Dissection in Renaissance Italy." *Renaissance Quarterly* 47 (1994): 1–33.

"The Life of the Corpse: Division and Dissection in Late Medieval Europe." *Journal of the History of Medicine* 50 (1994): 111–32.

"The Readers at the Florentine *Studio* according to Communal Fiscal Records (1357–80, 1413–46)." *Rinascimento* 20 (1980): 249–310.

Parrini, Paolo L., and Giuseppe Pizzigoni. "Lo stato di conservazione della superficie degli affreschi prima dell'intervento di restauro." In *La Cappella Brancacci: La scienza per Masaccio, Masolino e Filippino Lippi,* ed. Renzo Zorzi, pp. 123–9. Quaderni del restauro 10. Milan, 1992.

Philip, Lotte Brandt. *The Ghent Altarpiece and the Art of Jan van Eyck*. Princeton, 1971.

Phillips, Mark. *The Memoir of Marco Parenti: A Life in Medici Florence*. Princeton, 1987.

Poeschke, Joachim. *Die Kirche San Francesco in Assisi und ihre Wandmalereien*. Munich, 1985.

Polzer, Joseph. "The Anatomy of Masaccio's Holy *Trinity*." *Jahrbuch der Berliner Museen* 93 (1971): 18–59.

——— "Aspects of the Fourteenth-Century Iconography of Death and the Plague." In *The Black Death: The Impact of the Fourteenth-Century Plague (Papers of the Eleventh Annual Conference of the Center for Medieval and Early Renaissance Studies)*, ed. Daniel Williman and Nancy Siraisi, pp. 107–30. Binghamton, 1982.

Prager, F. D. "Brunelleschi's Clock?" *Physis* 10 (1968): 201–16.

——— and G. Scaglia. *Mariano Taccola and His Book De Ingeneis*. Cambridge, Mass., 1972.

Premuda, Loris. *Storia dell'iconografia anatomica*. Milan, 1957.

Procacci, Ugo. "Il Vasari e la conservazione degli affreschi della cappella Brancacci al Carmine e della Trinità in S. Maria Novella." In *Scritti di storia dell' arte in onore di Lionello Venturi*, vol. 1, pp. 211–22. Ed. Mario Salmi. Rome, 1956.

——— "La Cappella Brancacci: Vicende storiche." In *La Cappella Brancacci nella chiesa del Carmine a Firenze*, ed. Ugo Procacci and Umberto Baldini, pp. 9–20. Quaderni del restauro 1. Milan, 1984.

——— "Nuove testimonianze su Masaccio." *Commentari* N.S. 27 (1976 [1978]): 223–37.

Putti, Vittorio. *Berengario da Carpi: Saggio biografico e bibliografico*. Bologna, 1937.

Ringbom, Sixten. *Icon to Narrative: The Rise of the Dramatic Close-up in Fifteenth-Century Devotional Painting*. Acta Academiae Aboensis, Ser. A, Humaniora 31, 2. Åbo, 1965.

Roberts, K. B., and J. D. W. Tomlinson. *The Fabric of the Body: European Traditions of Anatomical Illustration*. Oxford, England, 1992.

Roselli, S. *Sepoltuario fiorentino*. MS dated 1657 in Florence, Archivio di Stato.

Rosenauer, Artur. *Donatello*. Milan, 1993.

Rotzler, Willy. *Die Begegnung der drei Lebenden und der drei Toten. Ein Beitrag zur Forschung über die mittelalterlichen Vergänglichkeitsdarstellungen*. Winterthur, 1961.

Rubin, Miri. *Corpus Christi: The Eucharist in Late Medieval Culture*. Cambridge, England, and New York, 1991.

Saalman, Howard. "Giovanni di Gherardo da Prato's Designs Concerning the Cupola of Santa Maria del Fiore in Florence." *Journal of the Society of Architectural Historians* 18 (1959): 11–20.

Sanpaolesi, Piero. "Le conoscenze techniche del Brunelleschi." In *Filippo Brunelleschi: La sua opera e il suo tempo,* vol. 1, pp. 145–60. Florence, 1980.

Satkowski, Leon. *Giorgio Vasari, Architect and Courtier.* Princeton, 1993.

Saunders, J.B. de C.M., and Charles D. O'Malley. *The Illustrations from the Works of Andreas Vesalius of Brussels.* Cleveland, 1950; rpt. New York, 1973.

Schiebinger, Londa. "Politica sessuale: Le prime rappresentazioni dello scheletro femminile nell'anatomia del XVIII secolo." *Memoria* 11–12 (1984): 145–51.

Schlegel, Ursula. "Observations on Masaccio's Trinity Fresco in Santa Maria Novella." *Art Bulletin* 45 (1963): 19–33.

Schultz, Bernard. *Art and Anatomy in Renaissance Italy.* Ann Arbor, 1985.

Seidel, Ernst, and Karl Sudhoff. "Drei weitere anatomische Fünfbilderserien aus Abendland und Morgenland." *Archiv für Geschichte der Medizin* 3 (1910): 165–87.

Shearman, John. *Only Connect . . . Art and the Spectator in the Italian Renaissance.* The A. W. Mellon Lectures in the Fine Arts, 1988. Bollingen Series XXXV.37 (Princeton, 1992).

Simons, Patricia. "Portraiture and Patronage in Quattrocento Florence with Special Reference to the Tornaquinci and Their Chapel in S. Maria Novella." Ph.D. dissertation, University of Melbourne, Australia, 1985.

Simson, Otto von. "Über die Bedeutung von Masaccios Trinitätsfresco in S. Maria Novella." *Jahrbuch der Berliner Museen* 6 (1966): 119–59.

Sindona, Enio. "Prospettiva e crisi nell'umanesimo." In *La prospettiva rinascimentale: codificazioni e trasgressioni,* ed. Marisa Dalai Emiliani, vol. 1, pp. 95–120. Florence, 1980.

Siraisi, Nancy G. *Medieval and Early Renaissance Medicine: An Introduction to Knowledge and Practice.* Chicago, 1990.

 Taddeo Alderotti and His Followers: Two Generations of Italian Medical Learning. Princeton, 1981.

Spike, John T. *Masaccio.* New York, 1996.

Staden, Heinrich von. "The Discovery of the Body: Human Dissection and Its Cultural Contexts in Ancient Greece." *Yale Journal of Biology and Medicine* 65 (1992): 223–41.

Strocchia, Sharon. *Death and Ritual in Renaissance Florence.* Baltimore, 1992.

Sudhoff, Karl. "Abbildungen zur Anatomie des Maître Henri de Mondeville (ca. 1260 bis 1320)." In Karl Sudhoff, *Studien zur Geschichte der Medizin, H. 4: Ein Beitrag zur Geschichte der Anatomie im Mittalter speziell der anatomischen Graphik nach Handscriften des 9. bis 15. Jahrhunderts,* pp. 82–9. Leipzig, 1908.

Tenenti, Alberto. *Il senso della morte e l'amore della vita nel Rinascimento (Italia-Francia).* Turin, 1957; rpt. 1976.

 Teoria del restauro e unità di metodologia. 2 vols. Florence, 1978–81.

Teuffel, Christa Gardner von. "Masaccio and the Pisa Altarpiece: A New Approach." *Jahrbuch der Berliner Museen* 19 (1977): 23–68.

Thomson, R. B., ed. and trans. *Jordanus de Nemore and the Mathematics of Astrolabes: De Plana Spera.* Toronto, 1978.

Thorndike, Lynn, ed. and trans. *University Records and Life in the Middle Ages.* New York, 1944.

Tintori, Leonetto. "Note sulla 'Trinità' Affrescata da Masaccio nella chiesa di Santa Maria Novella in Firenze, III. Gli ultimi interventi di restauro." In *Le pitture murali: Tecnico, problemi, conservazione,* pp. 261–8. Ed. Cristina Danti, Mauro Matteini, and Arcangolo Moles. Florence, 1990.

Tolnay, Charles de. "Renaissance d'une fresque." *L'Oeil* 37 (1958): 36–41.

Torp, H. "The Integrating System of Proportion in Byzantine Art, an Essay on the Method of the Painters of Holy Images." *Acta ad Archaeologiam et Artium Historiam Pertinentia.* Series in Altera 8. 4 (1984): 134–47.

Trexler, Richard. "Florentine Religious Experience: The Sacred Image." *Studies in the Renaissance* 19 (1972): 9–11.

[Valla, Lorenzo]. *The Treatise of Lorenzo Valla on the Donation of Constantine.* Ed. and trans. Christopher B. Coleman. New Haven, 1922. Rpt. Renaissance Society of America Reprint Texts 1. Toronto, 1993.

Vasari, Giorgio. *Le opere di Giorgio Vasari: Le Vite de' pi eccellenti pittori, scultori ed architettori.* 9 vols. Ed. Gaetano Milanesi. Florence 1906. Rpt. 1973.

Veltman, Kim H. "Ptolemy and the Origins of Linear Perspective." In *La prospettiva rinascimentale: Codificazione e trasgressioni,* vol. 1, ed. Marisa Dalmi Emiliani, pp. 403–7. Milan, 1980.

Review of Samuel Y. Edgerton, Jr., *The Renaissance Rediscovery of Linear Perspective* (New York, 1975). *Art Bulletin* 59 (1977): 281–2.

Voragine, Jacobi a. *Legenda Aurea.* Ed. T. Graesse, 1890. Rpt. Osnabrük, 1965.

Weinstein, Donald. *Savonarola and Florence.* Princeton, 1970.

White, John. "Measurement, Design and Carpentry in Duccio's Maestà, Part 1." *Art Bulletin* 45 (1973): 356–8.

White, Lynn Townsend. "Medical Astrology and Late Medieval Technology." In *Medieval Religion and Technology, Collected Essays,* pp. 301–11. Berkeley, Los Angeles, and London, 1978.

"Temperantia and the Virtuousness of Technology." In *Medieval Religion and Technology, Collected Essays,* pp. 181–204. Berkeley, Los Angeles, and London, 1978.

Wickersheimer, Ernest. *Les Anatomies de Mondino dei Liuzzi et de Guido de Vigevano.* Paris, 1926.

"L'Anatomie' de Guido de Vigevano, médecin de la reine Jeanne de Bourgogne (1345)." *Archiv für Geschichte der Medizin* 7 (1913): 1–25.

Wittkower, Rudolf. *Architectural Principles in the Age of Humanism.* New York, 1965.

"The Changing Concept of Proportions." *Daedalus* 89 (1960): 199–215.

Wolf-Heidegger, G., and Anna Maria Cetto. *Die anatomische Sektion in bildlicher Darstellung.* Basel, 1967.

Zervas, Diane Finiello. "Ghiberti's St. Matthew Ensemble at Or San Michele: Symbolism in Proportion." *Art Bulletin* 58 (1976): 36–44.

" '*Quos volent et eo modo quo volent':* Piero de' Medici and the Operai of SS. Annunziata, 1445–55." In *Florence and Italy: Renaissance Studies in Honour of Nicolai Rubinstein,* ed. P. Denley and Caroline Elan, pp. 465–79. London, 1988.

The Parte Guelfa, Brunelleschi and Donatello. Locust Valley, 1987.

"The Trattato Dell'Abbaco and Andrea Pisano's Design for the Florentine Baptistery Door." *Renaissance Quarterly* 28 (1975): 483–503.

Zorzi, Renzo, ed. *La Cappella Brancacci: La scienza per Masaccio, Masolino e Filippino Lippi.* Quaderni del restauro 10. Milan, 1992.

INDEX

DATE DUE